THE GREAT KANANASKIS FLOOD

A Disaster That Forever Changed the Face of Kananaskis Country

Gillean Daffern & Derek Ryder

RMB

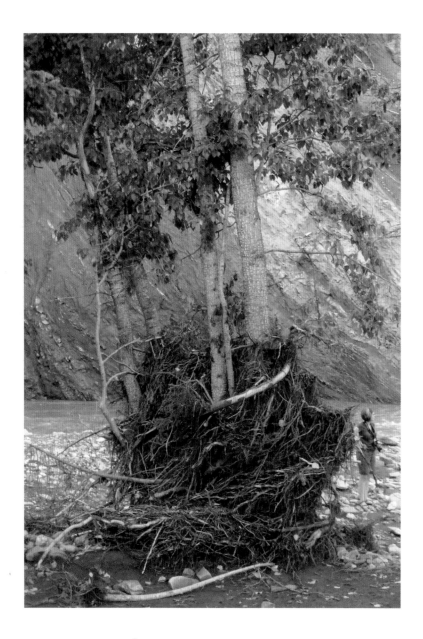

"Kanananaskis Country is part of our Alberta lifestyle, legacy and identity, and it is a vital part of our tourism industry. We get away to Kananaskis to have fun and connect with nature, and so do people from around the world. Restoring parks infrastructure benefits the people in our communities and helps support the local economy."

Dr. Richard Starke, former Minister of
Tourism, Parks and Recreation

Foreword

On June 20, 2013, my hometown of Canmore woke up to a natural disaster unlike anything we'd ever seen. Normally dry or low-flowing creeks became raging torrents cutting paths of destruction through roads and highways, trails, backyards and homes. Millions of dollars worth of flood control work done along Cougar Creek the previous year was washed away in a matter of hours in an event that, based on research done since, was a long time in coming. Millions more dollars worth of key highways were wiped out, cutting off the Bow Valley communities of Canmore, Banff, Dead Man's Flats, Kananaskis and Exshaw from each other and the outside world.

During that week my regular radio morning show became a broadcasting marathon as we worked hard to obtain accurate information and relay it to the community. Our staff was running on adrenalin dealing with the sheer volume of news to share: the devastation throughout Kananaskis backcountry; the isolation of Exshaw after two overflowing creeks cut off the hamlet in both directions; the evacuation of over a thousand people in Canmore alone. Nobody knew when it would end.

But finally the flooding stopped, leaving much of our landscape forever changed. In the aftermath, people began rebuilding their lives and rebuilding infrastructures all over Kananaskis Country, something that still continues to this day.

Yet I feel the real legacy of this disaster was the spirit of resiliency and community that affected everyone who lived through it. We saw neighbours helping neighbours however they could. Nobody who was displaced was left without a place to stay. Community flood fundraisers were packed with generous people willing to open their hearts and wallets. Countless volunteer hours were spent restoring access to our beautiful backcountry. It was a true community effort that made me love and appreciate the place I live in more than I did before.

In this book you'll see photos showing the shocking devastation caused by Mother Nature run amok. But I hope the reader will also take away impressions of the strength of our community and the dedication of the volunteers who continue to be loving stewards of our heaven in the mountains.

Rob Murray, Morning Show Host, 106.5 Mountain FM

FRIENDS OF
KANANASKIS COUNTRY

Friends of Kananaskis Country is a non-profit organization committed to sharing this special place through education, community engagement and volunteer participation. We dedicate this book to the Friends Program Coordinators Rosemary Power and Nancy Ouimet, and to the enthusiastic crew leaders and volunteers who are helping to restore Kananaskis trails.

All proceeds from this book will go towards repairs to trails and backcountry campsites.

CAPTIONS
Cover: Lineham Creek bridge after the flood.
Photo Gillean Daffern

Back cover: Just upstream of Beaver Flats Campground is a grove of trees wrapped with branches and roots carried down by the Elbow River. Photo Gillean Daffern

Page 2: Root-wrapped tree at Sandy McNabb day-use area.
Photo Gillean Daffern

ABBREVIATIONS USED IN THIS BOOK
AEP: Alberta Environment and Parks
ESRD: Environment and Sustainable Resource Development
EMS: Emergency Medical Services
MMBTS: Moose Mountain Bike Trail Society
CNC: Canmore Nordic Centre
SLS: Spray Lakes Sawmills
Friends: Friends of Kananaskis Country

Acknowledgements

We wish to express our gratitude to the following, who were willing to tell their stories: Reg Mullett of the Moose Mountain Bike Trail Society; parks services ranger Gareth Short; trails technologist specialists Jeff Eamon and James Cieslak; Duane Fizor, regional information and advisories coordinator for AEP; Jill Sawyer, regional communications officer for AEP; Pat Ronald, team leader for the Elbow/Sheep District; Dan LaFleur, woodlands operations supervisor for Spray Lakes Sawmills; Patrice Cloutier, acting director of human resources at Delta Lodge; Sheryl Green, co-owner of Sundance Lodges; Claude Faerden, owner of Kananaskis Outfitters; Vi Sandford of the town of Canmore; Andun Jevne, program head for BTFR (Backcountry Trails Flood Rehabilitation); Zhihong Hampton Han, owner of Fortress Junction gas station; Gord Hurlburt, senior geologist with Sherritt International Corporation; Simon Coward, owner of Aquabatics; Ubaid Khan and Jason Russell of Alberta Transportation; and not least, Rob Murray of Mountain FM, who has shared his experiences in the foreword.

Reg Mullett, Gareth Short, Dan LaFleur, Duane Fizor, Patrice Cloutier, Jason Russell and Andun Jevne also contributed photos, for which we doubly thank you.

Other photos, apart from those taken by the authors, were provided by Alf Skrastins; Jack Tannett; Colin Sproule; Robert Mueller, area forester for the South Saskatchewan Region; Riny de Jonge, co-owner of Indian Graves Campground; forest officer Troy Johanson; Tristan Zaba; Lynn Myette; Calvin Damen; Alan Kane; Joanne Godfrey; Bruce Steiner; Stephen Legault; Pat Michael; Allan and Angélique Mandel; Adam Lindenburger and Chuck Lee, executive director of the Alberta Whitewater Association.

Special thanks go to three professional photographers who generously provided their work free of charge: Gavin Young from the *Calgary Herald*; Craig Douce from *Rocky Mountain Outlook,* and Kelly Schovanek, whose own book on the flood, *Water Under the Bridge*, can be bought from Stonewaters Home Elements in Canmore.

Finally, the authors wish to acknowledge our partners Karen Irvine and Tony Daffern and the folks at Rocky Mountain Books: Don Gorman, Chyla Cardinal and Joe Wilderson, for lending their expertise.

We are indebted to everyone who contributed towards this book that will forever be a memento of the Great Kananaskis Flood of 2013.

6

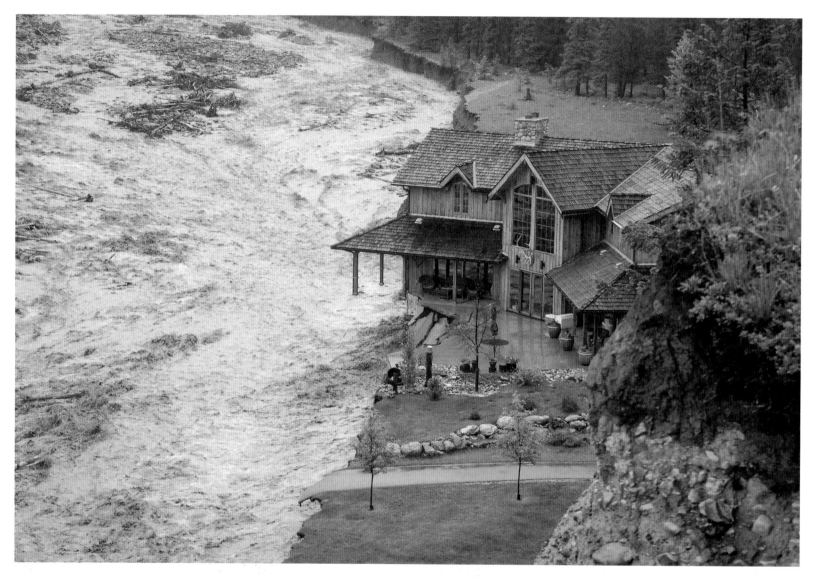

CANMORE On the morning of June 20th the uppermost house on Canyon Road is threatened by Cougar Creek.

Already the patio is breaking up and half the yard has disappeared. Photo Stephen Legault

The Flood

June 17, 2013, was a glorious day in Kananaskis Country: blue skies, perfect temperatures, light wind — and a rainfall warning issued for the coming days. There were hundreds of people recreating in Kananaskis Country. Campgrounds were filling up, William Watson Lodge was booked solid, handicapped kids were having fun at Tim Horton's Ranch. A mountain bike race was scheduled for the Canmore Nordic Centre. Virtually no one in the area was expecting the next few days to unleash a nightmare of water that would be the costliest natural disaster in Canada's history.

According to Environment Canada:

> The storm featured an intense and slow-moving moist upper low that parked itself over southern Alberta, delivering three days of torrential rains. What was not typical was that it stalled and sat over the mountains for days due to a massive high-pressure ridge to the north that blocked it from moving east and pinched it up against the Rocky Mountains. The stationary, wide-ranging low drew in warm air and cargoes of moisture from the Pacific Ocean, the Gulf of Mexico and beyond before drenching the Rockies watershed in southeastern British Columbia and southern Alberta... Beginning late on June 19th, the skies opened and poured for 15 to 18 hours — a fire hose aimed directly at southwestern Alberta. The trapped low studded with thunderstorms just kept drenching the mountains, melting the snowpack but not thawing the partially frozen ground. The already saturated soil on thinly covered steep slopes couldn't take any more water. The rainfall west of Calgary in the elevated headwaters of the Bow and Elbow rivers was exceptionally heavy and torrential — more typical of a tropical storm in quantity and intensity. Rainfall rates of 3 to 5 mm/h are considered high; rates from this storm were 10 to 20 mm/h in the higher elevations, with several stations reporting 50 to 70 per cent of their storm rainfall in the first 12 hours. Totals averaged 75 to 150 mm over two and a half days, with Burns Creek (west of High River at 1800 m elevation) recording a phenomenal 345 mm. At Canmore over 200 mm of rain fell — ten times that of a typical summer rainfall.

The water came down off the mountains like a runaway train, carrying billions of tons of rocks with it, scouring the gullies, ripping out trees, tearing away mountainsides and in creeks and rivers building to an immense power that removed everything in its path, including roads, bridges, culverts and buildings. The debris carried along only intensified the damage caused by the water itself.

The rain started in Canmore at 4:15 on the Wednesday afternoon of June 19. By 6:30 some homeowners living alongside Cougar Creek were worried, but were assured the creek was running normally through the culverts. But it wasn't fine. When residents were woken up at 2:30 in the night and ordered to evacuate, raging floodwaters were already ripping out the foundations from the back of the houses facing the creek. Back garden trampolines and lawn furniture were floating down the creek towards the Bow River. Downstream, the Trans-Canada Highway was breached and the CPR bridge collapsed. Water began pouring along Bow Valley Trail toward the hospital. In some areas electricity and gas were cut off, leading to the evacuation of 1,200 people all told. The broken bridge across Carrot Creek and debris flows from Grotto, Exshaw and Jura Creeks across Highway 1A ensured the town remained cut off from the rest of Alberta for another seven days.

That same Wednesday evening, a parks service ranger, out doing his usual check on campground and day-use areas in the Kananaskis Valley, was driving up to his final stop at Highwood Pass. The wind and the rain were unusually ferocious, the lightning constant. In his rear-view mirror he noticed a mudslide creeping across the road behind his truck. By the time he had turned around it was too late. The slide was already across and he was stuck. The only way back to the valley was via Longview. Luckily the culverts at Lineham Creek had not yet been breached.

On arriving back in the valley at 1:30 a.m. on the Thursday morning — the Evan-Thomas Creek bridge was still another 8 hours away from collapsing — he and an RCMP corporal based at Kananaskis Emergency Services near Ribbon Creek raced to rescue campers from flooding Eau Claire Campground and take them to Fortress Junction. At around 3:30 a.m. when he was finally driving back to his digs at the hostel, a section of Rocky Creek bridge beneath his back wheels caved in. His momentum carried him forward to safety, but the back of the truck was a writeoff. Quickly he radioed the EMS for pickup and advised the corporal following behind him to stay put at Fortress Junction. Which she did for another three days.

The same scenario was played out in neighbouring Peter Lougheed Park, where a park employee working alone at the visitor centre spent a busy night rounding up all the campers and taking them to William Watson Lodge.

Higher up the Kananaskis valley, staff at Sundance Lodges were persuaded by EMS to retreat to higher ground at Kananaskis Village and left at 5 a.m. on the Thursday morning. That day, the owner of Kananaskis Outfitters had been unable to get out of Exshaw because of landslides and in any case he wouldn't have made the village, because one hour after the Sundance staff reached the village, the Ribbon Creek bridge collapsed, leaving everyone up there stranded.

The power was out everywhere in the valley and there was no telephone or water. Conversely, there was plenty of muddy water flooding the basements of the hostel,

Boundary Ranch and Fortress Junction. For three days the folks at Fortress existed on cold food like chocolate bars filched from the grocery shelves.

The Kananaskis Village hotels had a much better time of it. Bottled water was flown in and fridges in guest rooms were raided for alcohol. Morning coffee, deemed an essential, was heated up in a big pot over a wood fire on the patio. Frozen food, fast defrosting from fridges, was cooked on outdoor barbecues and in firepits to feed the whole village and declared "delicious."

It would be three days before some 1,000 people could be evacuated by armoured vehicles and helicopters provided by the Canadian military. Some were flown to Stoney Nakoda Resort and Casino, where buses took them into Calgary. It would be nearly a month before vehicles could be collected, leaving overseas visitors renting RVs with some explaining to do. Staff at Mount Kidd RV Park were the last to leave the valley. For three days they had been drinking rain water collected from an upturned voyageur canoe.

A few backpackers stuck in the backcountry were taken out by helicopter, most notably a large group of schoolchildren camped at Carnarvon Lake. It had been snowing heavily up there, and some children were not in good shape by time a big helicopter was procured and able to make the two flights in to rescue them.

Meanwhile, in the Elbow, an MMBTS mountain biker out inspecting trails in Canyon Creek spent a sleepless night in his van, kept awake by the thump of horizontal rain far worse than anything he had experienced in his native Newfoundland. He barely got out the next morning on a road a foot deep in water, en route noticing the normally placid Canyon Creek had washed away the Shell bridge and the bike bridge the MMBTS had so carefully built a few years before. On Highway 66 the Elbow River was lapping the road, the whole of the valley flooded from bank to bank. At 9:40 he drove across the bridge over the Elbow into Bragg Creek, where he barely had time to eat breakfast before flood waters started pouring into the building. Some time between his going over the bridge and 10 a.m., the bridge collapsed.

When it was realized what had happened, stranded campers from higher up the valley were told to drive to the old ranger station (Elbow Fire Base), and over the next two days they were helicopter-hopped across the Elbow to waiting family and colleagues on the far side. Five stranded tree planters with 270,000 seedlings bound for the Jumpingpound had to wait a little longer until Spray Lakes Sawmills could hire a helicopter out of Fernie to evacuate them and their porta-potties.

Campers and campground operators in the Sheep and Highwood fared a little better and were able to drive out along roads starting to fall apart.

After touring the area by helicopter, Premier Redford declared Kananaskis Country a disaster area and ordered it shut down.

Aftermath

The only way to get around Kananaskis Country was by helicopter and what a disaster photos and videos revealed: roads washed out, bridges gone, day-use areas damaged beyond repair, flooded campgrounds, decimated trail systems, altered river courses and all but four holes of the world renowned Kananaskis Golf Course obliterated when Evan-Thomas Creek escaped its banks. Photos of Highway 940 revealed it had washed out completely for a distance of many kilometres across Wilkinson Summit, where there was damage to Direct Energy's installations by rock slides. And who knew what had happened to the trails in the backcountry. An Alberta Parks official described it as "heartbreaking."

The heavily damaged Powderface Road, which had 21 washouts, 12 mudslides and four damaged or missing bridges, became a temporary lifeline into the Elbow. Shell had an urgent need to access their wells and facilities in the Moose Mountain area, so they signed a road use agreement, installed bridges rented from Alberta Transportation and made temporary fixes until Alberta Transportation could get the Bailey bridge in place on Highway 66. A little later, Alberta Transportation contacted Spray Lakes Sawmills to see if they needed to get at their operations in the Jumpingpound. Unable to access the Lost Creek area in the Highwood, SLS decided to move forward with their plans off Powderface Road that included logging, reclamation and tree planting. This road-use exclusivity proved a sore point for the recreating public who were salivating to get onto their favourite trails like Jumpingpound Ridge. They would wait another three years for the road to be permanently fixed and opened.

The next priority for Alberta Transportation and Volker Stevin after dealing with the Trans-Canada Highway and Highway 1A was to tackle Highway 40. To keep the traffic flowing, three Bailey bridges went in over Evan-Thomas Creek, Lineham Creek, and Livingstone Creek on Highway 940. Like Powderface Road, Highway 532 was low down on the totem pole. Very gradually, sections of Kananaskis Country were reopened to the public on a very limited basis. Of course, the recreationists had an insatiable curiosity to see what had happened to their playground and were soon venturing onto trails that were accessible and making temporary reroutes.

The public's response to the Canmore Nordic Centre's problems was typical. The CNC, while relatively unaf-

fected, suffered some minor damage with culvert wash-outs on a few trails. An urgent call for help was put out through The Friends of Kananaskis to help with restoration. A major mountain biking event was scheduled for June 29/30, and while the Trans-Canada Highway was still closed, there was faith that the road would reopen in time and that the event would go on as planned. So on June 25th the Friends put out a call to the local Canmore membership for 20 volunteers. They stopped taking names after 30 people put their hands up. But then the story hit the local radio station, and on the 26th almost 60 people showed up. But with not enough tools and supervisors to go around, many had to be turned away.

This was only the start. Alberta Parks fielded hundreds of inquiries from people wanting to know how they could help. By early July, meetings were being held with key stakeholder groups regarding what could be fixed, when, how and for how much. Parks trails and infrastructure staff triaged the damage, looking for low-hanging fruit projects that would open up key areas.

In the initial assessment of official trails, it was reckoned that 250 km had suffered major damage (the number was amended to 160 km in a later funding announcement), 275 km had minor damage and almost 300 km were simply deemed "status unknown" as access was impossible. To that, add 65 backcountry bridges that had been damaged or washed away. Instantly, future trail plans for 2013 were thrown out the window. For instance,

Alberta Parks had been considering an upgrade to the Memorial Lakes trail. Now you couldn't even get to it. The entire stretch of Ribbon Creek trail that accessed it had been obliterated, churned into an impassable mess of tangled trees and rocks. When two members of the Alberta Parks trail crew tried to walk up the creek to assess the damage, one suffered a concussion after being hit by a falling tree and the second injured his shoulder.

It soon became clear that Alberta Parks had neither the budget nor the manpower to fix all that was necessary. But help was at hand. In October the Government of Alberta announced they would put aside $60-million towards damage repair in Kananaskis Country, most of the monies going to roads and infrastructure. In July of 2014 they announced a further $18-million to restore the Kananaskis Golf Course, a "vital part of tourism." That same year, $10-million over three years became available to the ESRD (Environment and Sustainable Resources, later to be amalgamated with Alberta Parks as AEP) to cover recreational trails on public land, including ATV and snowmobile trails up and down the eastern slopes from Nordegg to the Crowsnest Pass and Castle areas. With help from Friends, ATV and snowmobile clubs, the Ghost Watershed Alliance, Shell and Exxon, the ESRD was back in the trail building business.

Kananaskis Country would be reborn, though not quite in the same way.

Rebuilding

Two years after the flood, Alberta Transportation and Volker Stevin were still fixing up the roads. The work was not always straightforward. For instance, Storm Creek south of Highwood Pass had crossed Highway 40 and was running along the wrong side of the road and had to be persuaded back to its original channel before repairs could be made. And decisions had to be made on whether to replace bridges over culverts with span bridges. In 2015, spanking new span bridges went in over Lineham Creek and Livingstone Creek. The railway culverts in Canmore were also replaced by a bridge the same year.

It is little known that Alberta Transportation is also responsible for some bridges in the backcountry. The window of opportunity to replace the blue bridge on Little Elbow trail came and went in 2015 and is now scheduled for 2016. The bridge on Sheep trail west of Highway 546 was rebuilt in the nick of time before the winter road closure in 2015. Perhaps its rebuilding was premature, because, unfortunately for recreationists, P. Burns Resources Ltd. is refusing to let the government fix up the badly damaged trail west of the bridge through the Burns property. Farther down the Sheep River, replacing the bridge over Tiger Jaws Fall is still on the horizon.

Most day-use areas were put back to some semblance of order, though two: Picklejar Creek and Sentinel have been abandoned, with no immediate plans to replace them. Others like the popular Cat Creek and Sandy McNabb day-use areas are still inaccessible for vehicles and are awaiting repairs to their access roads. Porcupine Group Campground was unsalvageable; River Cove group campground will likely open in 2016 after the access road is rebuilt.

Finally able to drive Highway 940 in 2014, Spray Lakes Sawmills was able to inspect the Lost Creek Logging Road, that is also well used by recreationists. All three bridges over Cataract Creek were washed out and the road reduced to bedrock and rubble in many places. They set about restoration a year later, in 2015 building 3.5 km of new road that circumvented the first two crossings. A new 80-ft-long bridge with 8 feet of clearance was installed at the third crossing, where the road heads south into the Lost Creek drainage. The old bridge was left where it fetched up, downstream of the old rustler's cabin. Not so the first two bridges that were removed and in one case reused after SLS agreed to jump through the necessary bureaucratic hoops.

The next major step for Alberta Parks was to sort out how to most effectively tackle the trails. It was obvious that dedicated flood-restoration construction crews would be required, and they would need heavy equipment that Alberta Parks and the ESRD did not have. This would take time to organize, and some projects could not wait. There was a real urgency to fix up in some fashion the immensely popular Peter Lougheed ski trails for the winter of 2013/14. Rolly Road, Whiskey Jack, Fox Creek and Elk Pass trails all had bridges out and washouts and were either covered in silt and stones or deeply eroded by water into gullies. Boulton Creek trail alongside Boulton Creek and the easy section of Pocaterra in the lowlands of Pocaterra Creek were writeoffs. A new intermediate Pocaterra was hastily rebuilt on the ridge to the west, to be finished off later. A reroute for Boulton Creek trail had to wait until 2015.

During that winter, the future AEP put tenders out for bid. Each of the four primary districts of Kananaskis Country — the Bow Valley, Peter Lougheed, Elbow-Sheep and the public lands under the newly developed Backcountry Trails Flood Rehabilitation program (BTFR) — would get a new, 5–8 person temporary seasonal crew committed to repairing flood damage. They would work with the regular district trail crews who were still responsible for yearly maintenance work.

In May 2014 the crews were in place and a major training workshop was held at Sibbald Flats, which was a microcosm of all the different types of trail and facility damage they would experience. Crews were certified in chainsaw work, safety protocols, volunteer management, heavy-equipment operation, trail route planning, and other skills necessary to execute the job.

A planner was brought in to deal with approvals and ensure the new work tied in with overall management plans. Temporary staff were added to Ecology and Heritage Resources, because all trail reroutes and facility rebuilds and relocates had to be reviewed for wildlife and archeological impacts. And because of the outpouring from the public who wanted to help, Parks brought on board a full-time volunteer coordinator.

There were many debates about best practices, one good example being that of backcountry bridges. Most of the 65 missing or damaged spans were sturdy wooden structures made of downed logs taken from the area near the bridge — an inexpensive solution in the backcountry. But many of these bridges had broken free to become the core of logjams which had made the damage that much worse. This was especially true of bridges close to roads, where the bridges exacerbated culvert clogging, as was the case in the Heart Creek and Trans-Canada culverts. Was the right answer to put back the same type of bridge? Ideas such as sacrificial bridges, lightweight fibreglass bridges made in Pennsylvania and even just simple creek fords were examined. Into favour came fibreglass spans, which could be assembled to whatever length was required and had easily replaceable components.

With so much to prepare for and approvals to obtain, it wasn't until early July of 2014 that flood restoration crews started getting their boots on the ground. Quick-fix trail projects had been identified. At Heart Creek, Parks staff spent two weeks roughing-in a trail with heavy equipment. Six of seven bridges that had been washed away were found and dragged back into place. Then staff and Friends put in five straight days of volunteer work using 20–30 volunteers a day to turn the roughed-in trail into an actual one. Finally, 50 Air Cadets spent two days brushing out the trail. All that work just to reopen one 3.5-km interpretive trail!

Ribbon Creek was a much more complex project. The section west of Link trail was the first to be rebuilt in 2014, the trail rerouted out of harm's way along a bench high on the north bank. Over the course of 10 work days, 58 Friends volunteers put in over 400 hours. Meanwhile, heavy equipment and crews were airlifted into the Ribbon Falls and Ribbon Lake areas to clean up two backcountry campgrounds. That didn't quite go to plan when a fierce September snowstorm blew in and buried the work under almost a metre of snow that isolated the crews for several days.

In 2015 the decision was made to split the first section of trail from Ribbon Creek parking lot to Link trail junction into two. A new single-track trail suitable for hikers, bikers and snowshoers was made with difficulty along the narrowed valley bottom with the aid of four of the newfangled fibreglass bridges. At the end of the year a 4-m-wide ski trail was pushed in from Hidden trail that avoided all creek crossings.

In many cases, such as with the Jewel Pass trail, the newly aligned trail is better than the old one and less prone to flooding, Down in the Highwood, the Cataract snowmobile trails have likewise been realigned away from marauding creeks like Etherington, with help from the Calgary Snowmobile Club. For a few trails the options are limited. For instance, while Quaite Valley trail has been realigned in its upper part, the lower part through the narrows has been put back in situ and will undoubtably wash out again during the next flood. Others, like Moose Creek interpretive trail, are still awaiting decisions. And what of the hundreds of undesignated trails? They too have their champions in outfitters and hikers who with their bare hands and folding saws are quietly forging new ways that bypass the debris.

While all this was going on, the Conservative and NDP governments were mulling over flood mitigation for Calgary and Bragg Creek. In the end they decided not to build a 50-m-high dam costing in excess of $342-million across the Elbow River at McLean Creek, much to the dismay of some Bragg Creek residents. Instead, they would built dikes around Bragg Creek and Redwood Meadows at a cost of $8.9-million. That cost has recently mushroomed to $33-million with the possibility that up to 20 riverfront properties will have to be expropriated.

In Canmore the thinking went the other way. Rather than remove houses along the east side of Cougar Creek—cited as the most densely developed alluvial fan in Canada—and let the creek have its way, the bed was deepened and lined with articulated concrete mats that look like ice cube trays. A debris net, made up of hundreds of tensile steel rings manufactured by a Swiss company, was installed at the narrows upstream as a temporary measure until a $40-million, 30-m-high dry dam is built at the same site many years in the future. Flood mitigation plans are in hand for other "steep creeks" around Canmore such as Three Sisters, Smith and Pigeon creeks.

Powderface Trail, the last road to be repaired, will open to the public in 2016. However, there is still more work to be done in fixing up day-use areas, backcountry campgrounds and damaged trails not yet looked at, and in fine-tuning the reroutes. Because the Tom Snow trail is a section of the Trans Canada Trail that has its 25th anniversary in 2017 to coincide with Canada's 150th birthday, the rerouting of Tom Snow away from flood-damaged Moose Creek is the next big priority, with discussions ongoing between both factions of AEP about where to put it. There is an urgency because government money runs out in March 2017.

It's a given that volunteers from the public will continue to give back to their mountain playground, in so doing reinforcing the connection many people have with Kananaskis Country. As an example, Friends of Kananaskis Country not only provides volunteers but has embarked on a ten-year project in partnership with Alberta Parks to revitalize interpretive trails. New signs at Heart Creek, Ribbon Creek and Elbow Falls will describe how people, wildlife and the landscape were affected by the floods of 2013.

Why is all this expensive work important? Robin Campbell, environment minister with the Conservative government at the time, said: "It is paramount that we repair damage done to the trails so future generations can spend time in their own backyard." He also touched on Alberta's beautiful landscape as a teaching tool and its importance to tourism. But of course it goes much deeper than that. The Friends see Kananaskis Country as a restorative place where city folk can destress from the pressures of everyday living. "In restoring K-Country we restore ourselves" is their catchphrase.

People are once again out there in large numbers, checking out the trails in the backcountry, finding new river crossings and skirting around new scars on the landscape en route to the summits. Catastrophes such as floods are not a disaster for the landscape, which is constantly changing anyway, only for the people who live, work and play there. And while we are busy rebuilding our man-made infrastructure at mind-boggling expense, we are hopefully learning a little from what has happened.

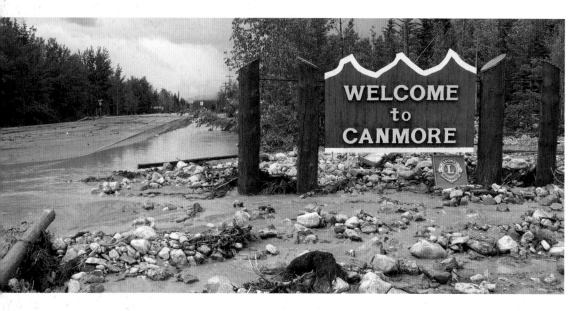

COUGAR CREEK

Opposite: An unbelievable scene showing Cougar Creek on the rampage below Elk Run Boulevard. Though most houses lost their backyards and lawn furniture, in the end only two houses alongside Cougar Creek were demolished. Photo Schovanek Photography

CANMORE

Above: The sign along the Trans-Canada Highway welcomes you to Canmore. However, you're not going to get too far…
Photo Schovanek Photography

Right: Semis on the Trans-Canada Highway lined up behind the breach.
Photo Schovanek Photography

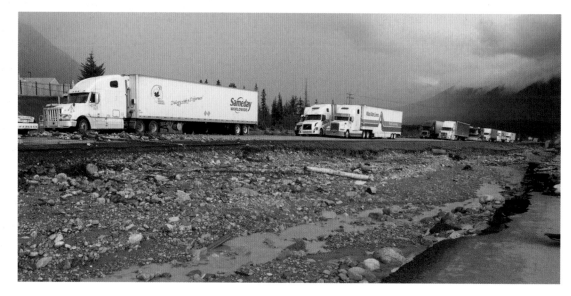

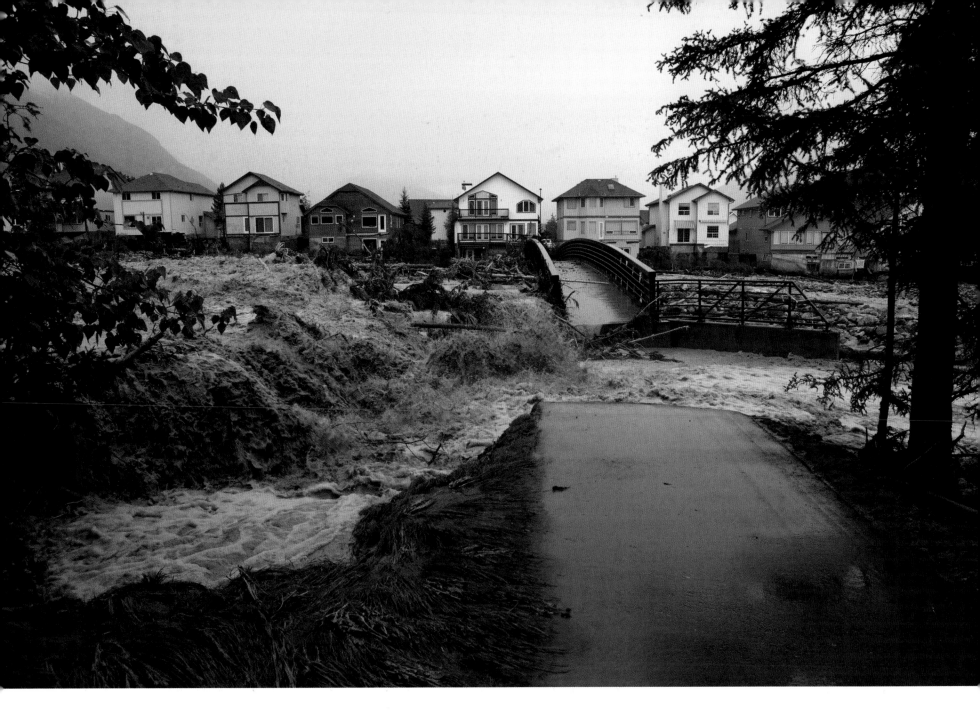

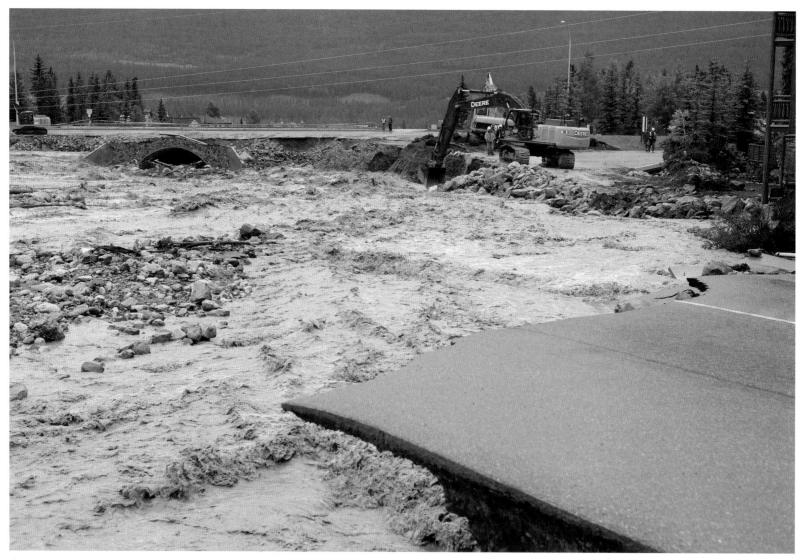

COUGAR CREEK

Upstream of Elk Run Boulevard the creek has taken out not only the popular Cougar Creek parking lot and trailhead but also Eagle Terrace Trail, effectively cutting off Eagle Terrace subdivision from the rest of Canmore. Photo Schovanek Photography

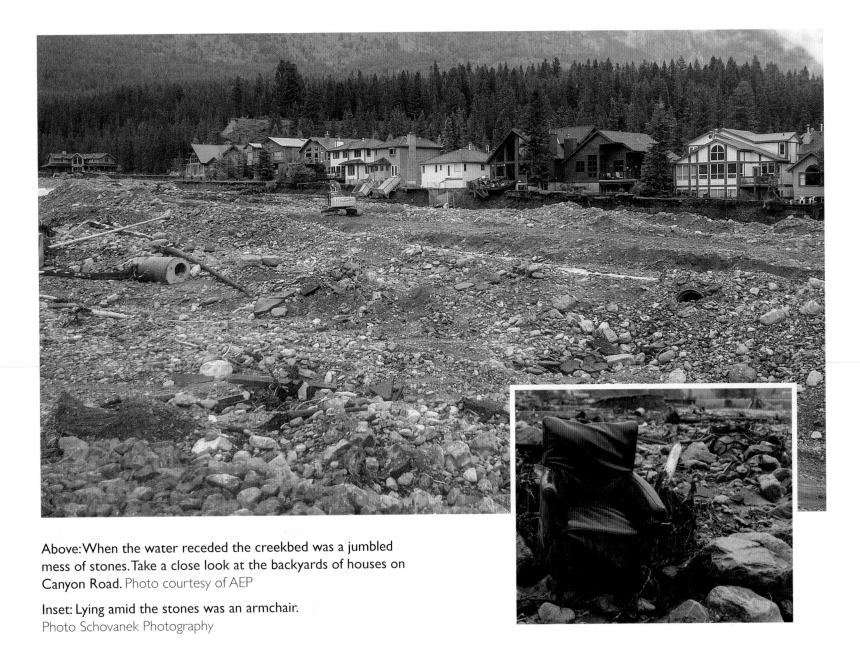

19

Above: When the water receded the creekbed was a jumbled mess of stones. Take a close look at the backyards of houses on Canyon Road. Photo courtesy of AEP

Inset: Lying amid the stones was an armchair.
Photo Schovanek Photography

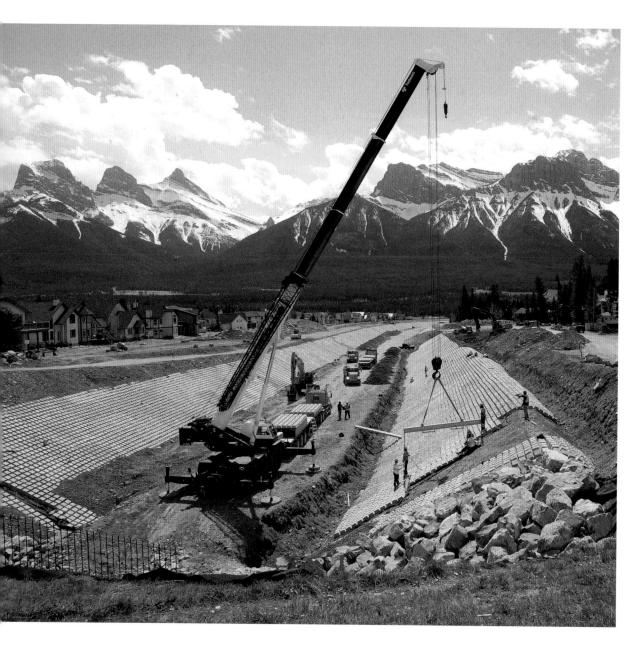

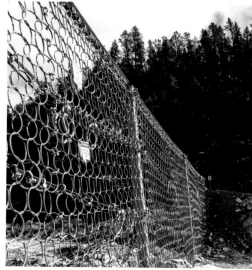

COUGAR CREEK MITIGATION

Left: In 2015 the bed of Cougar Creek was deepened and armoured with articulated concrete mats that cut down the rate of erosion. Photo Craig Douce

Top: Mitigation also includes a 6-m-high debris net at Cougar Creek narrows that will be removed once a 30-m-high dry dam is in place. Behind the dam would be a sediment retention basin that would store water and debris during a flood while still allowing a certain amount of water to flow through it. The dam, however, is several years in the future.
Photo Gillean Daffern

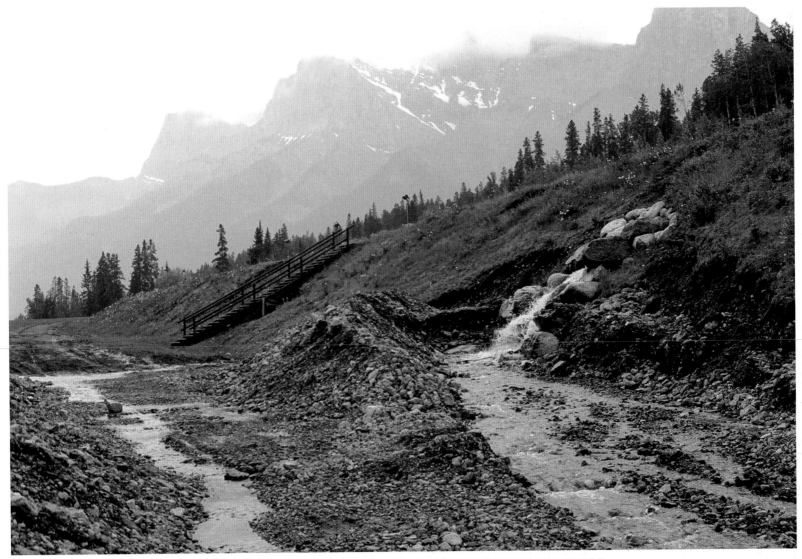

CANMORE NORDIC CENTRE
The stadium at the CNC was not immune to flooding.
Photo courtesy of AEP

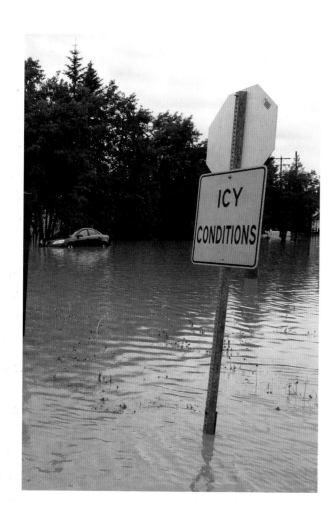

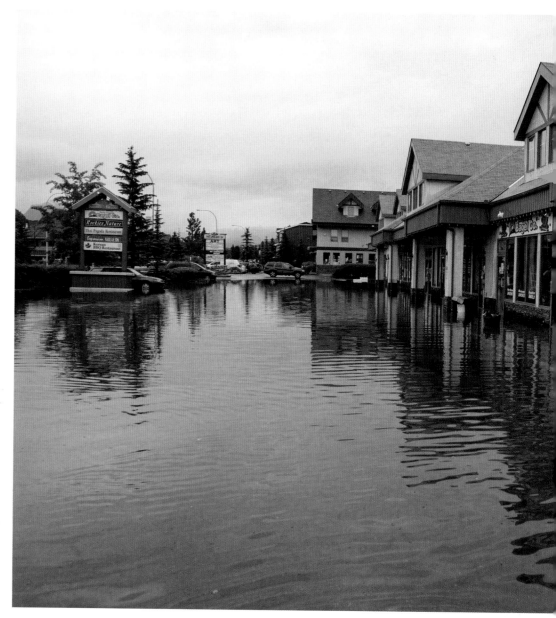

CANMORE
Above and right: Flooding along Highway 1A spread as far as the hospital. This photo is of Summit Place.
Photos Schovanek Photography

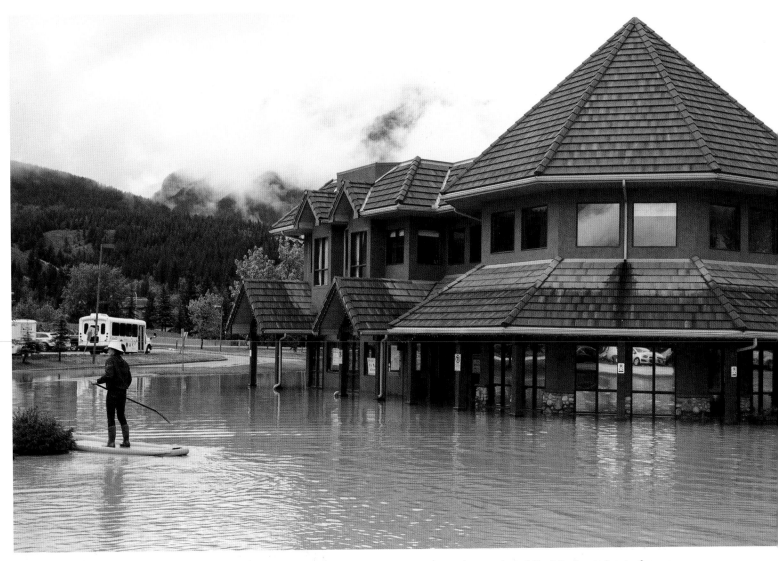

Above: One has to get around somehow! Paddle boarder in front of the Professional Building on Highway 1A.

Photo Schovanek Photography

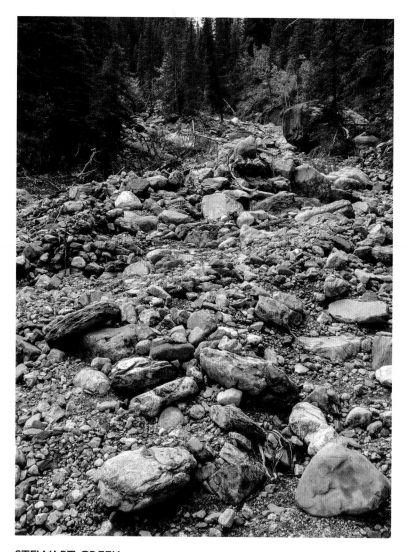

STEWART CREEK
Getting to Middle Sister is going to take a lot longer. The lower valley is a jumble of rocks with no sign of the trail.
Photo Alan Kane

Conversely, Upper Stewart Creek has been scoured down to bedrock. Photo Alan Kane

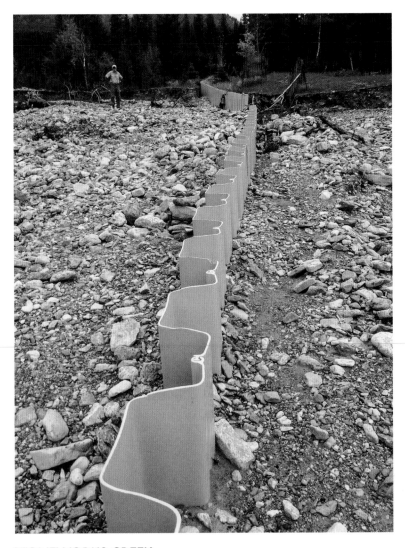

STONEWORKS CREEK
An earlier effort at mitigation didn't work too well during the 2013 flood. Photo Gillean Daffern

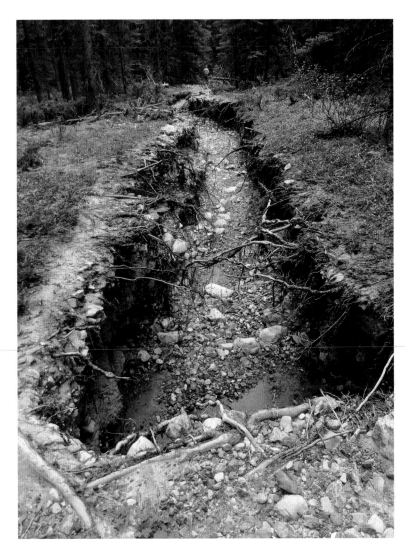

Much of the trail up Stoneworks Creek is a trench. A new trail has since been established along the banktop.
Photo Gillean Daffern

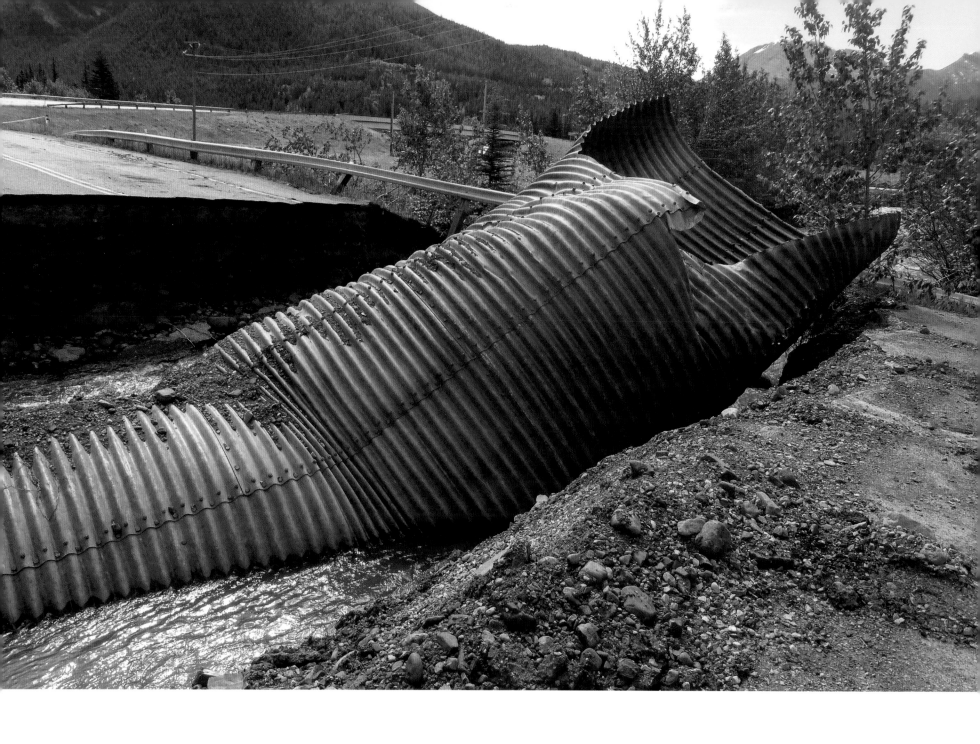

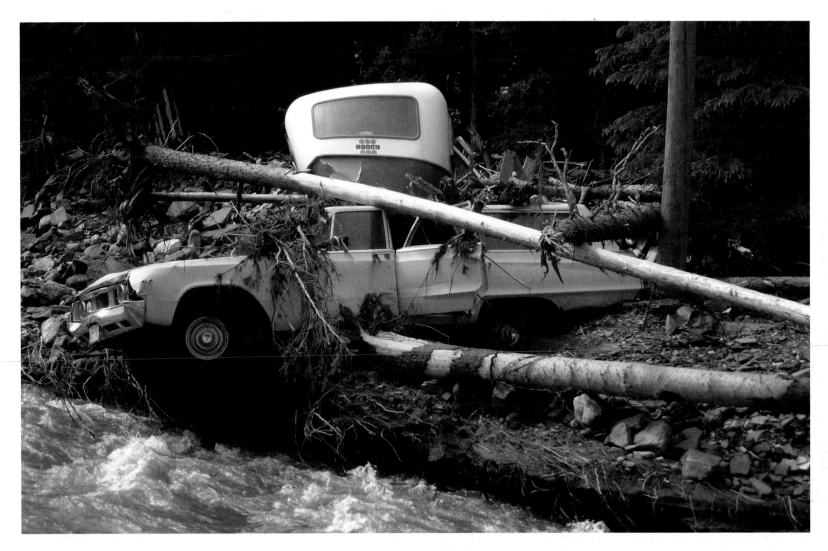

DEAD MAN'S FLATS
Opposite: This road was deliberately cut to allow Pigeon Creek to bypass a bridge and a culvert. Photo Gillean Daffern

Above: Residential trailers and vehicles at Thunderstone Quarry were swept away down Pigeon Creek and buried under debris. Photo Gillean Daffern

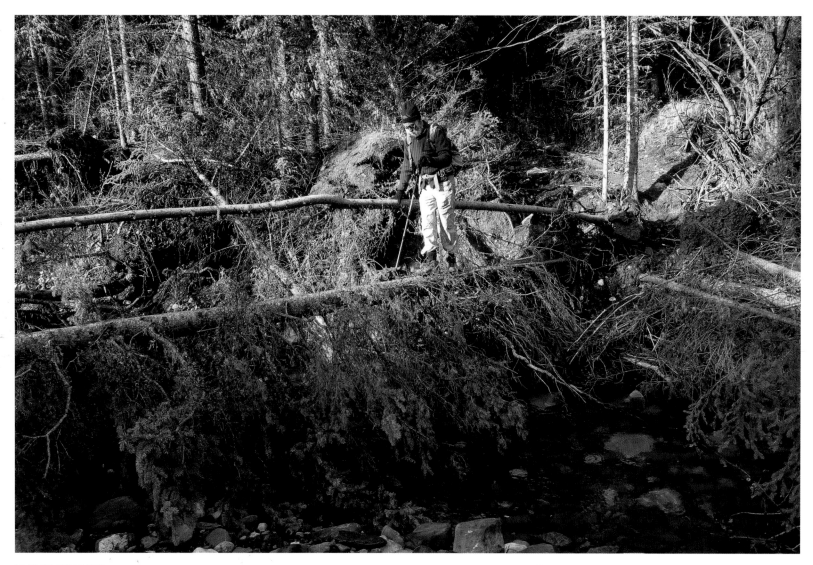

WIND VALLEY
Finding a new way to cross Wind Creek sans bridge. There's even
a hand rail! Photo Gillean Daffern

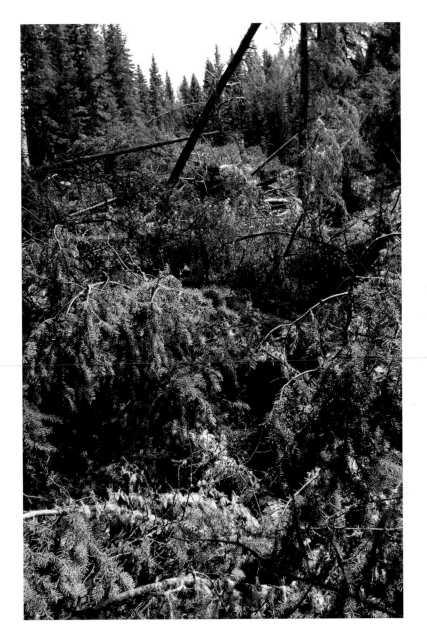

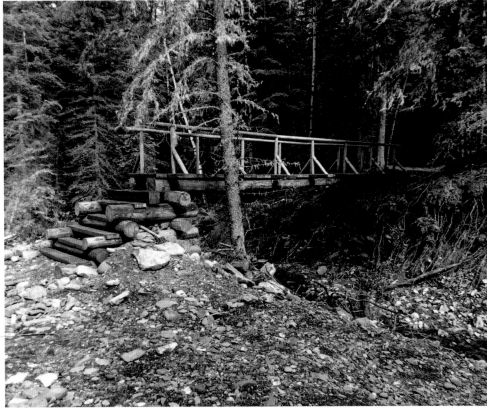

Above: At least there's a new bridge across Pigeon Creek. Built in 2015, it was placed farther upstream and high above the creek. Unfortunately, we may have to wait awhile for a bridge across Wind Creek and the clearing of Wind Ridge trail.
Photo Derek Ryder

Left: Somewhere under these trees is the Mount Allan Centennial Trail. Photo Gillean Daffern

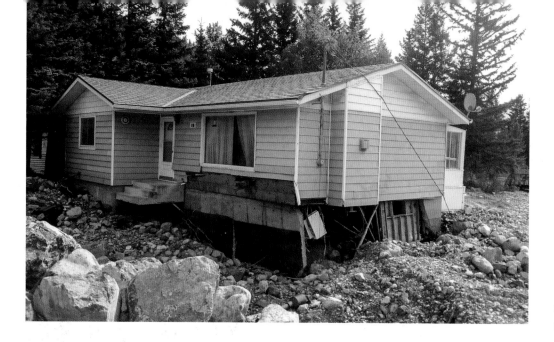

EXSHAW

Opposite: When both Exshaw and Jura creeks broke their banks the water poured into the hamlet and left silt nearly a metre deep. Photo Schovanek Photography

Left top: Around 20 houses suffered significant damage. This home alongside Exshaw Creek was the hardest hit and had to be demolished. For a time, electricity, gas, water and sewage services were cut off and water and portable toilets shipped in.
Photo Gillean Daffern

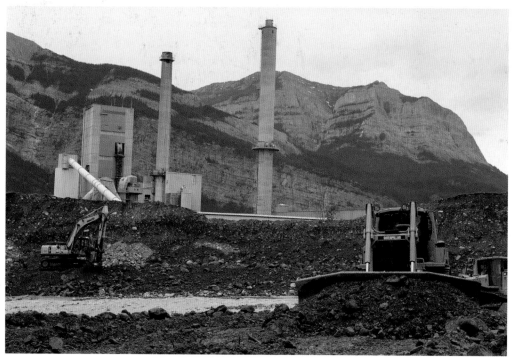

Left bottom: The *Calgary Herald* reported that "as the waters rose, Lafarge hauled in 10,000 tonnes of rock over 24 hours to build up the banks of Exshaw Creek," so saving the fire hall and Heart Mountain store and cafe.
Photo Schovanek Photography

Various mitigation plans were announced two weeks before 2016. At a cost of around $18-million, they include an 8-m-high dam on Exshaw Creek upstream of the hamlet, upgrades to the Highway 1A bridge and a widening of the creekbed coupled with a small berm along the east bank. Then, starting in spring 2016, the bed of Jura Creek will be realigned to ensure the water runs in a direct line down to the highway bridge.

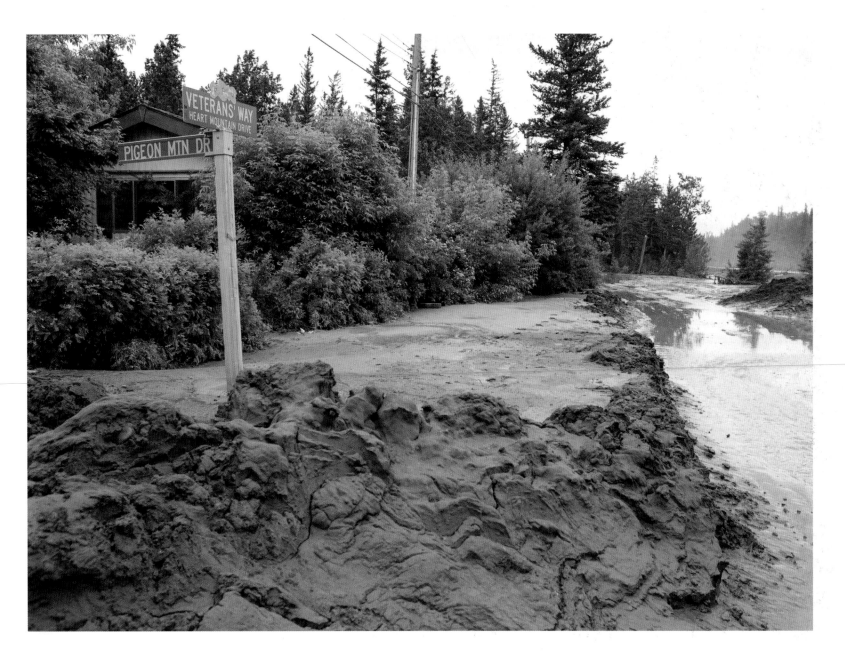

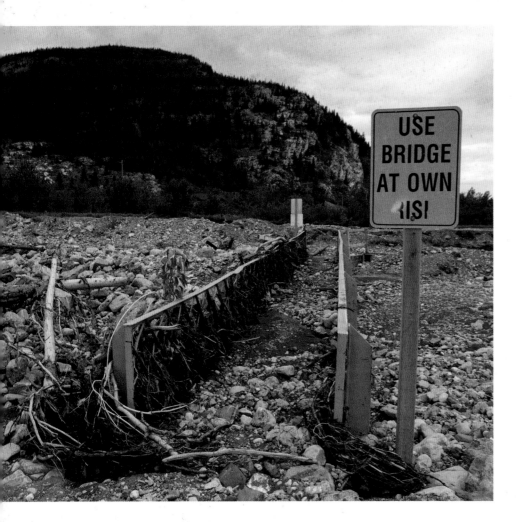

Below: Higher up the creek, conditions aren't much better either.
Photo Alan Kane

EXSHAW CREEK
Top left: The one footbridge across Exshaw Creek left standing is weighed down with stones. Photo Schovanek Photography

THREE SISTERS CAMPGROUND
Opposite: Mud and water.
Photo courtesy of AEP

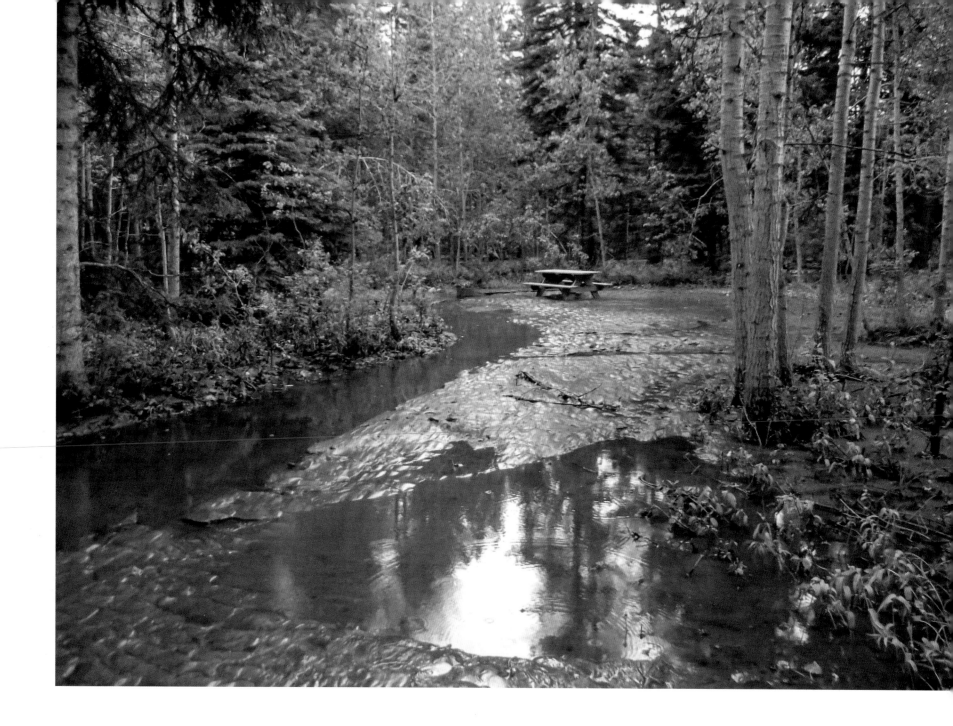

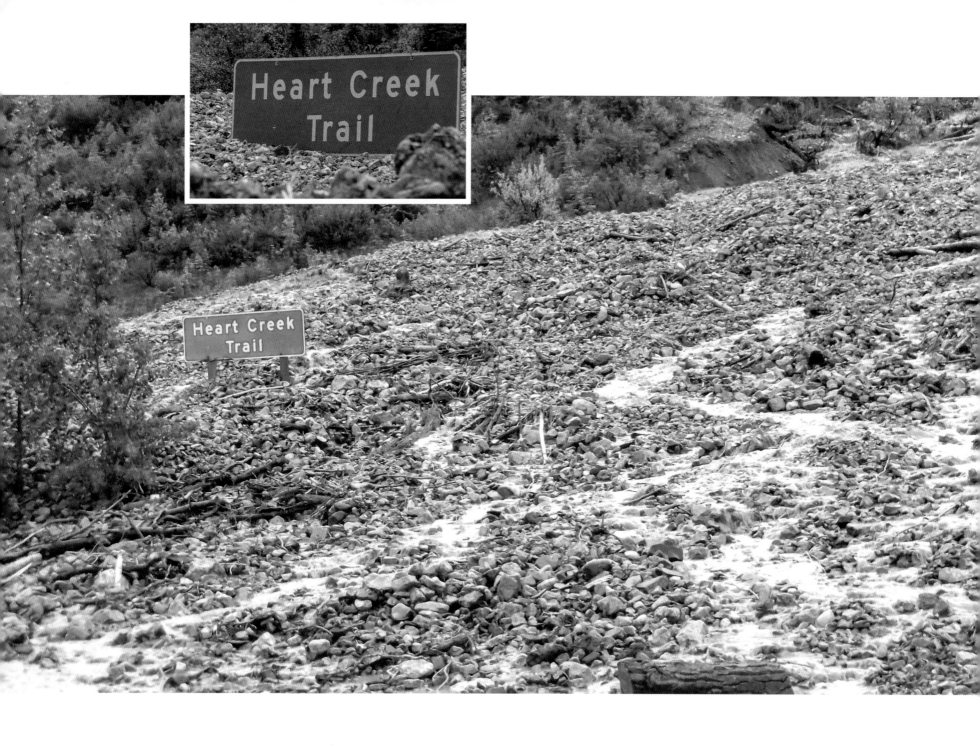

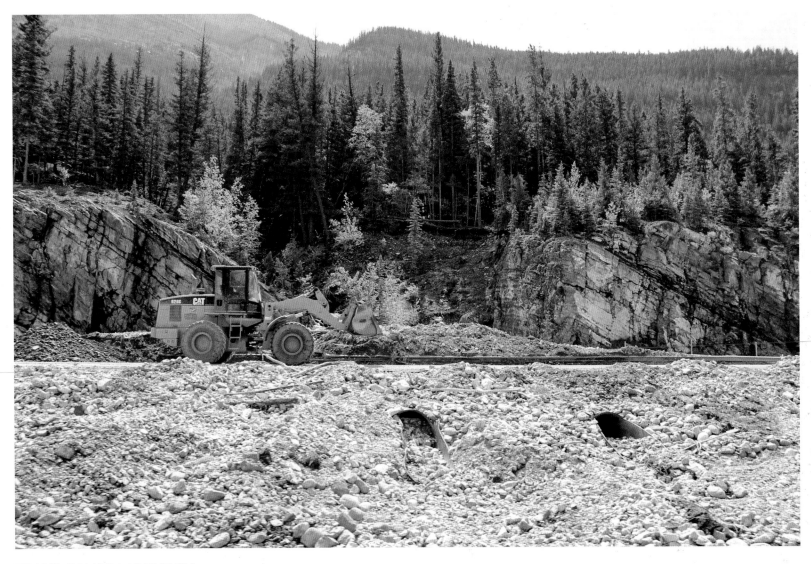

TRANS-CANADA HIGHWAY

Opposite: Heart Creek parking lot access road (and nearly the road sign) is buried under a rock slide. Photos courtesy of AEP

Above: Stones and more stones. Front-end loader clearing a rock flow off the Trans-Canada Highway. Photo courtesy of AEP

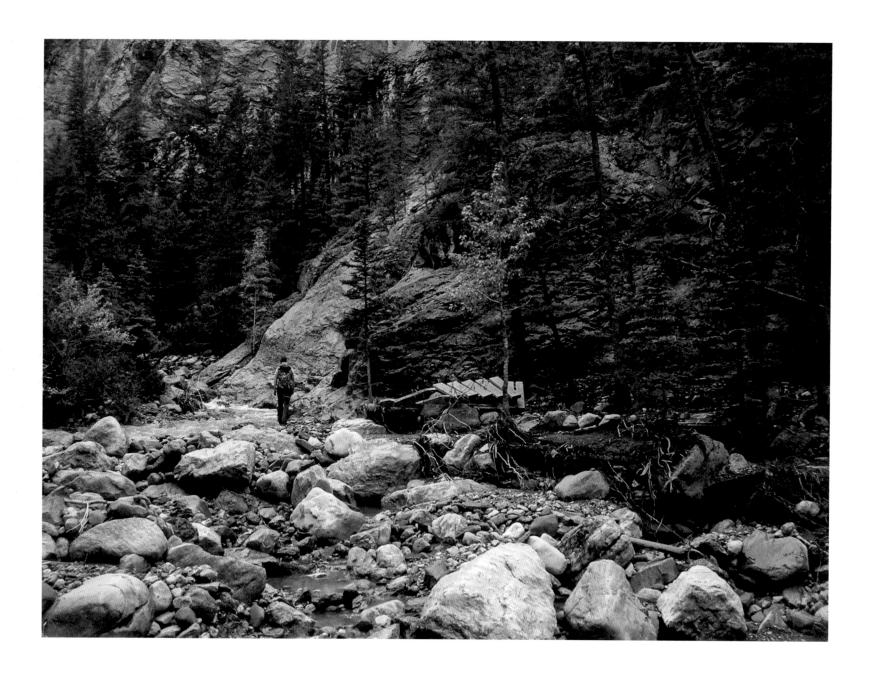

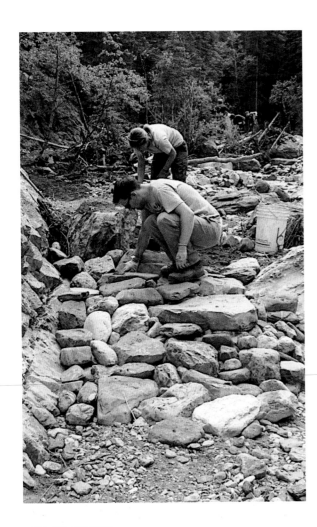

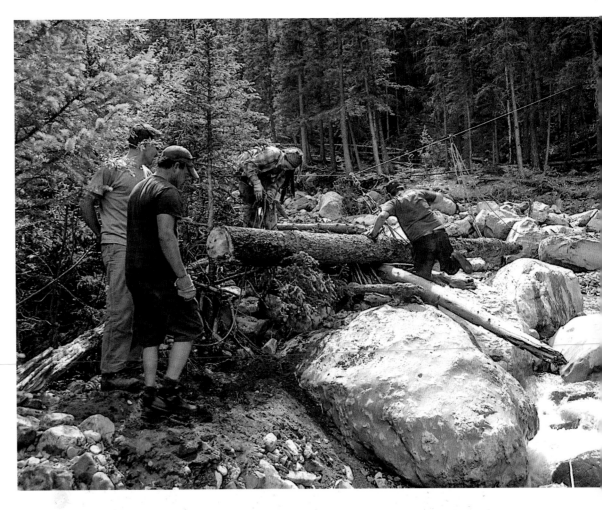

HEART CREEK

Opposite: A first foray up the creek five days later. So that's where the bridge went to! No sign of a trail, though.
Photo courtesy of AEP

Above left: Laying down the new trail rock by rock, Grassi style.
Photo Alf Skrastins

Above right: Having slung down a log, trail crew are preparing it as a stringer for a new bridge. Photo Alf Skrastins

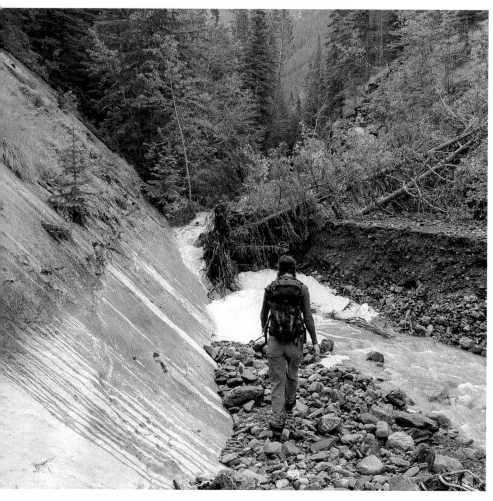

QUAITE VALLEY TRAIL

Walking up the narrows after the flood was tiring and time-consuming, especially in places where the road had completely disappeared. Photos above left and opposite courtesy of AEP. Photo above right Tony Daffern

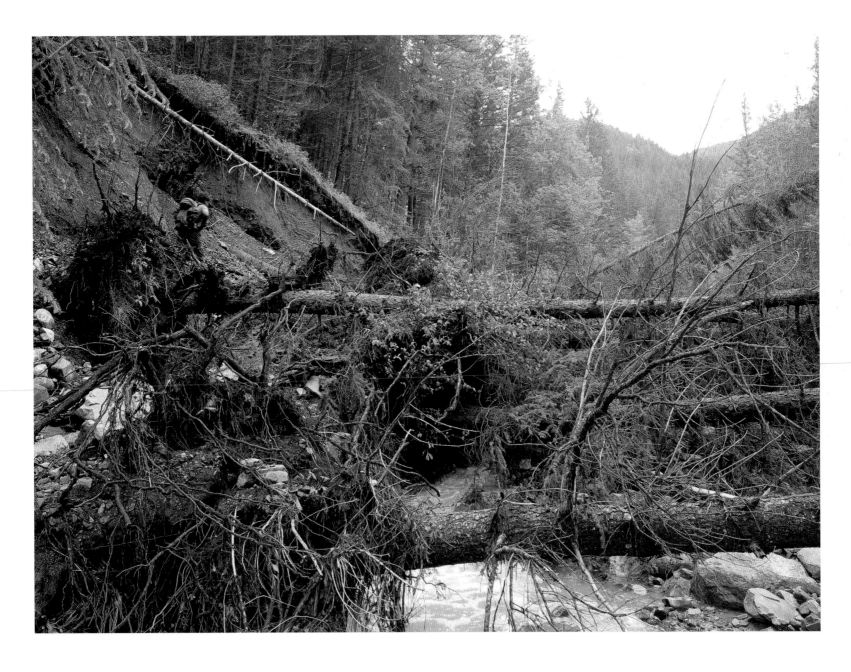

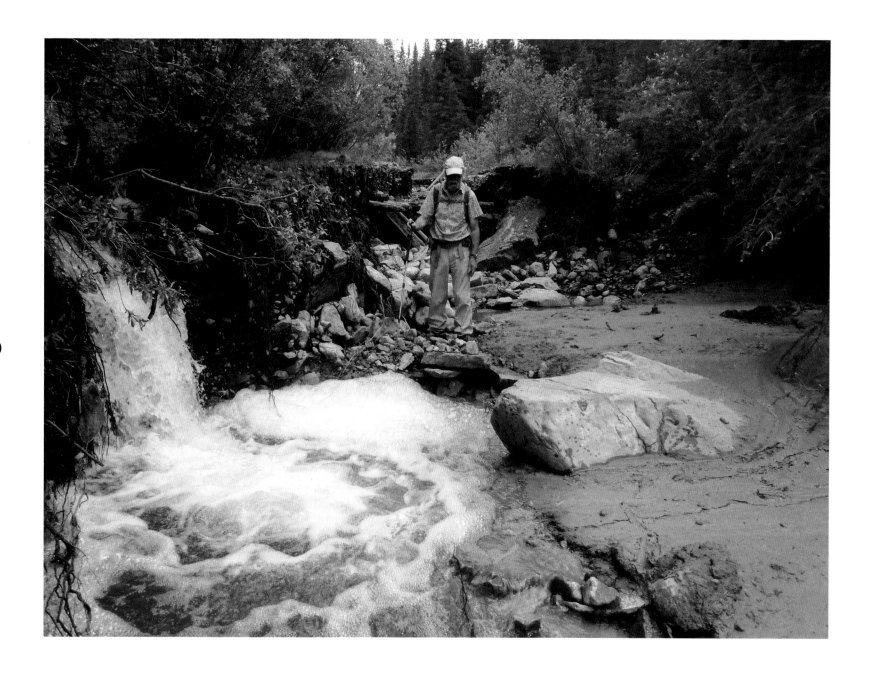

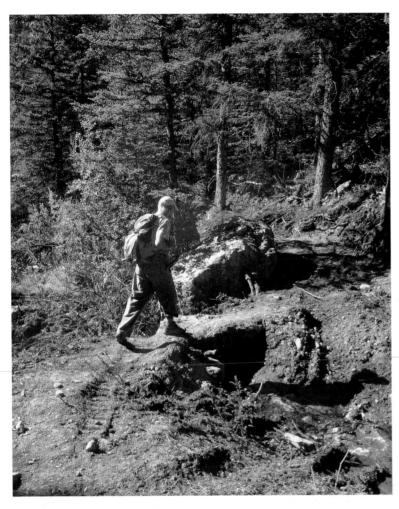

41

QUAITE VALLEY TRAIL
Opposite: You might think the road would improve higher up out of the narrows? Not really. Here it has sunk into quicksand.
Photo Gillean Daffern

Top left: An initial reroute has been sketched out.
Photo Gillean Daffern

Top right: The road a year later, put back in situ in the lower narrows. How long it will stay that way is anybody's guess.
Photo courtesy of AEP

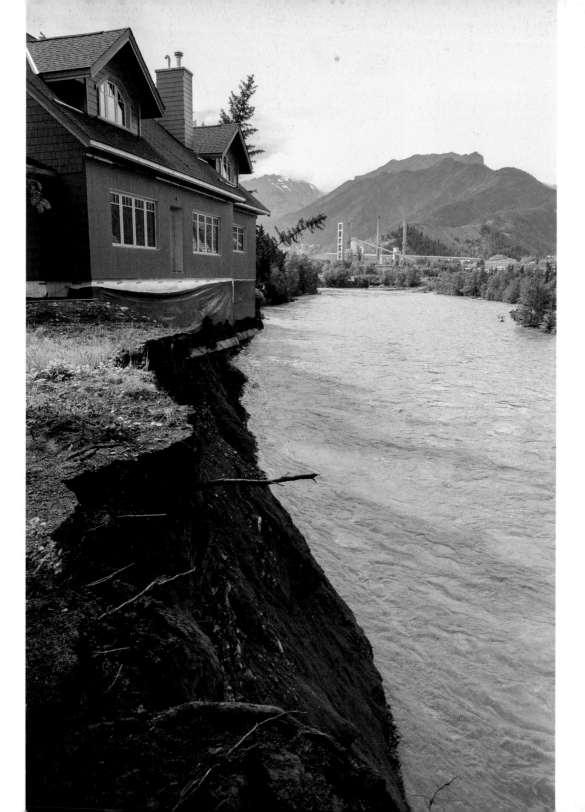

42

LAC DES ARCS
Left: One of six homes damaged by floods. The community was hit a double whammy by overflowing Heart Creek and the Bow River eroding its banks. Everyone was evacuated to Cochrane just before a highway bridge failed over Heart Creek. A diversion berm and channel are planned for Heart Creek below the highway.
Photo Schlovanek Photography

TRANS-CANADA HIGHWAY
Opposite top: Aerial photo of the Trans-Canada Highway under water from Lac des Arcs.
Photo courtesy of AEP

HIGHWAY 1A
Opposite bottom: Aerial view of the flood adjacent to the top photo, showing Lac des Arcs and Highway 1A between Grotto Creek and Gap Lake. Note the submerged CPR line.
Photo courtesy of AEP

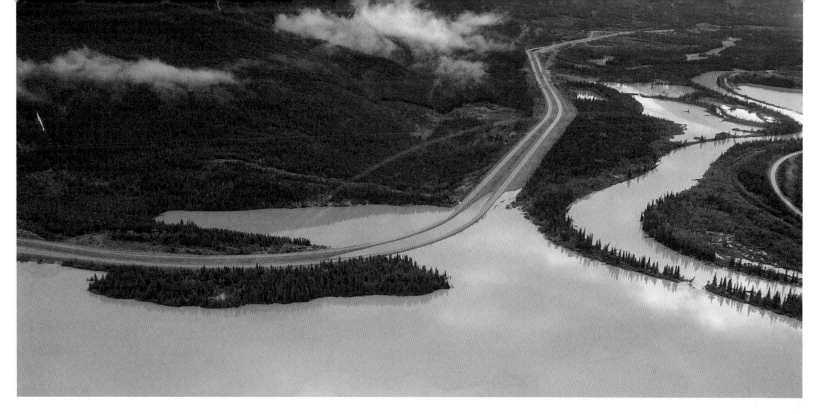

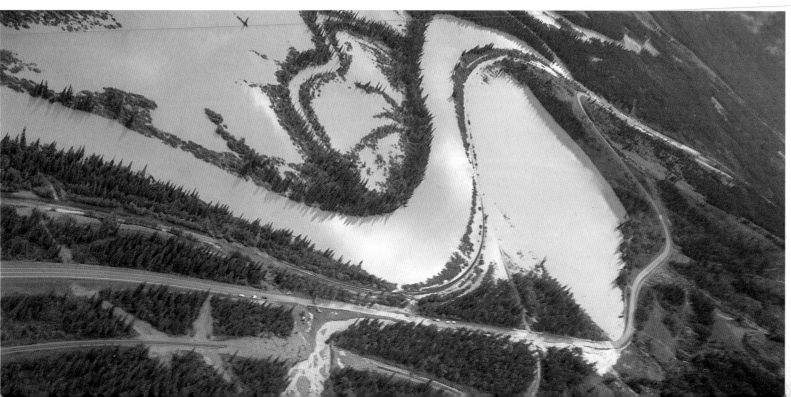

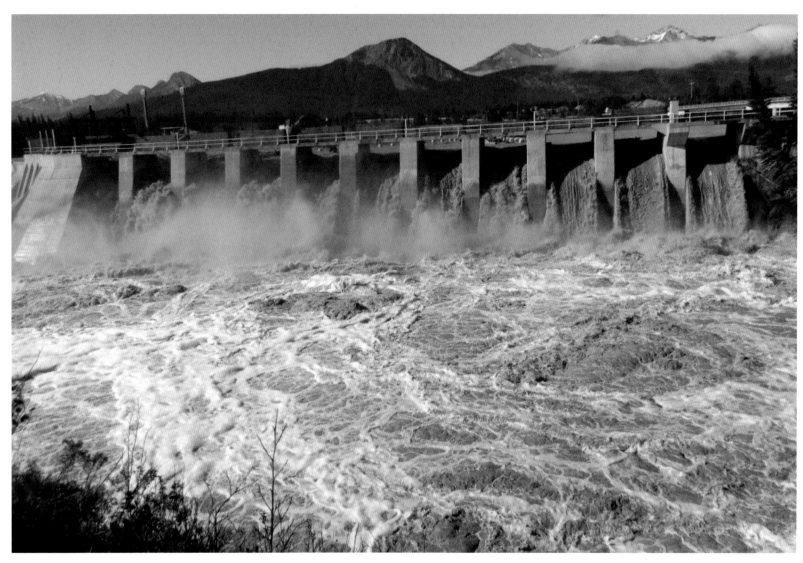

44

BOW RIVER
A few days after the flood, TransAlta's Kananaskis plant at the confluence of the Bow and Kananaskis rivers was still discharging an enormous amount of water. That same year, the dam was inducted into *Hydro Review*'s Hall of Fame after 100 years of continuous operation. Photo courtesy of AEP

THE GHOST

Below: The Ghost River as you've never seen it before at Richards Road bridge—or what's left of it. Photo courtesy of AEP

Inset: Direct Energy's bridge over the Waiparous is a goner. Photo Dan LaFleur

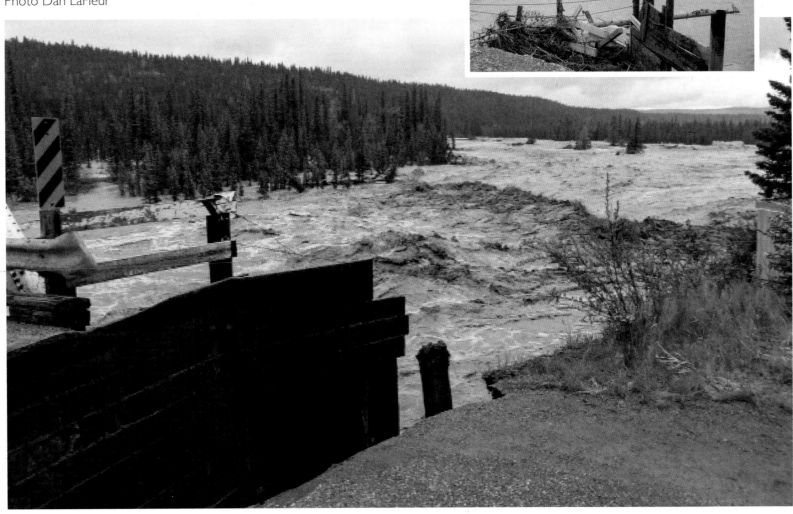

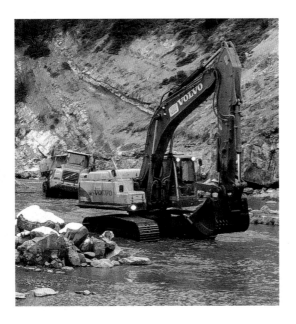

Opposite top: Nearly a week later and the river is still raging downstream at the Miami Beach section of the slalom course. The grey slider bar is hanging from a damaged wire.
Photo Chuck Lee

Opposite bottom and below: The same view when the water is turned off, allowing repairs to be made to the creekbed and gates.
Photos Chuck Lee

KANANASKIS RIVER
On the Thursday morning, flood waters were pouring over rocks on either side of The Widowmaker rapid. Many man-made rapids downstream disappeared when carefully placed piles of boulders were flattened. Photo courtesy of AEP

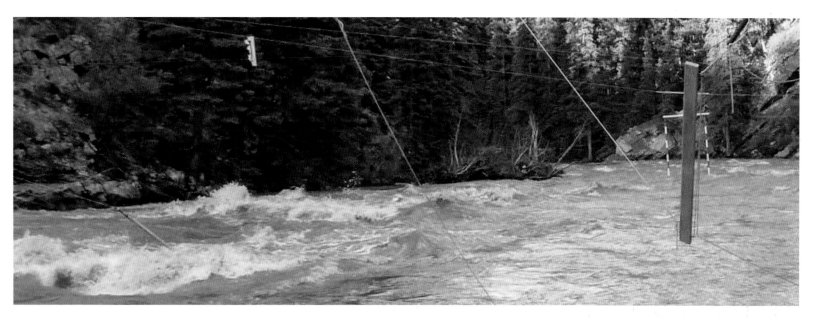

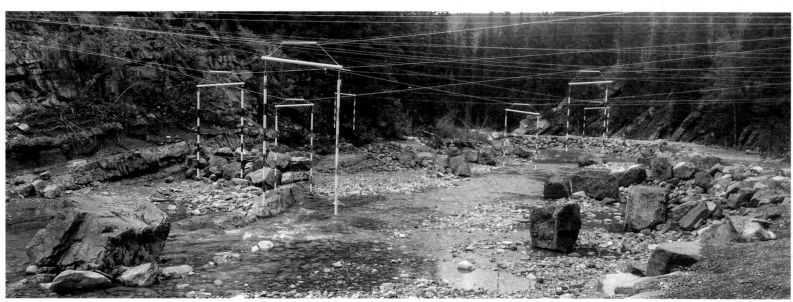

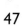

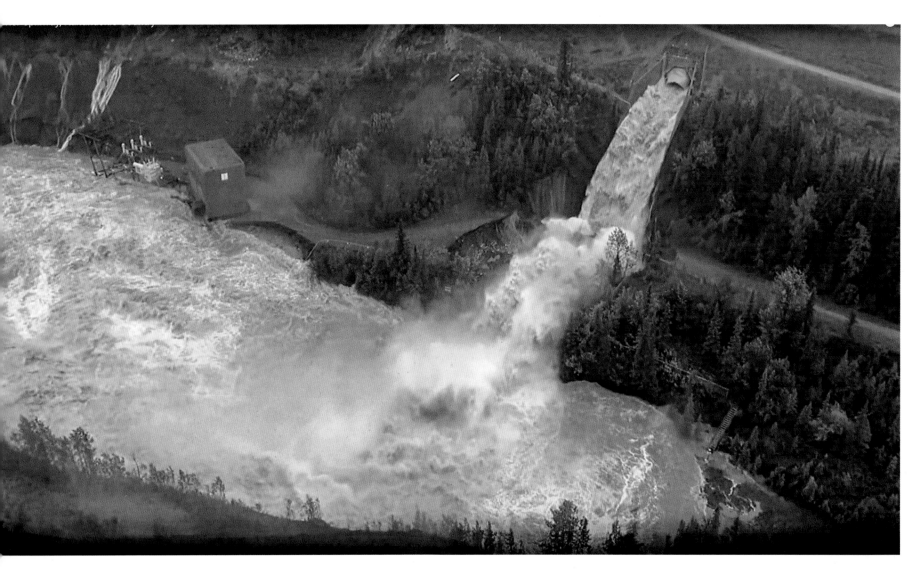

BARRIER DAM
A sight you don't see too often: A controlled release of the
spillway. Aerial screen shot courtesy of AEP

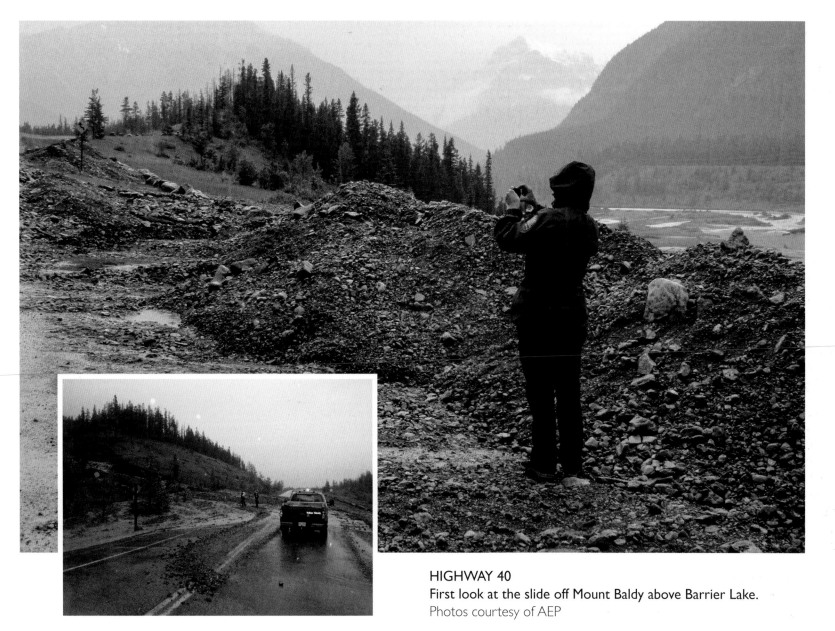

HIGHWAY 40
First look at the slide off Mount Baldy above Barrier Lake.
Photos courtesy of AEP

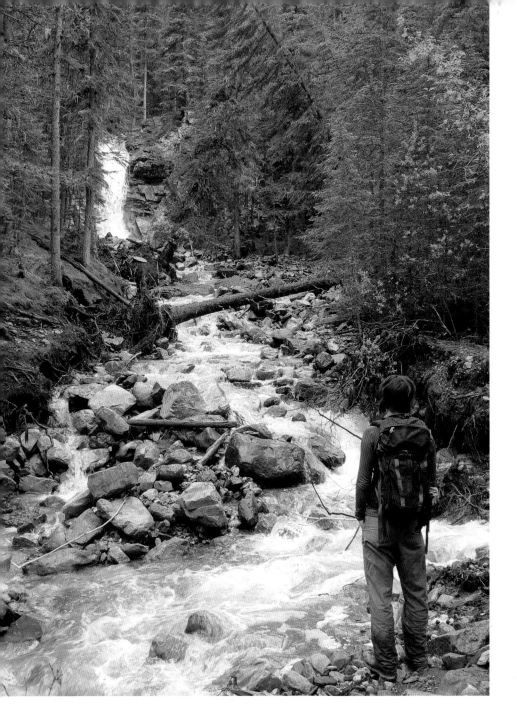

JEWELL PASS TRAIL

Left: The trail is a complete washout in Jewell Creek, but the falls look good. Photo courtesy of AEP

Opposite: Rerouting Jewell Pass trail to the top of the falls. Photo Alf Skrastins

Above: Trying out the reroute. Photo Alf Skrastins

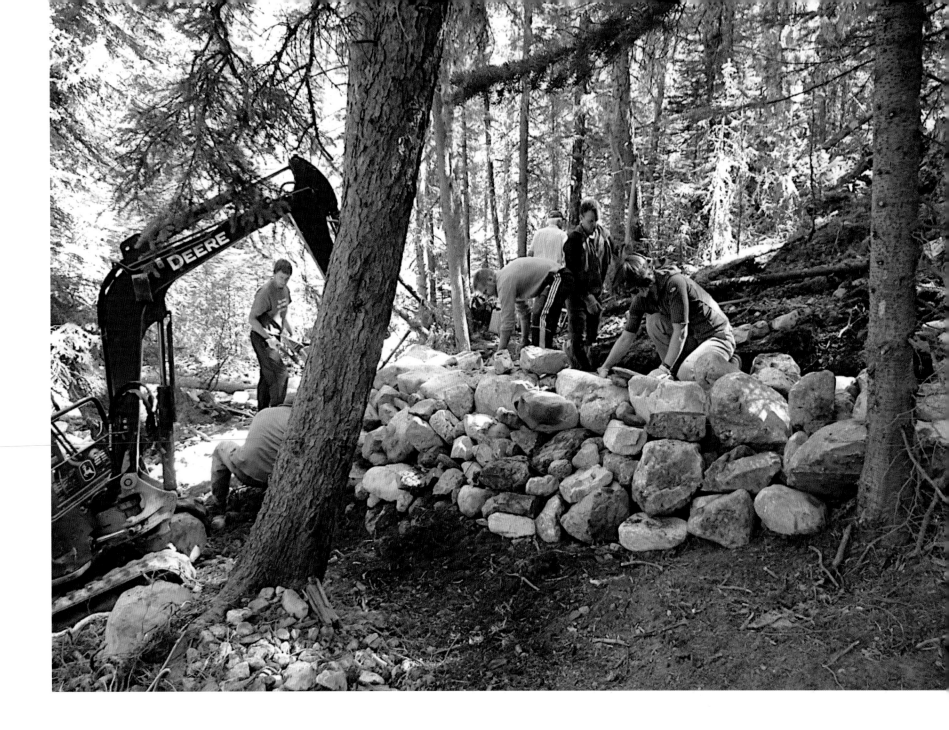

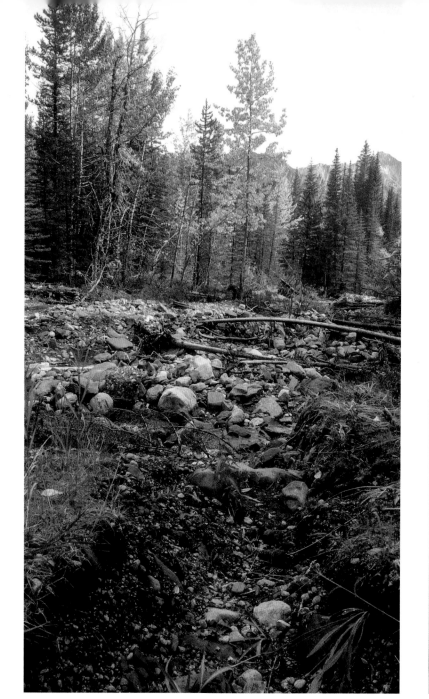

MARMOT BASIN TRAIL

Left: Marmot Creek did a thorough wrecking job on the ski trail, either washing it away completely or burying it under boulders. The entire valley floor was affected by flood waters, and because of cliffs lining the northeast bank, the trail cannot be put back into its old location. Rerouting it to the southwest is a long shot, says the trails technologist. Photo courtesy of AEP

SKOGAN PASS TRAIL

Below: A washout at Marmot Creek crossing discloses culverts. Photo courtesy of AEP

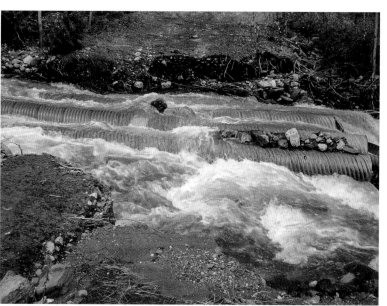

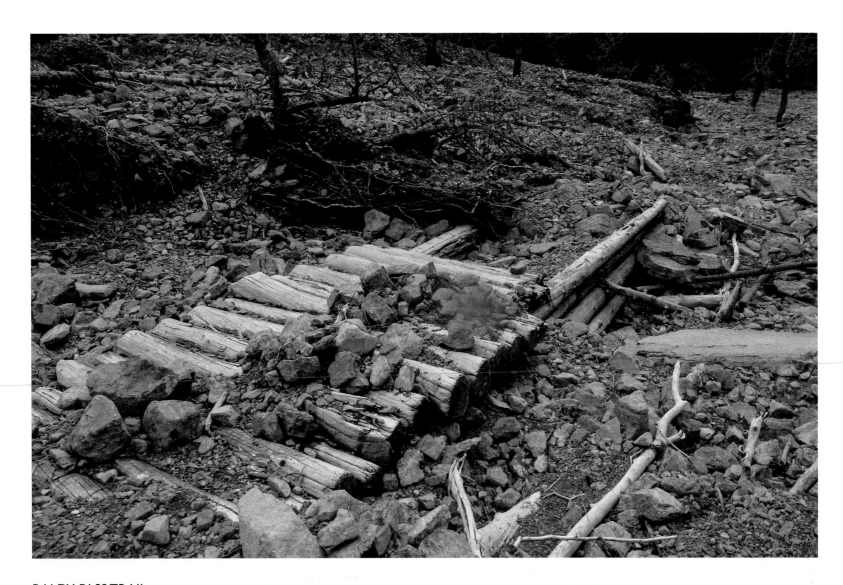

BALDY PASS TRAIL

Flood water down the main valley and a rock slide off Midnight Peak joined forces at this point and made a mess of the trail all the way down into the forest. The trail has once again been re-routed and waymarked by cairns. Photo Gillean Daffern

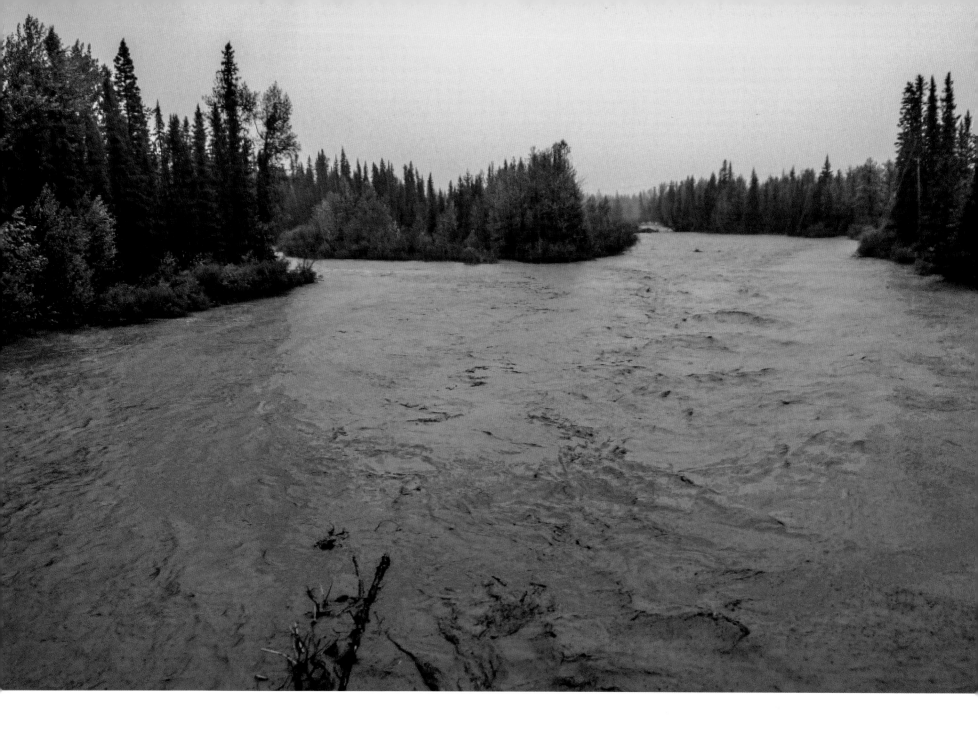

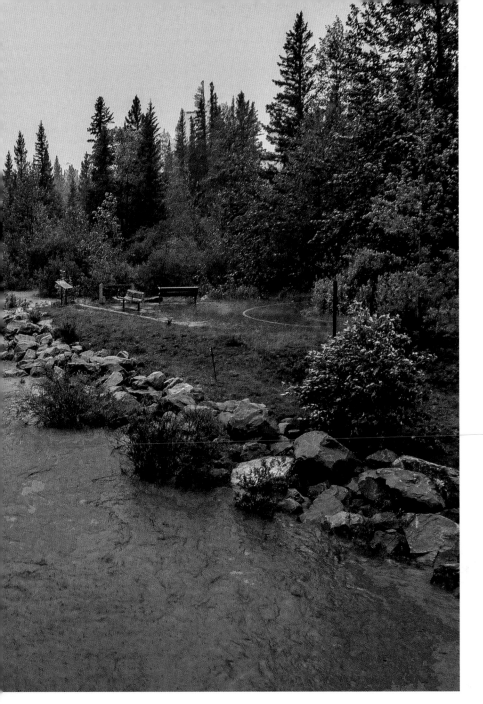

KANANASKIS RIVER

It's the morning of June 20 and the river is in full flood in this downstream view from the bridge leading to Kananaskis Village. This span survived, but the one across Ribbon Creek was not so lucky. Photos courtesy of AEP

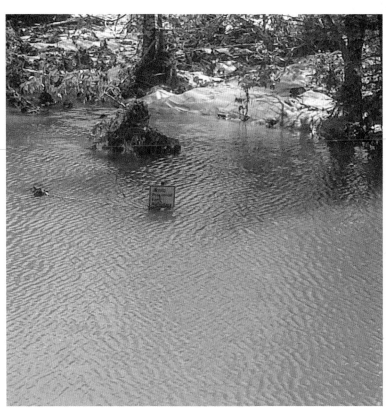

55

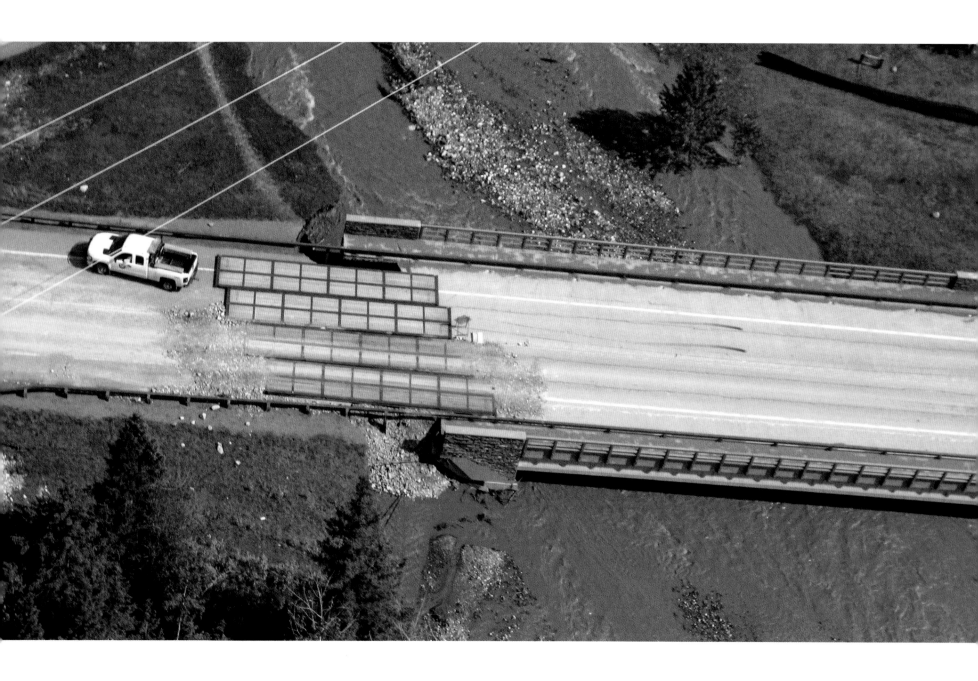

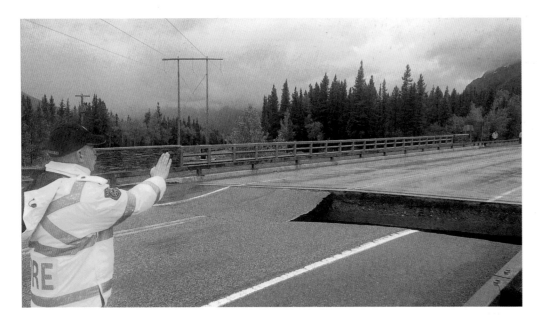

RIBBON CREEK BRIDGE

Left and below: "Stay back! Stay back!" The asphalt is bending and sure enough the last piece of Ribbon Creek bridge fell a few seconds later. This left hotel guests, staff and evacuees, ironically seeking safety from Sundance Lodges and the Kanananskis Country Golf Course, stranded at Kananaskis Village for three days. Screen shots by Gareth Short

Opposite: A drilling company doing a leadership session at Delta Lodge arranged to have the gap bridged with heavy-duty rig matting. This was on day 4, after the slide across Highway 40 above Barrier Lake had been cleared and people could drive out to the Trans-Canada Highway and Calgary. Photo courtesy of AEP

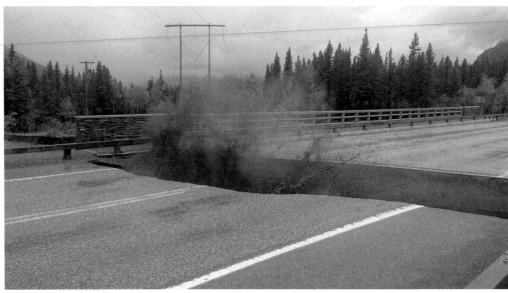

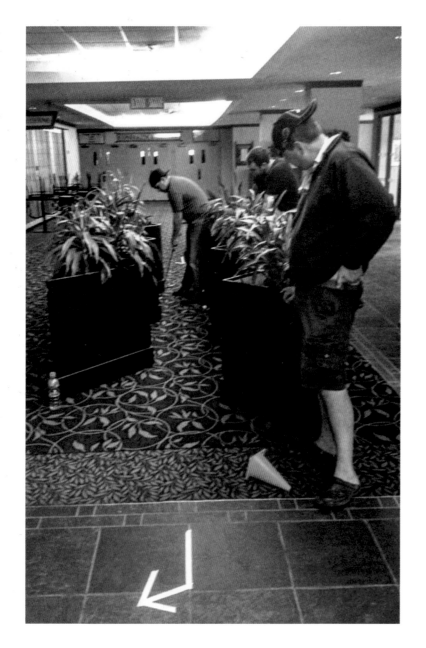

58

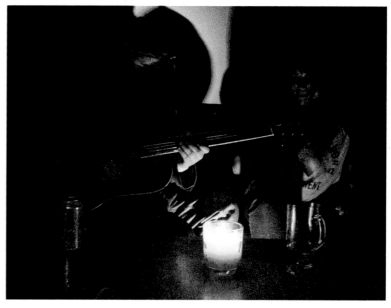

KANANASKIS VILLAGE

Left: Stranded staff, guests and evacuees passed the time in a variety of ways. Especially popular was putting golf balls down the stairs and through the lobby and hallways of the Delta Lodge. After the rain stopped, the game moved outside to a new starting point at the top of the artificial waterfall. Photo Patrice Cloutier

Above: When darkness fell, out came the candles and flashlights. What could be more romantic than a musical evening by candle-light? Photo Patrice Cloutier

Opposite: Ribbon Creek has taken another chunk out of the trails at nearby Kovach day-use area. Photo courtesy of AEP

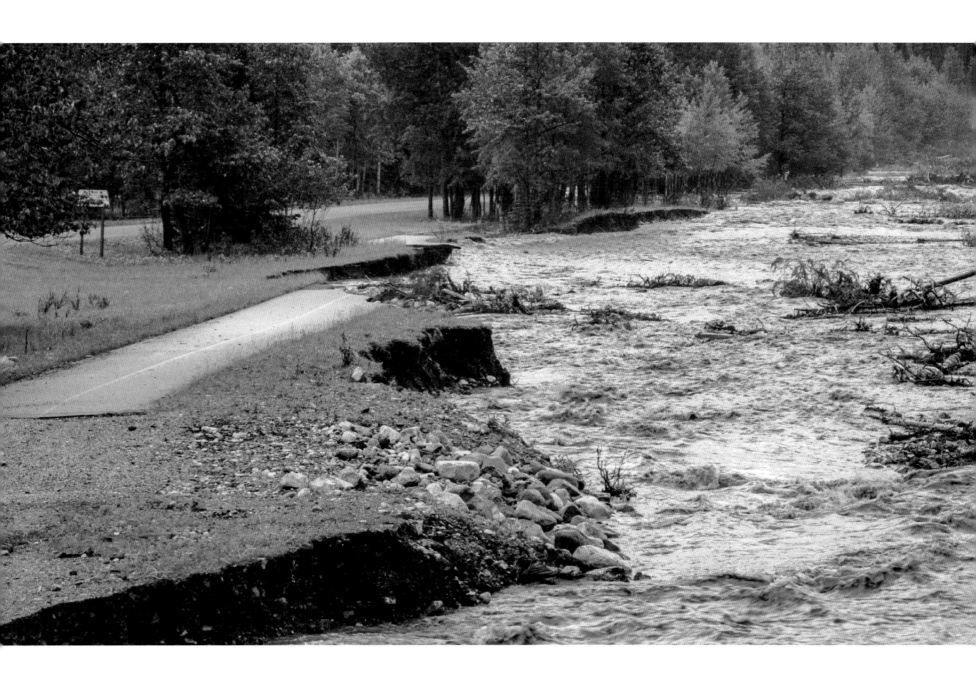

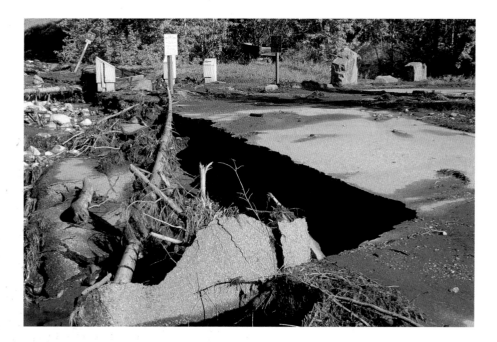

60

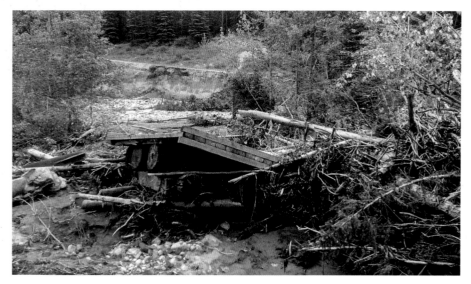

RIBBON CREEK

Left top: Some of the parking lot was broken up, the rest covered in silt that surrounded the picnic shelter. Photo courtesy of AEP

Left bottom: The bridge between the parking lot and Terrace Trail. Photo Gareth Short

Opposite: Aerial photo of Ribbon Creek at the north fork confluence. The beautiful meadow with its artifacts of 1940s logging has completely vanished under a deluge of stones. Remnants of the bridge can be spotted over the original course of the north fork, which moved westward (bottom left-hand corner). Photo courtesy of AEP

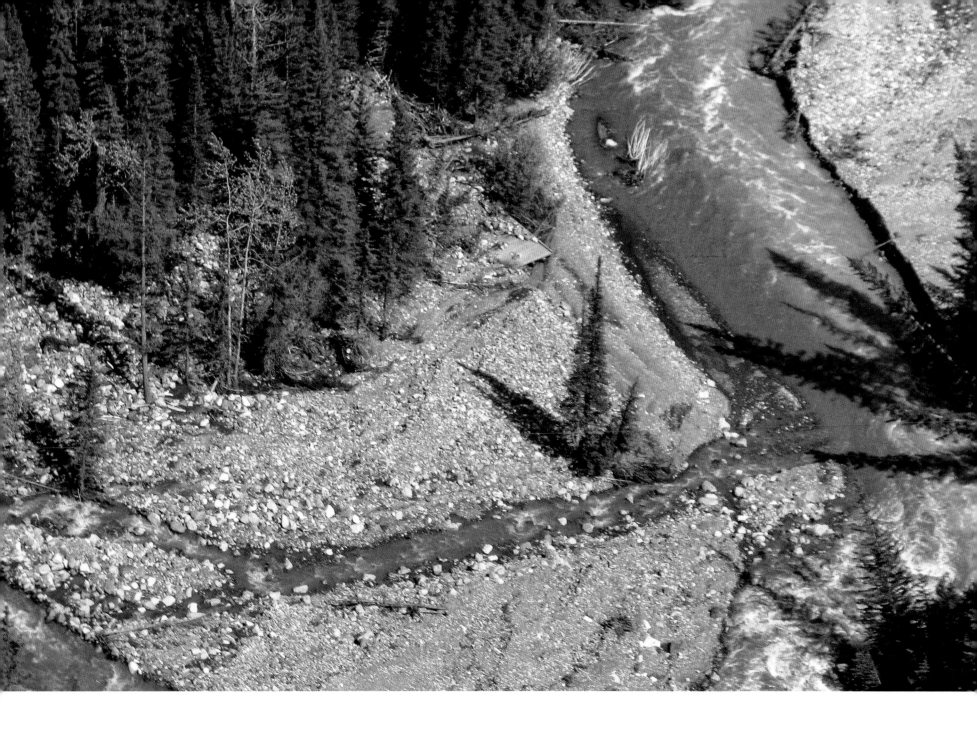

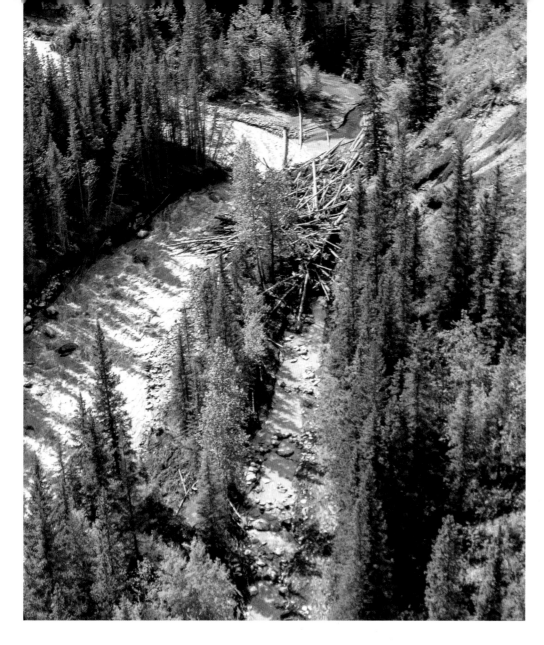

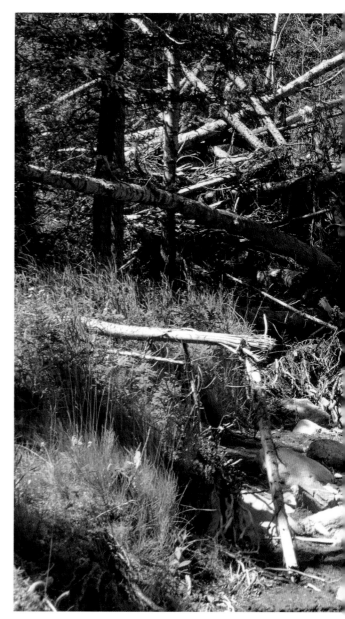

RIBBON CREEK
Aerial view of the big logjam blocking the trail. In 2015 it was by-passed by bridge number 3 to the left of it. Photo courtesy of AEP

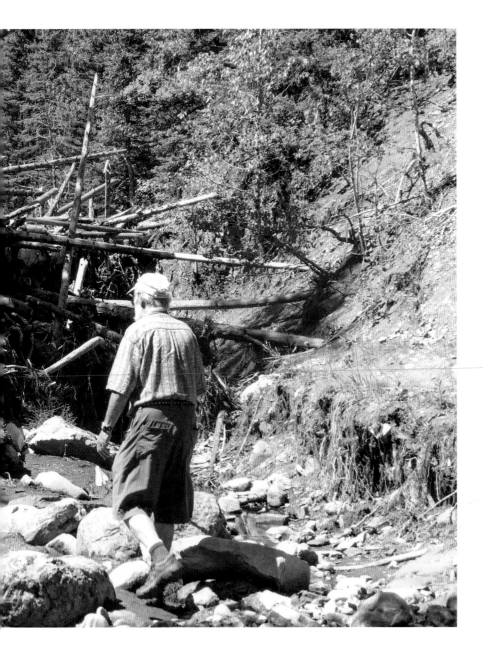

Above: Steps leading up onto bridge number 3 in 2015.
Photo Gillean Daffern

Left: The old trail, or what's left of it, coming to a full stop against the logjam. Photo Gillean Daffern

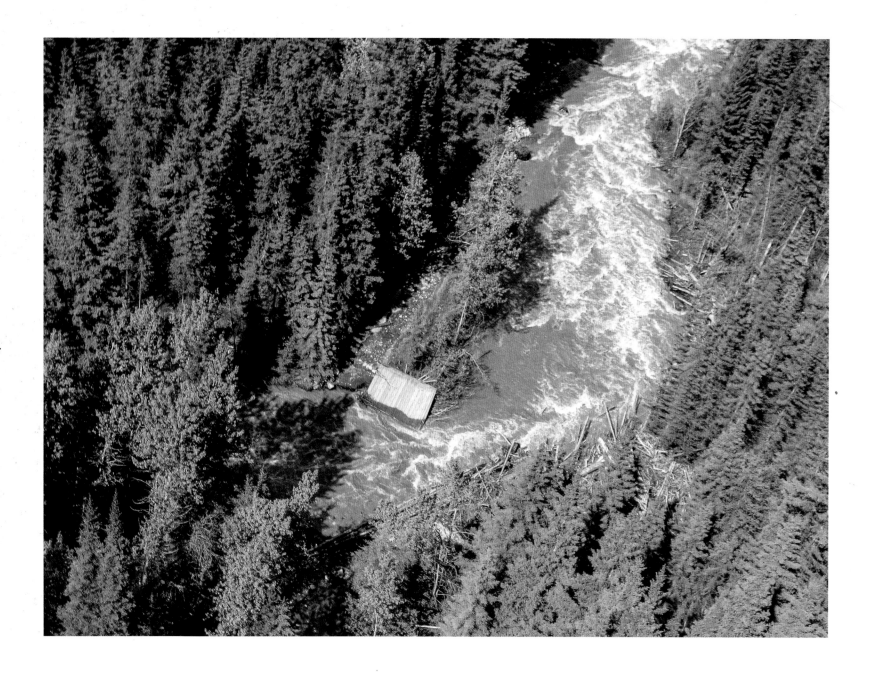

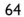

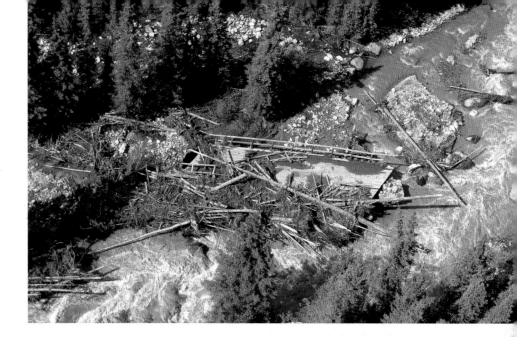

RIBBON CREEK

Opposite: Aerial view of old first bridge, broken and washed up on both banks. Just downstream the Eleanor McAndrew memorial bench is still standing, cut off from access in both directions. The new trail stays on the near bank between the logjam and bridge number 4. Photo courtesy of AEP

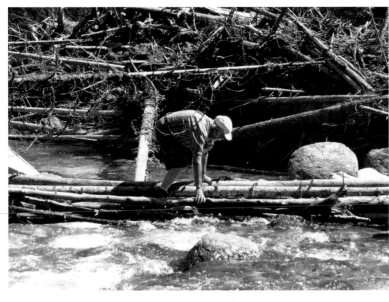

Above: Before the trail was rerouted, curious hikers were making new ways across Ribbon Creek at the first crossing.
Photo Gillean Daffern

Right top: Aerial view of old second bridge. Photo courtesy of AEP

Right bottom: The old second bridge can be seen more closely from below the junction with the new 2015 ski trail.
Photo Gillean Daffern

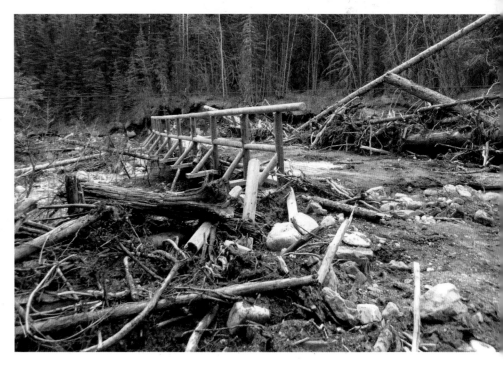

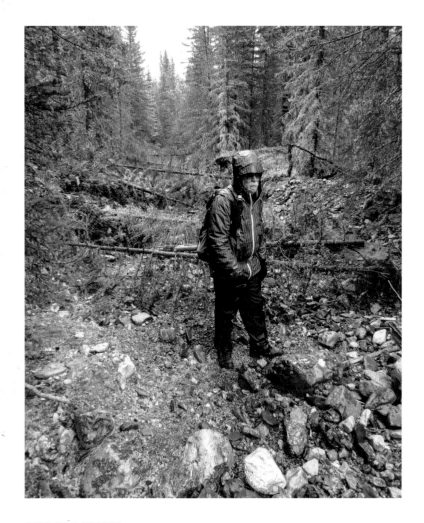

RIBBON CREEK
Top left and right: The trail between Link trail and the north fork junction is a mix of waterlogged ditch, stones and silt.
Photos courtesy of AEP and Gillean Daffern

Opposite: Remaking the trail between Link trail and the north fork junction. Forsaking Toad Forest in the valley bottom, "this time we're taking the scenic high line along a convenient bench."
Photos Alf Skrastins

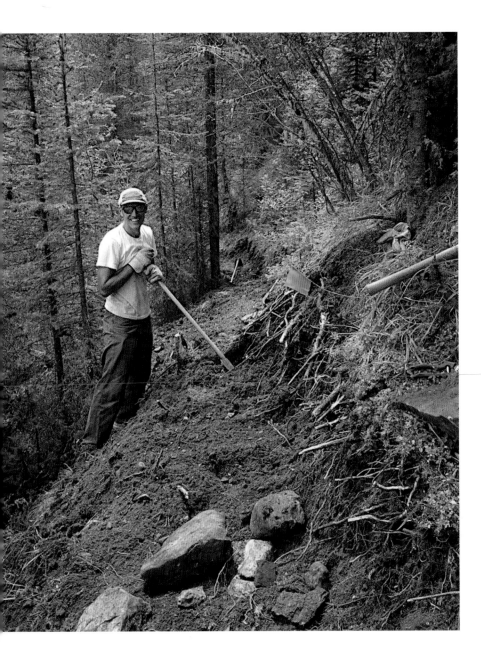

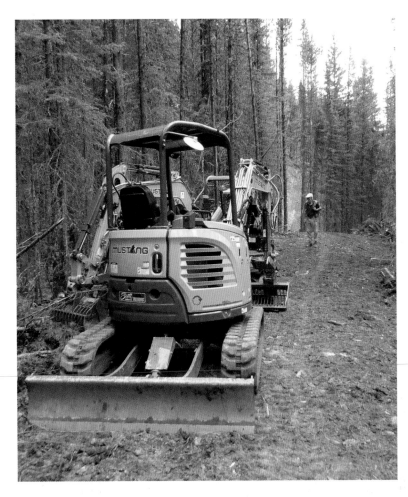

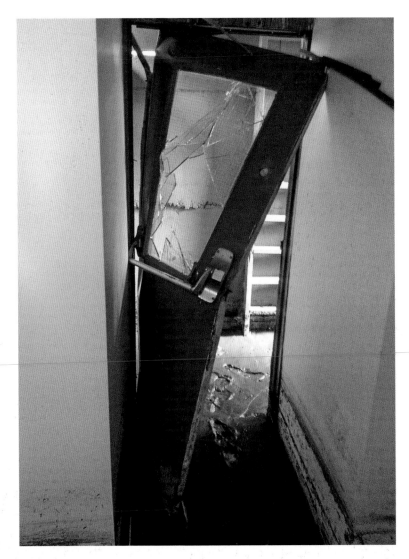

RIBBON CREEK
Above: Building the new ski trail up and across the north bank.
Photo Gillean Daffern

Opposite: Fibreglass bridge at the first crossing. There are now four such crossings where once there were two.
Photo courtesy of AEP

KANANASKIS WILDERNESS HOSTEL at Ribbon Creek
The storm door was bent by the force of the water pouring into the basement. Photo Gareth Short

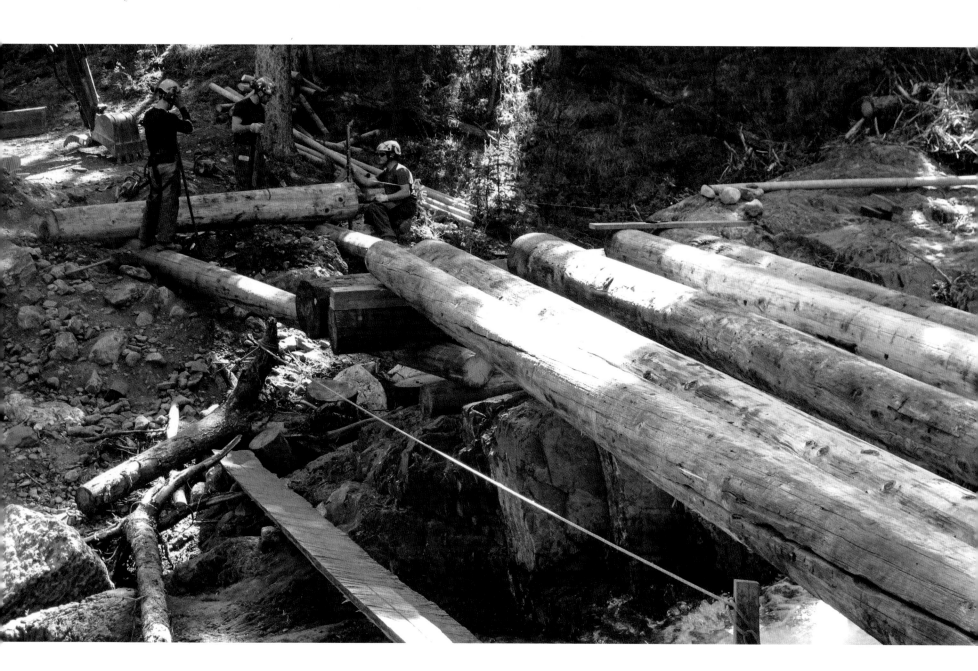

REBUILDING LINK TRAIL BRIDGE OVER RIBBON CREEK

Opposite: After the bridge was washed out, a bigger and better bridge took shape over the next few years. Here the construction crew are putting in the support beams. Photo courtesy of AEP

Right top: The decking has been laid and the bridge is once again passable for those who don't want to walk the plank.
Photo Alf Skrastins

Right bottom: In 2015 the bridge is nearing completion. The posts are up and there are just the railings to finish. This popular resting spot now sports five benches. Photo Gillean Daffern

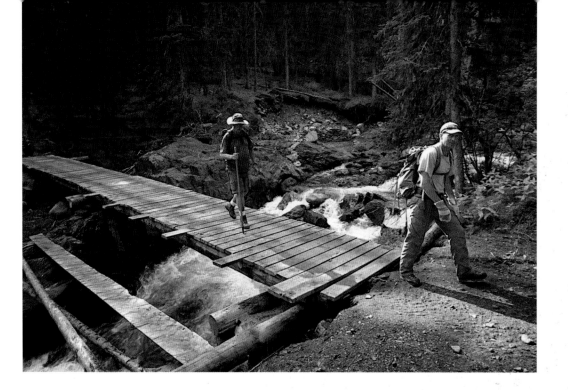

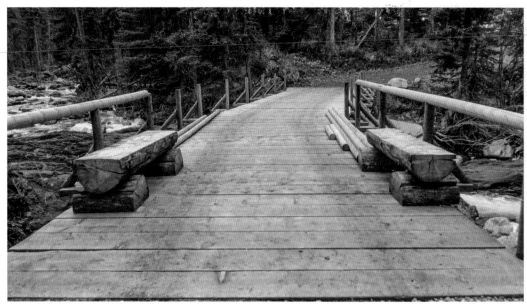

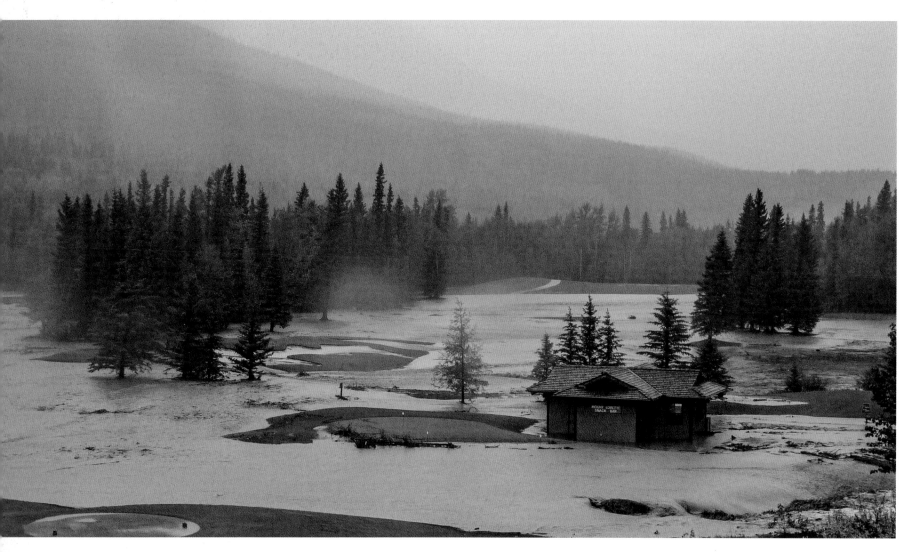

KANANASKIS COUNTRY GOLF COURSE
The world-renowned golf course on June 20 after Evan-Thomas Creek burst its banks and destroyed all but four holes. The course is currently being rebuilt. Photo Duane Fizor, courtesy of AEP

HIGHWAY 40
Opposite: Water pouring down the bank onto the highway opposite the turnoff to Kananaskis Village and Nakiska Ski Resort. Photo Gareth Short

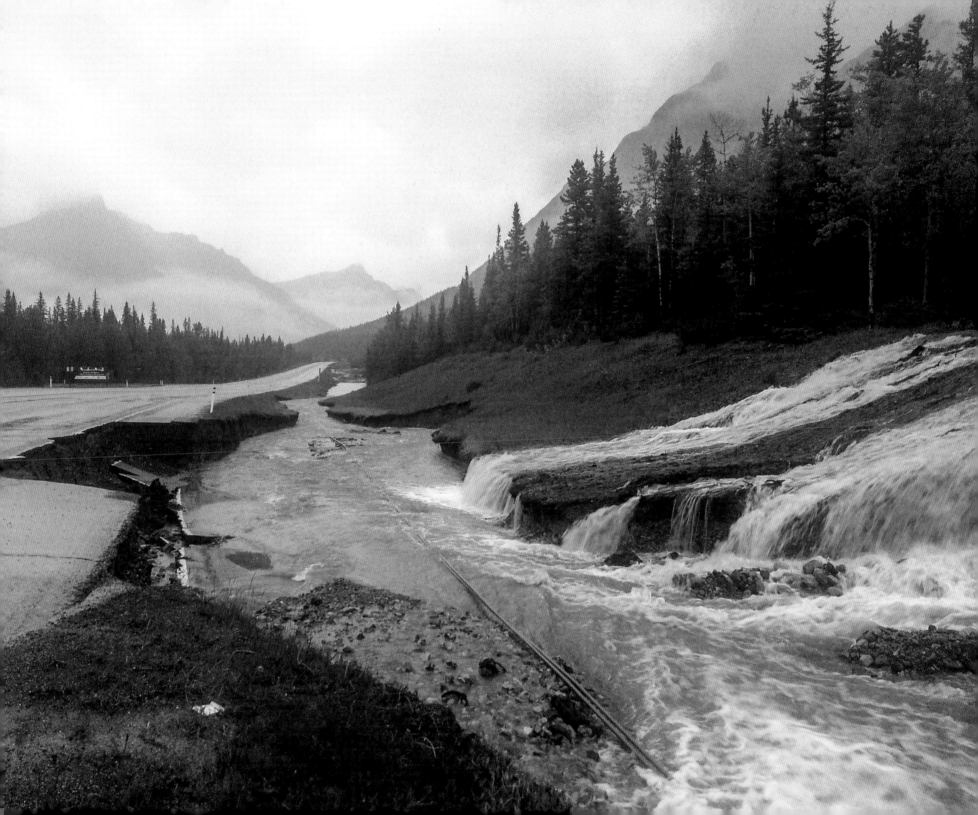

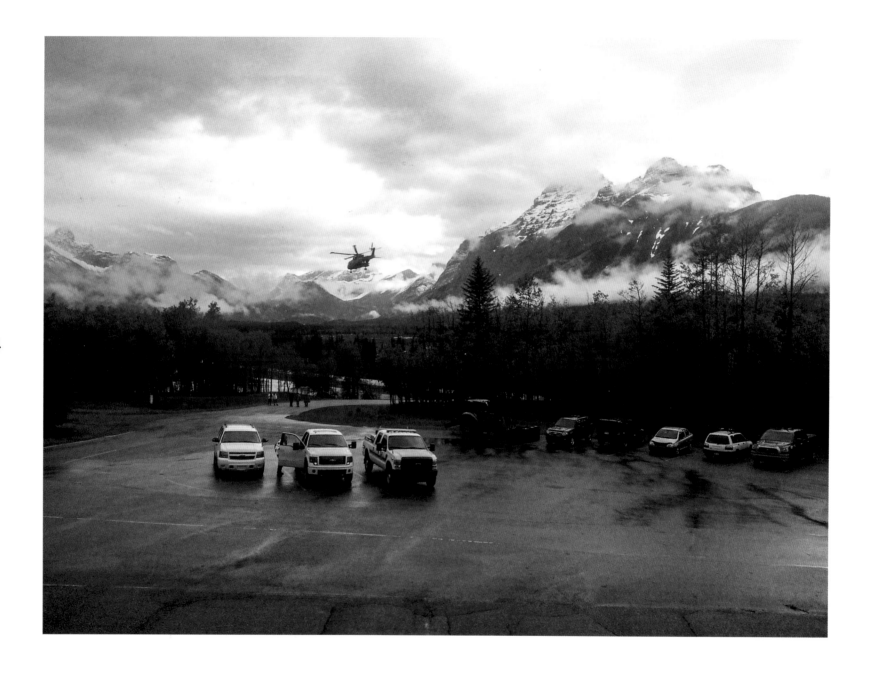

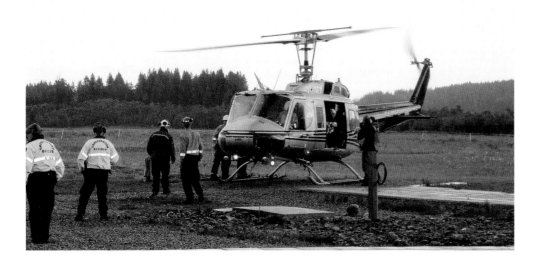

STAGING AREA AT STONEY NAKODA RESORT AND CASINO
Left: Evacuees landing at the helipad. From here buses were waiting to take people to Calgary. Photo courtesy of AEP

Below: "Paid on call" firefighters loading supplies to be flown in to William Watson Lodge. Photo courtesy of AEP

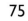

RIBBON CREEK EMS STATION
Opposite: The station was the centre of operations in the Kananaskis valley. In this photo, lifting clouds reveal fresh snow on the mountains.
Photo Gareth Short

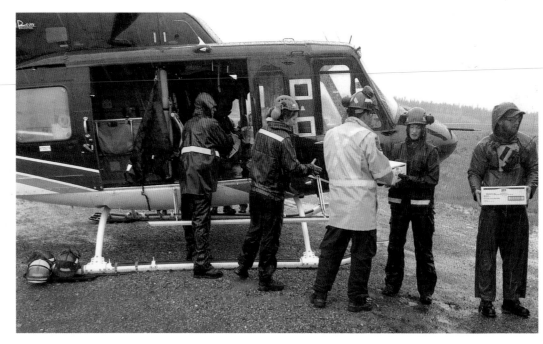

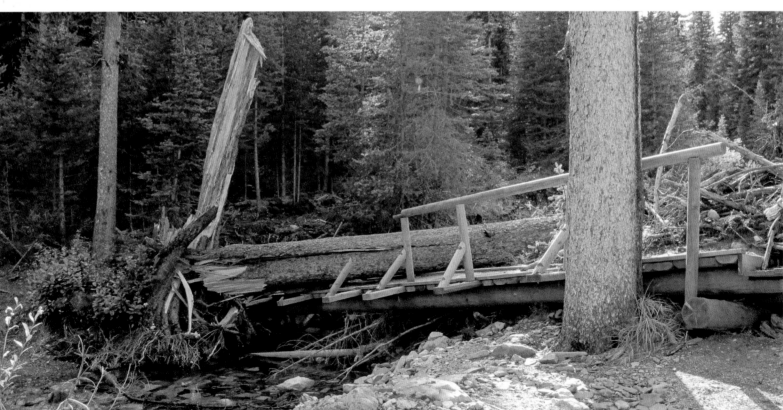

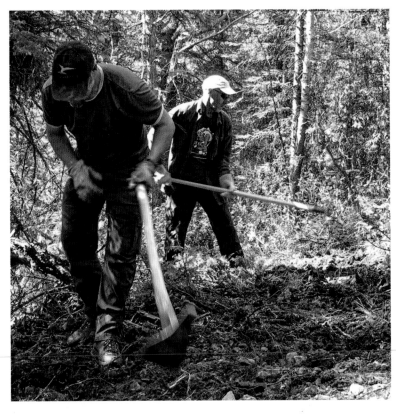

GALATEA CREEK

Opposite top: Broken-up bridge. Photo Alan Kane

Opposite bottom: This bridge has a tree on top of it.
Photo courtesy of AEP

Above left: Remaking the trail. Photo courtesy of AEP

**Above right: Half of Lillian Lake backcountry campground is
covered in stones.** Photo Gillean Daffern

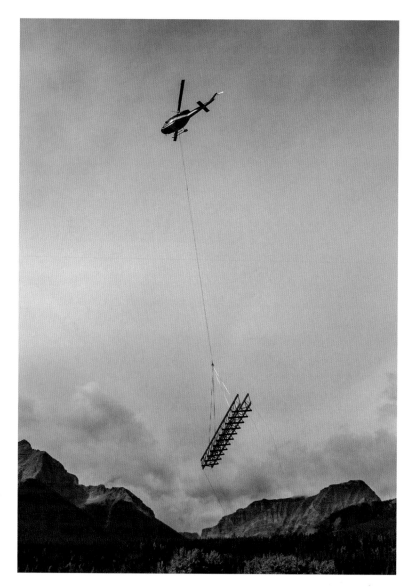

GALATEA CREEK

Above: Walking the tree at the last creek crossing proved too daunting for some. But help is at hand… Photo Gillean Daffern

Right: A new fibreglass bridge being flown in.
Photo courtesy of AEP

Opposite: The bridge assembled. Photo Alf Skrastins

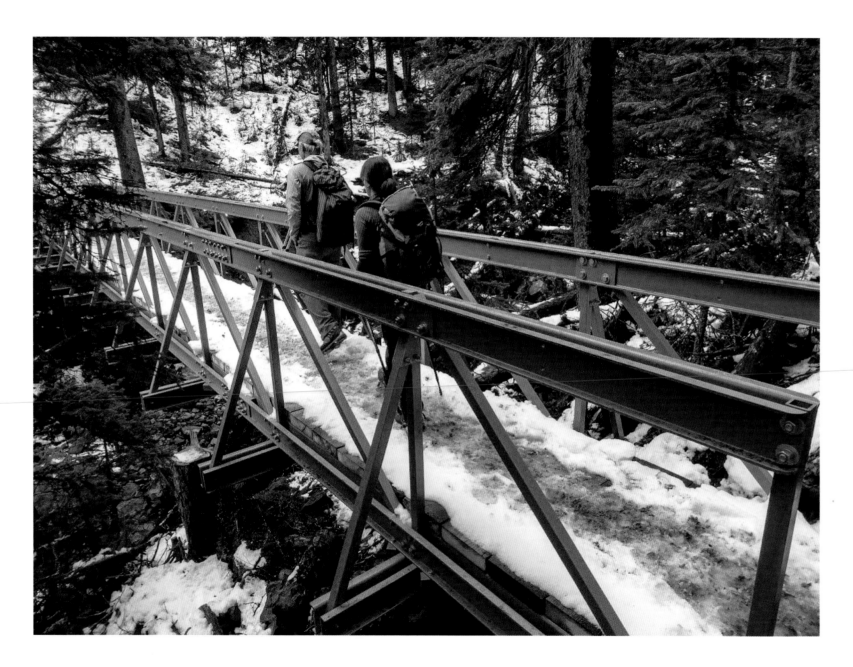

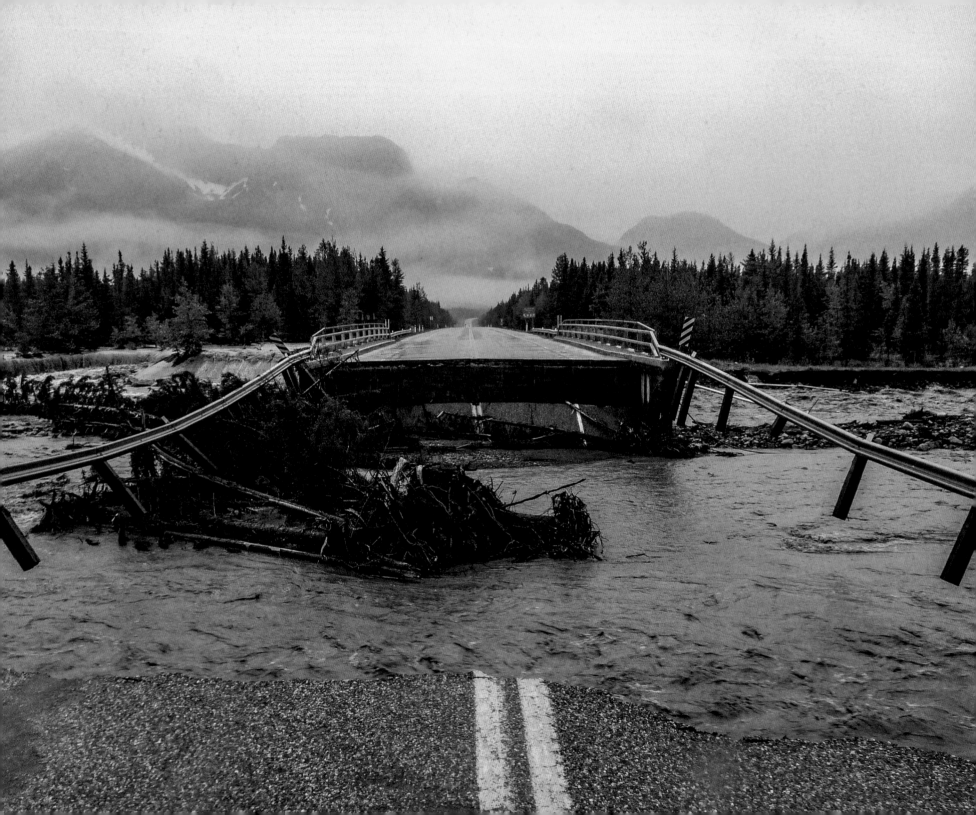

EVAN-THOMAS CREEK BRIDGE

Opposite: By mid-morning of the 20th, the rampaging Evan-Thomas Creek had broken through the Highway 40 bridge.

Photo Duane Fizor, courtesy of AEP

Below: Looking south to where the creek has washed away the Bill Milne bike trail. Only a little farther on, the creek overflowed its banks and turned Kananaskis Country Golf Course into a lake.

Photo Duane Fizor, courtesy of AEP

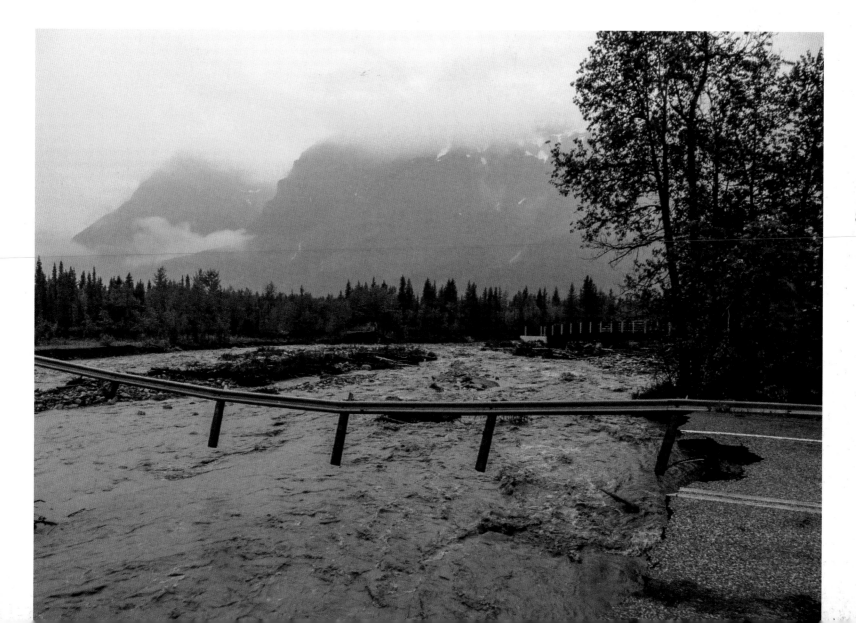

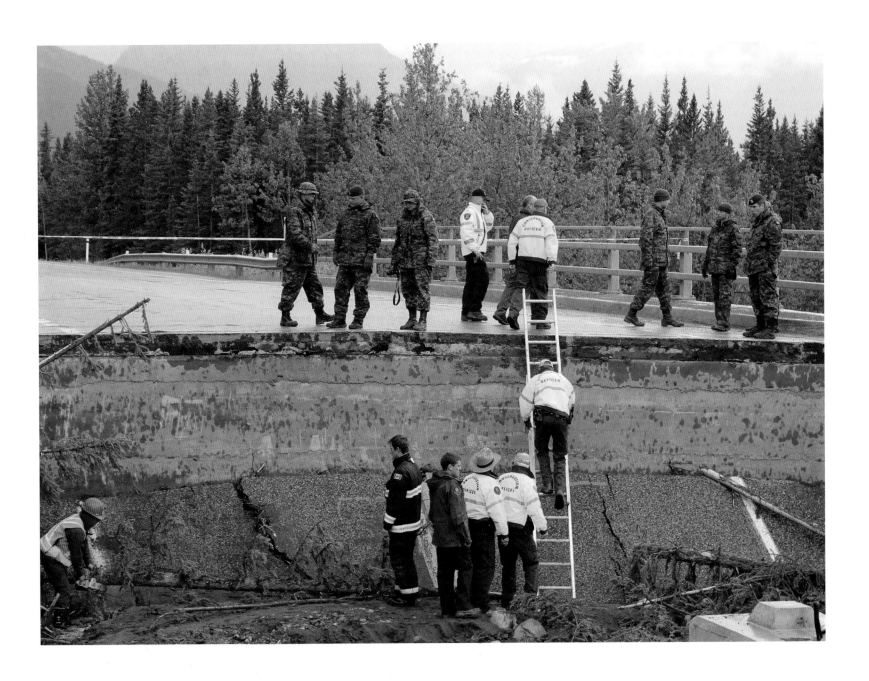
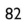

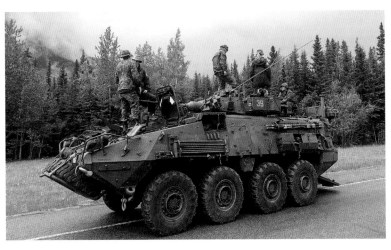

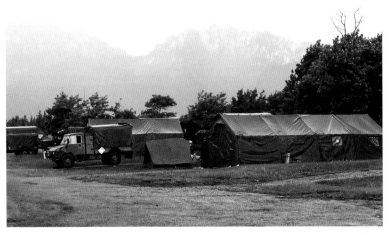

EVAN-THOMAS CREEK BRIDGE

Top left: Armoured vehicles were tried out as a means of crossing the creek-bed. Photo Gareth Short

Top right: The military's camp at Willow Rock Campground in Bow Valley Provincial Park.
Photo courtesy of AEP

Right: Conservation officers en route to checking out the bridge.
Photo courtesy of AEP

Opposite: The officers arrived at the bridge with members of the Canadian Forces. Lack of a bridge at this strategic point proved a big stumbling block during the evacuation, but luckily there was a ladder on hand.
Photo courtesy of AEP

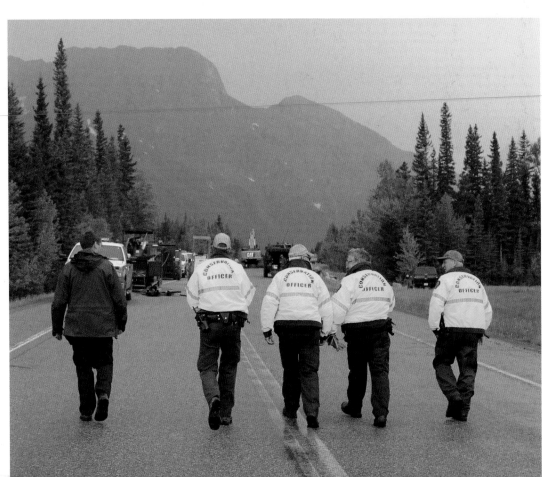

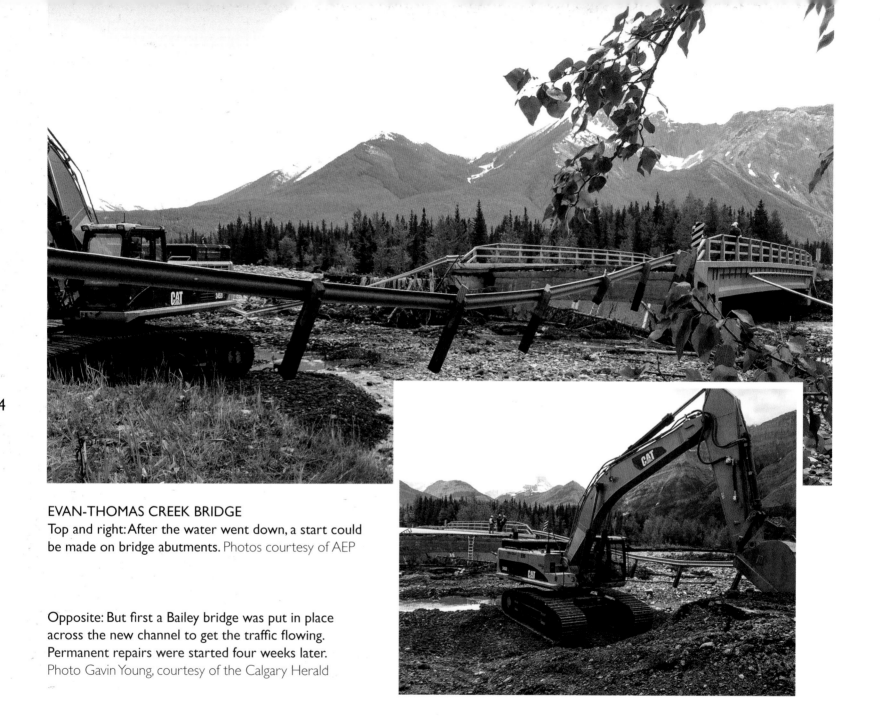

EVAN-THOMAS CREEK BRIDGE

Top and right: After the water went down, a start could be made on bridge abutments. Photos courtesy of AEP

Opposite: But first a Bailey bridge was put in place across the new channel to get the traffic flowing. Permanent repairs were started four weeks later.
Photo Gavin Young, courtesy of the Calgary Herald

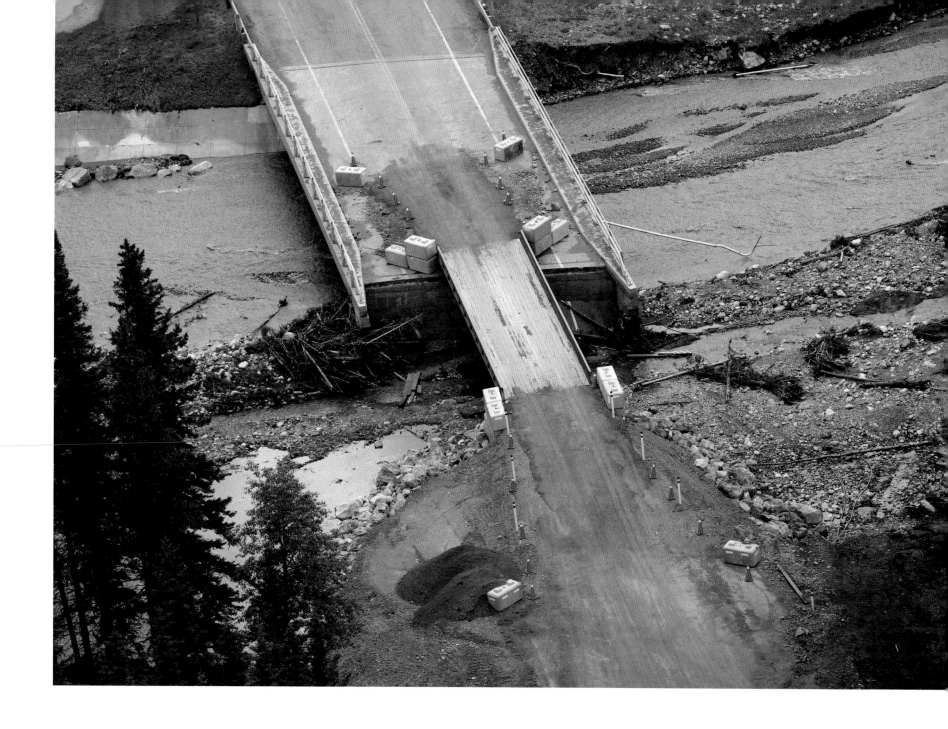

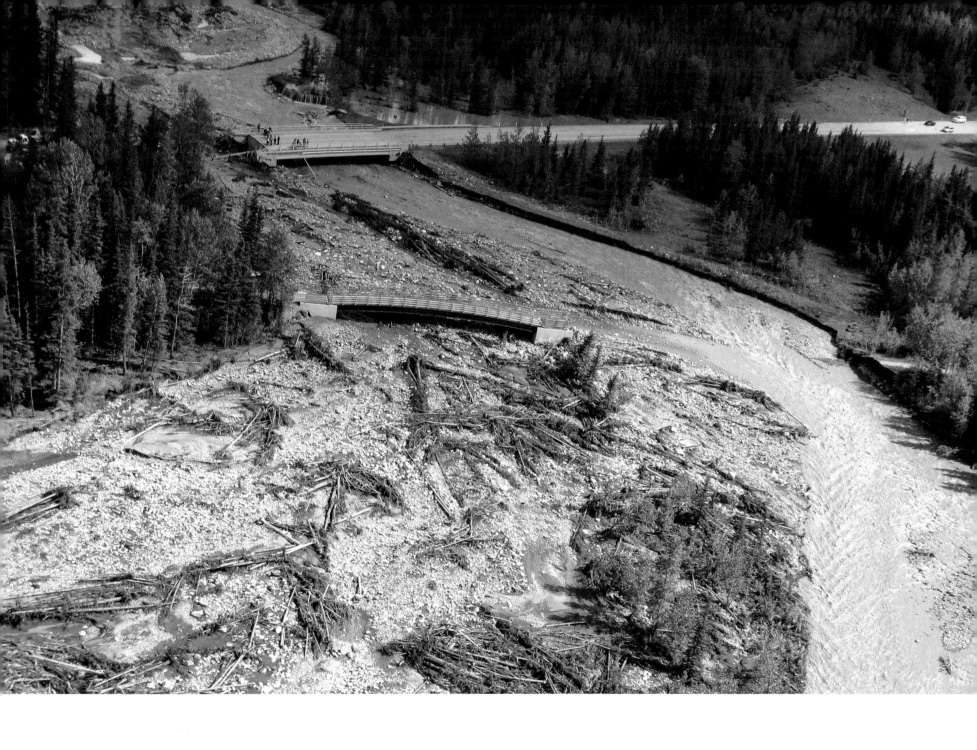

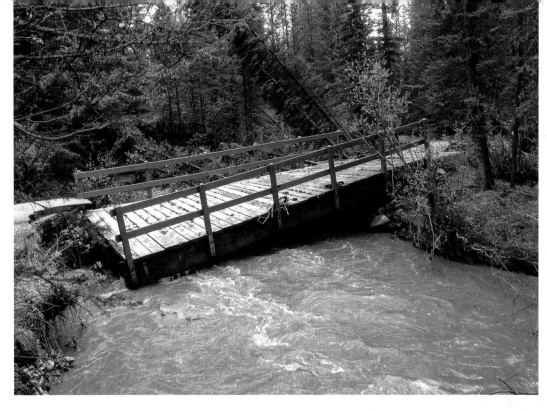

BIKE PATHS

Top right: The Lakeside bike path was not left unscathed. This photo shows the bridge over Boulton Creek disconnected from the bank. Photo courtesy of AEP

Bottom right: The Bill Milne bike path is heading into a creek, and this is before it even gets to the big one at Evan-Thomas! Photo Gareth Short

Opposite: Aerial view of Evan-Thomas Creek, the Highway 40 bridge and the gap in the Bill Milne bike path. It clearly shows the new channel taken by the creek that left the footbridge high and dry and superfluous. Photo courtesy of AEP

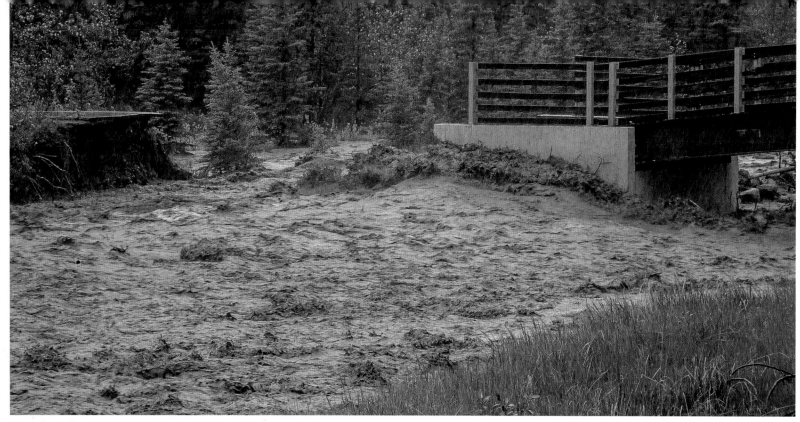

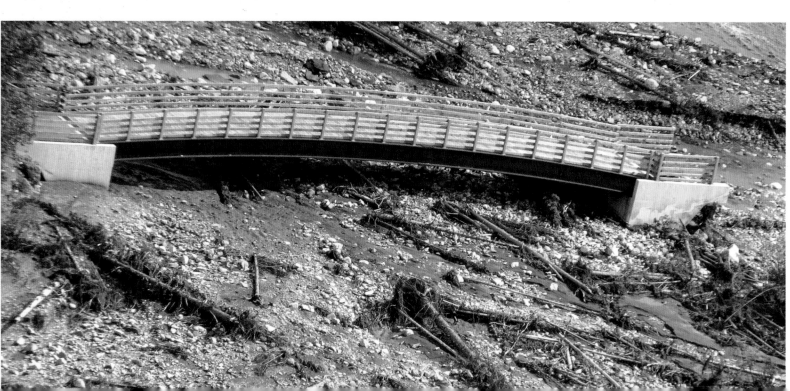

BILL MILNE FOOTBRIDGE

Opposite top: By mid-morning on June 20, Evan-Thomas Creek had washed away the Bill Milne bike path south of the footbridge.
Photo Duane Fizor, courtesy of AEP

Opposite bottom: The bridge was still standing after the waters receded, but unfortunately it was the creek that had moved. For 18 months the stranded bridge was a familiar sight along Highway 40.
Photo courtesy of AEP

Right: Finally, in November 2014, the bridge was moved to its new position next to the highway bridge. The bike path was rerouted the next year.
Photo courtesy of AEP

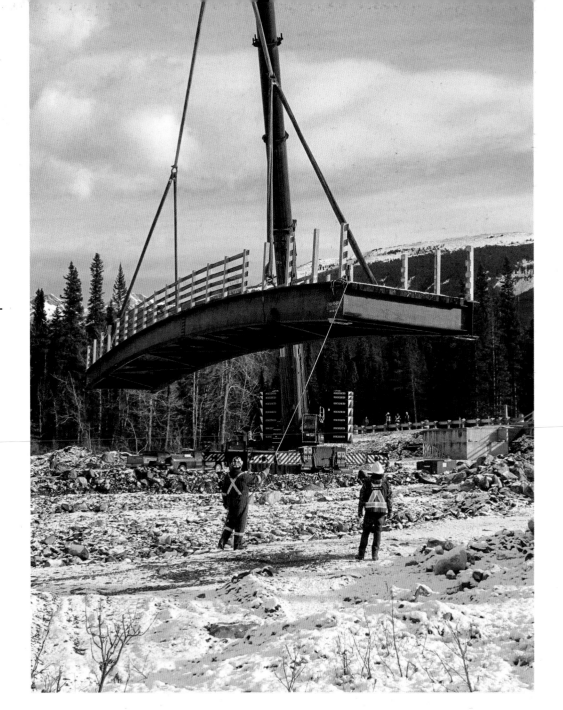

89

EVAN-THOMAS CREEK TRAIL

Opposite: A bemused tourist pointing out the first of two big washouts between the parking lot and the Wedge Connector. Just a few steps in front of her is a high vertical bank. Photo Gillean Daffern

Left: No sign of the old exploration road 7 km higher up the valley. This has severely affected pack trips from Boundary Ranch. Photo Alan Kane

WEDGE CONNECTOR

Right: The Wedge Connector bridge that crosses Evan-Thomas Creek got pushed into the bank. The first idea was to replace it with a cheaper sacrificial bridge that, after washing out in spring floods, could be gathered together from wherever it washed up downstream and put back in place… until next year's floods. But eventually a new trail and bridge were built farther upstream. Photo Gareth Short

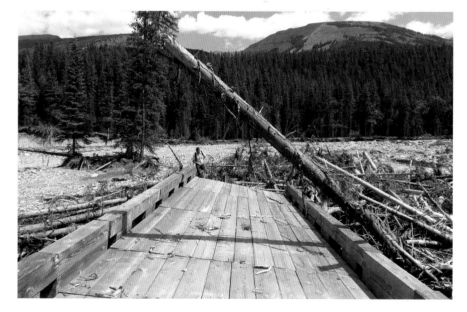

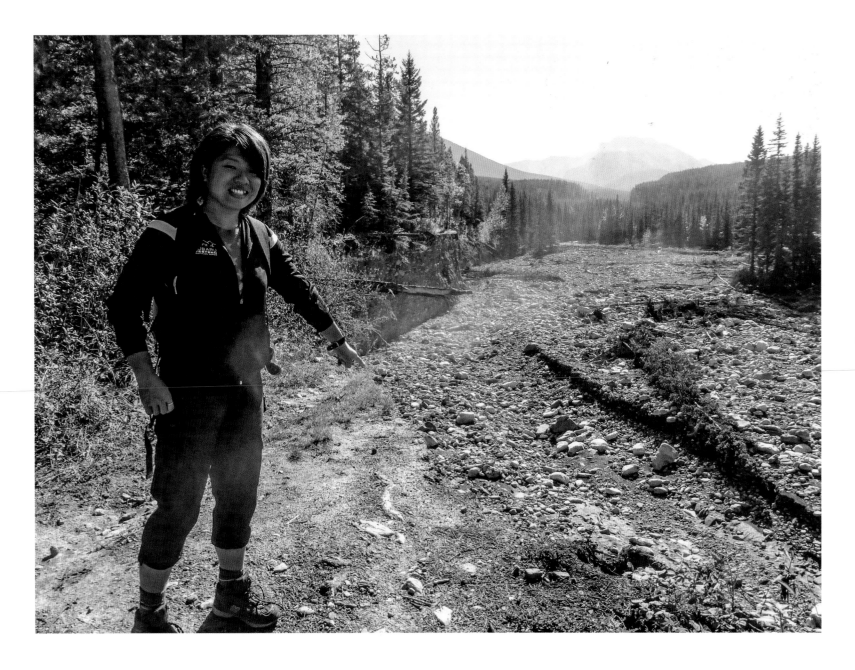

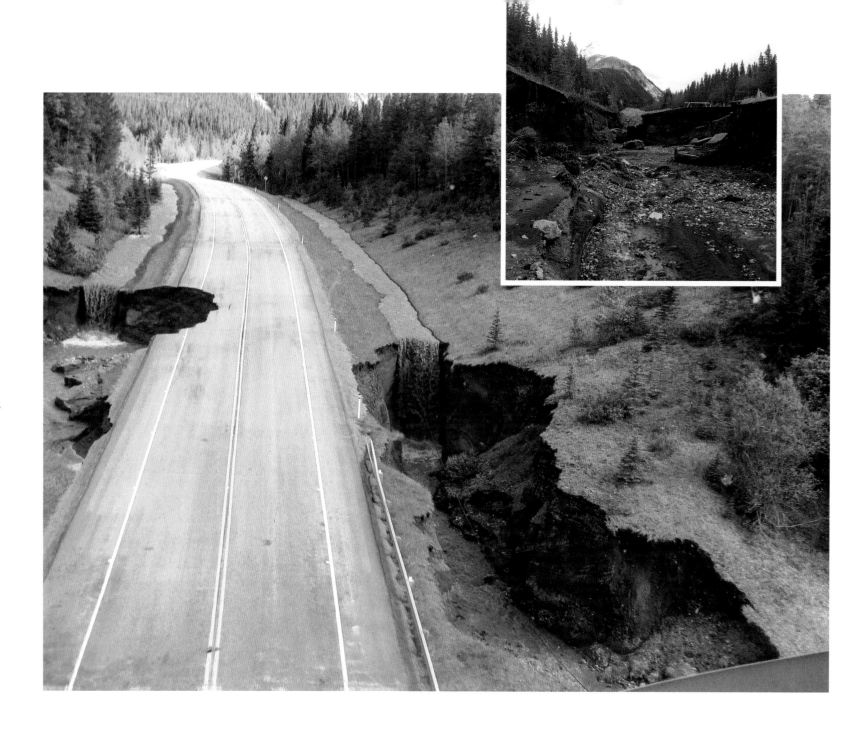

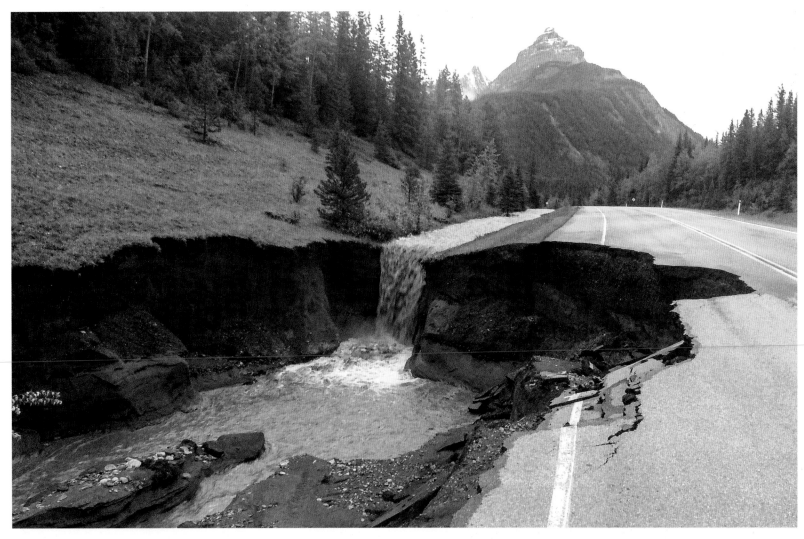

HIGHWAY 40

Opposite: Aerial view of the washouts between Galatea Creek trailhead and Rocky Creek bridge. The one on the right took out the utility line. Photo James Cieslak, courtesy of AEP

Above: A closer view of the washout. Downstream is another waterfall and hole. Photo Gareth Short

Inset on opposite page: Photo Gareth Short

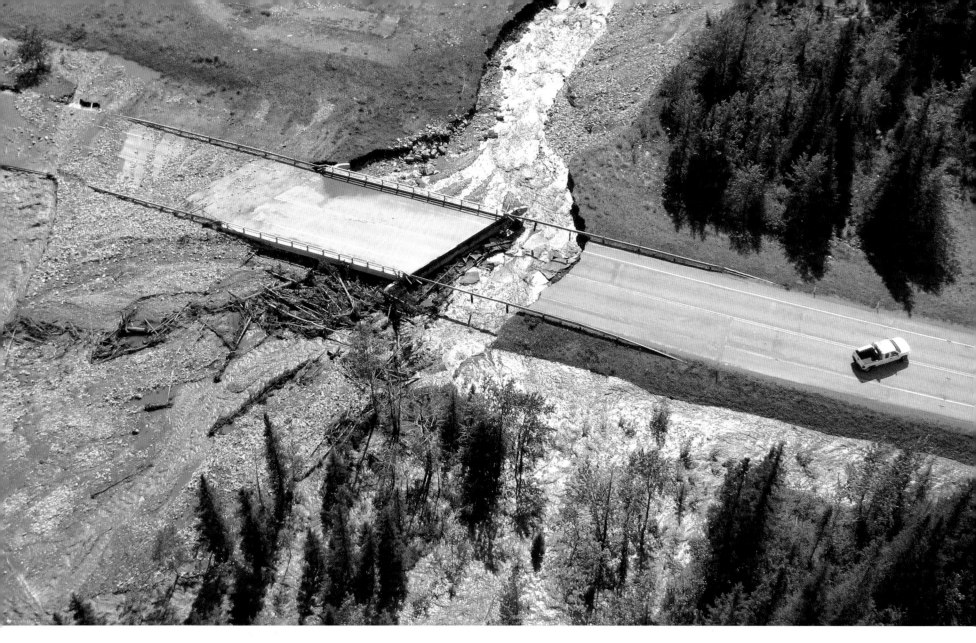

ROCKY CREEK BRIDGE
Aerial view of the bridge and the parks services ranger's
abandoned truck. Photo courtesy of AEP

Opposite: Ground-level views of the broken bridge taken by
the parks services ranger two days later. Photos Gareth Short

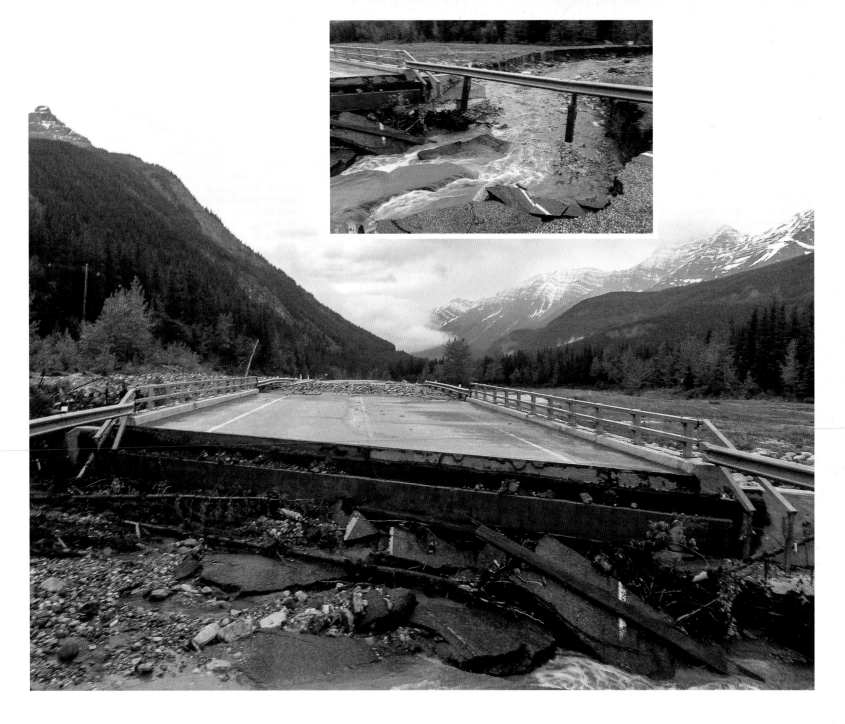

WHISKEY JACK TRAIL

Left: So what happened here? Spotted Wolf Creek overwhelmed the culvert under the ski trail and flowed down the trail, eroding it to a depth of 4 m before finding a dip in the terrain and flowing off into the trees. After an initial fix, further repairs were made to the culvert in 2014 and a protective berm was built. Photo courtesy of AEP

This wasn't the only ski trail to be badly damaged in Peter Lougheed Provincial Park. On the following pages are equally shocking pictures of Elk Pass, Tyrwhitt, Fox Creek, Rolly Road, Pocaterra and Boulton Creek trails. Amazingly, all were repaired to some degree in time for the 2013/14 ski season. Finishing touches will still be ongoing into 2017.

ELK PASS TRAIL

Opposite: Inspecting the bridge south of Hydroline junction. Can it be salvaged? Maybe. Photo courtesy of AEP

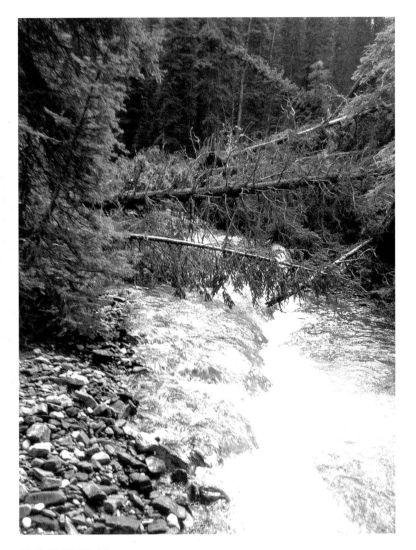

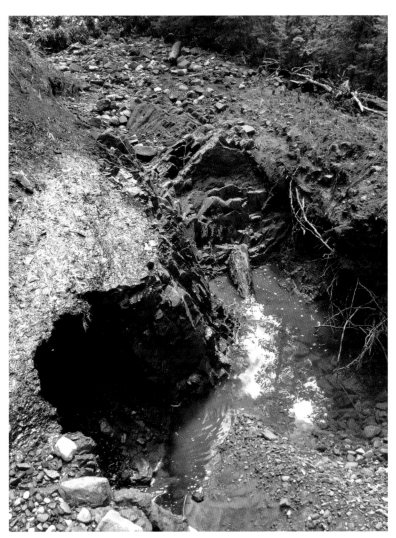

ELK PASS TRAIL
Above and right: The worst-hit section lay between Fox Creek trail junction to a point south of Hydroline trail junction in Fox Creek valley where three bridge washouts, slumps and erosion required two substantial reroutes. In 2015, after two summers of wading, hikers got to cross the third and last bridge to be replaced. Photos courtesy of AEP

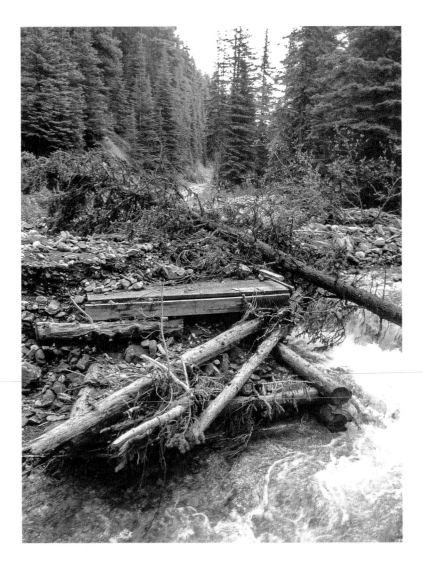

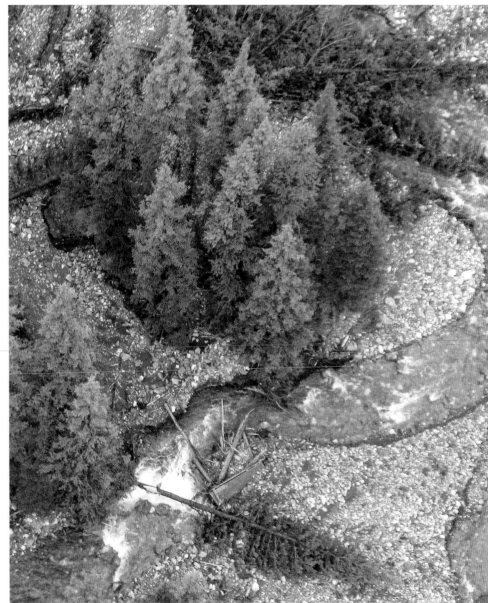

Above and right: Two views of the second bridge south of Hydroline trail, the aerial shot showing the onslaught of stones and no sign of the trail. Photos courtesy of AEP

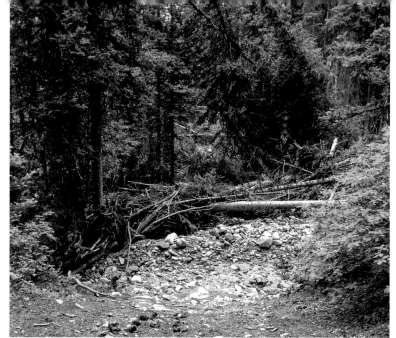

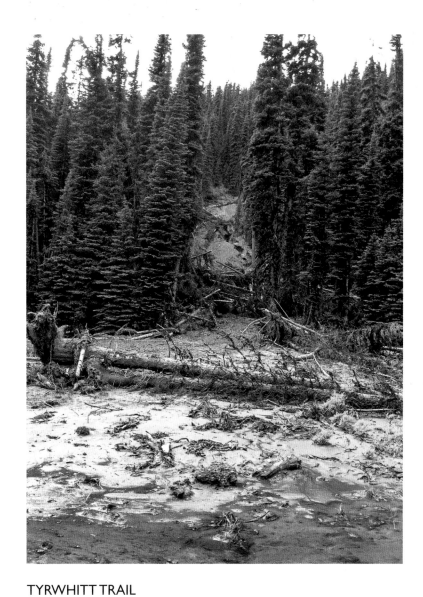

TYRWHITT TRAIL
The last thing you expect to see across the beautiful Tyrwhitt meadows is a mud flow, but here it is. Photo courtesy of AEP

FOX CREEK TRAIL

Opposite top and bottom: Everybody's favourite trail was clobbered by silt, stones and fallen trees that forced several reroutes. The second bridge over Boulton Creek had to be completely rebuilt and repairs made to the other two bridges. Work is still ongoing. Photos courtesy of AEP

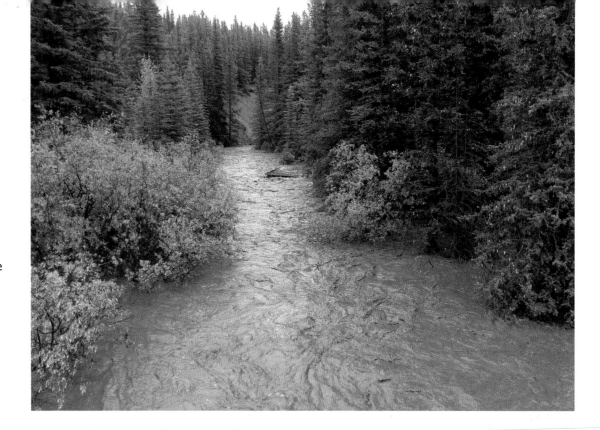

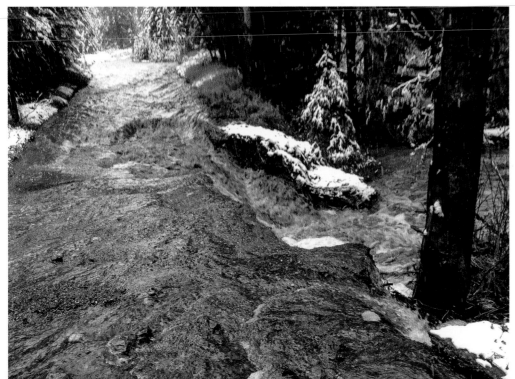

ROLLY ROAD

Above: As you can see, the bridge crossing Pocaterra Creek proved too short when the creek widened its bed.
Photo courtesy of AEP

Left: The trail on June 21 after the summer solstice snowfall. Photo courtesy of AEP

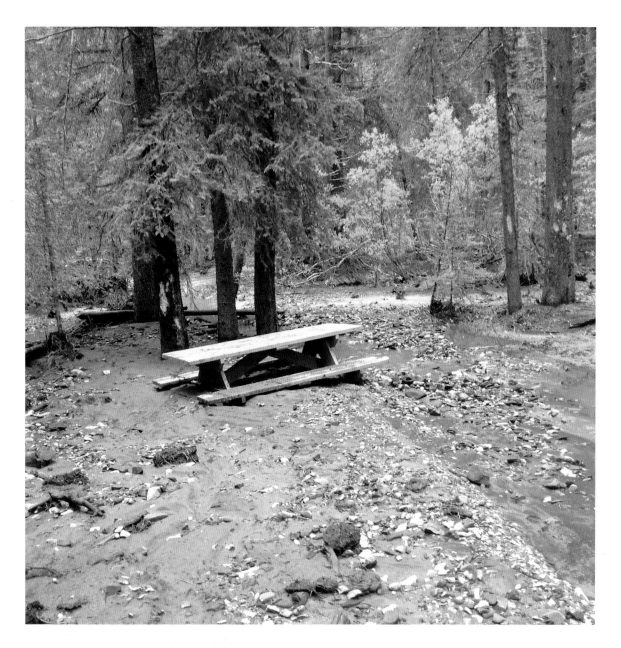

POCATERRA GROUP CAMP
Left: Immediately after the flood, reaching the camp by any trail was a challenge. Some of the camp was relatively untouched, but not this bit.
Photo courtesy of AEP

POCATERRA TRAIL
Opposite: Trail crew discovering the trail is a river.
Photo courtesy of AEP

Inset: But the hand fishing is great! Photo courtesy of AEP

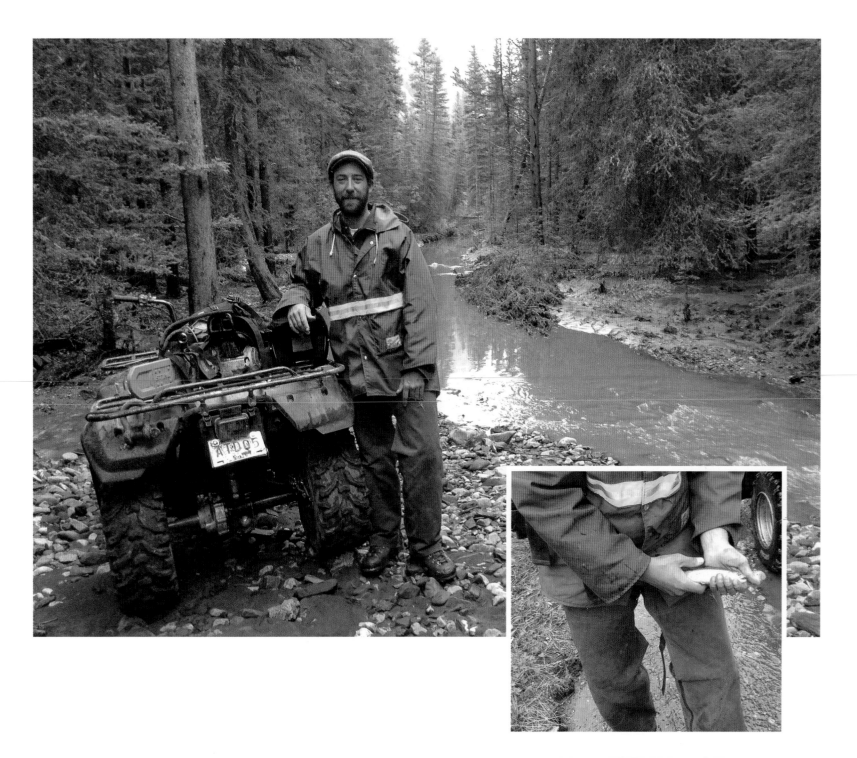

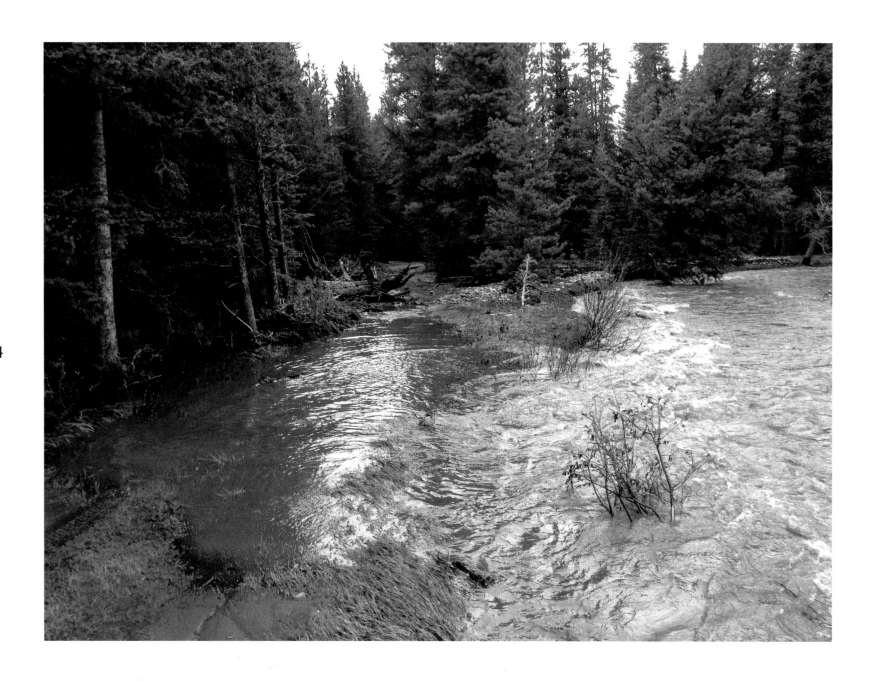

POCATERRA TRAIL

Opposite: The section of Pocaterra in the valley bottom has always been prone to floods. After the biggie of 2013, it was decided to relocate the trail onto higher ground to the west.
Photo courtesy of AEP

Top right: A bridge between Stroil junctions. This section of Pocaterra has been abandoned, as has Stroil, the easy part along the ridge now conscripted into the new Pocaterra.
Photo courtesy of AEP

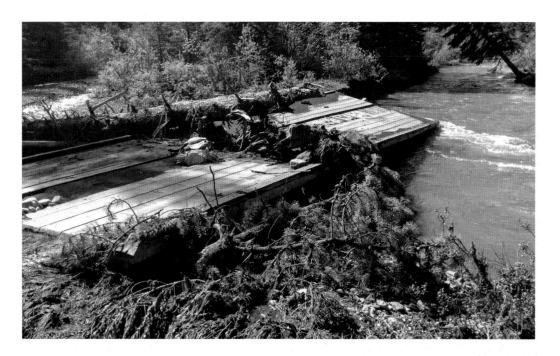

Bottom right: So how about trying to reach Pocaterra trail from Highway 40? No, that won't work. Even here, Pocaterra Creek has got between the bridge and the road, foiling access.
Photo courtesy of AEP

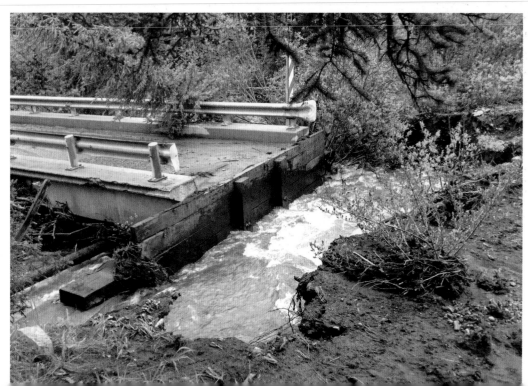

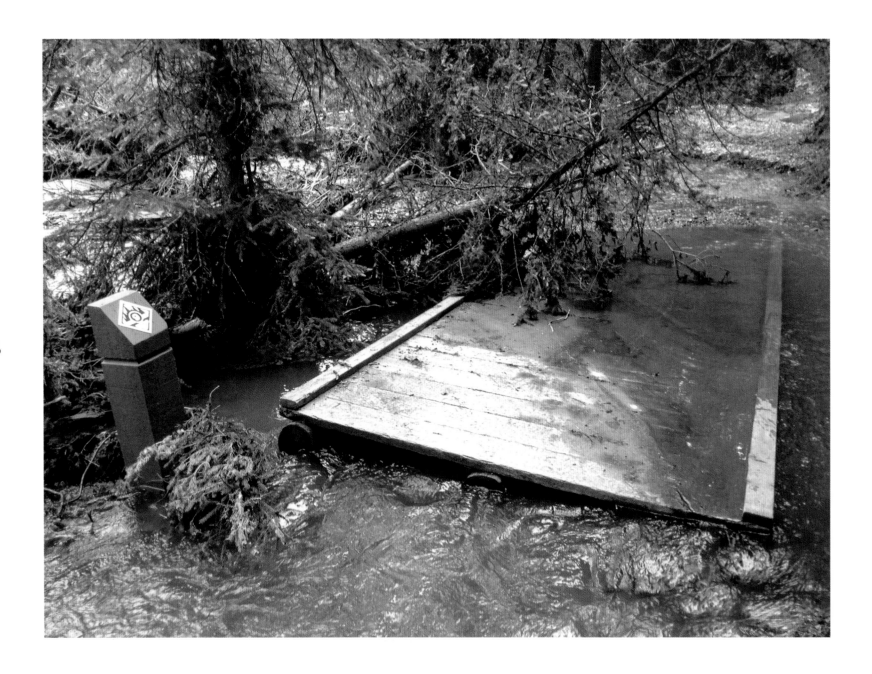

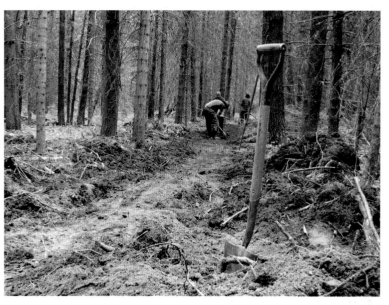

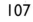

BOULTON CREEK TRAILS

Opposite: The interpretive trail wiped out at post #9.
Photo courtesy of AEP

Above: The Boulton Creek bridge on the interpretive trail is a good example of how bridges cause logjams.
Photo courtesy of AEP

Right top and bottom: The trails in Boulton Creek—the ski trail and the interpretive trail have a history of being flooded and then rebuilt, but the flood of 2013 was the last straw. In 2015 the ski trail was rerouted in three places, most notably between the Boulton Creek bridge on the interpretive trail and the Boulton Bridge parking lot as seen here. Photos courtesy of AEP

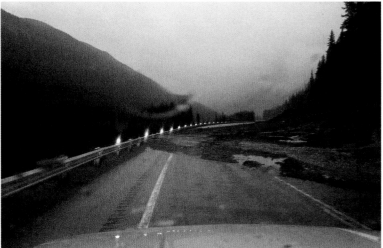

PETER LOUGHEED DISCOVERY CENTRE
The meadow behind the centre is a lake. The water is going down in this photo taken about two months after the flood, and islands are starting to appear. Photo courtesy of AEP

HIGHWOOD PASS
Both photos show the June 19 slide across Highway 40 near Highwood Pass and its progression as the night wore on. Photos Gareth Short

INTERLAKES
Slump on the Interlakes Interpretive Trail.
Photo courtesy of AEP

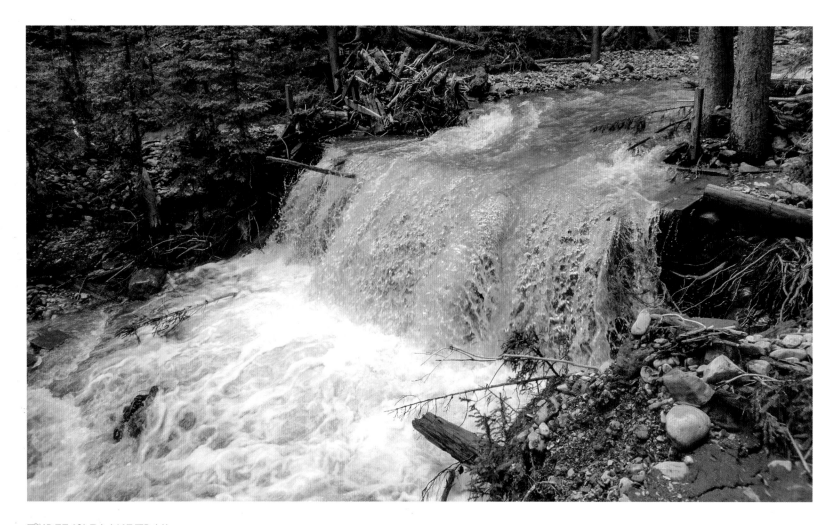

THREE ISLE LAKE TRAIL
Above: The intact bridge across Invincible Creek made a rather fine waterfall. Photo courtesy of AEP

Opposite: Getting around the mess near Invincible Creek crossing was especially difficult with a bike. Photo courtesy of AEP

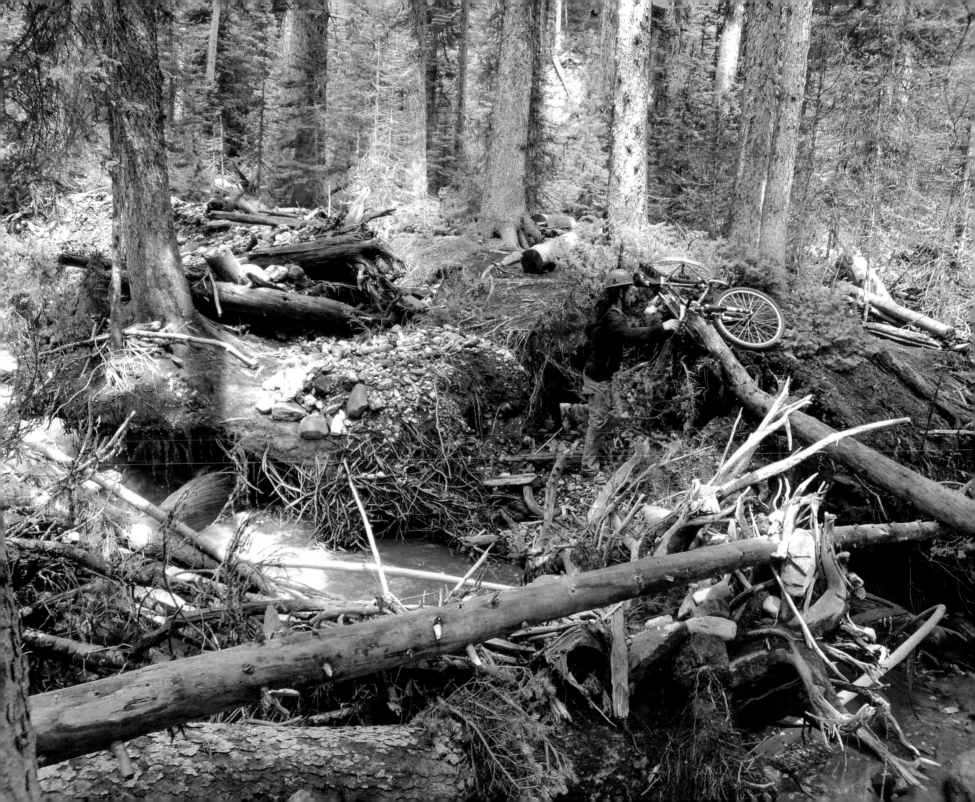

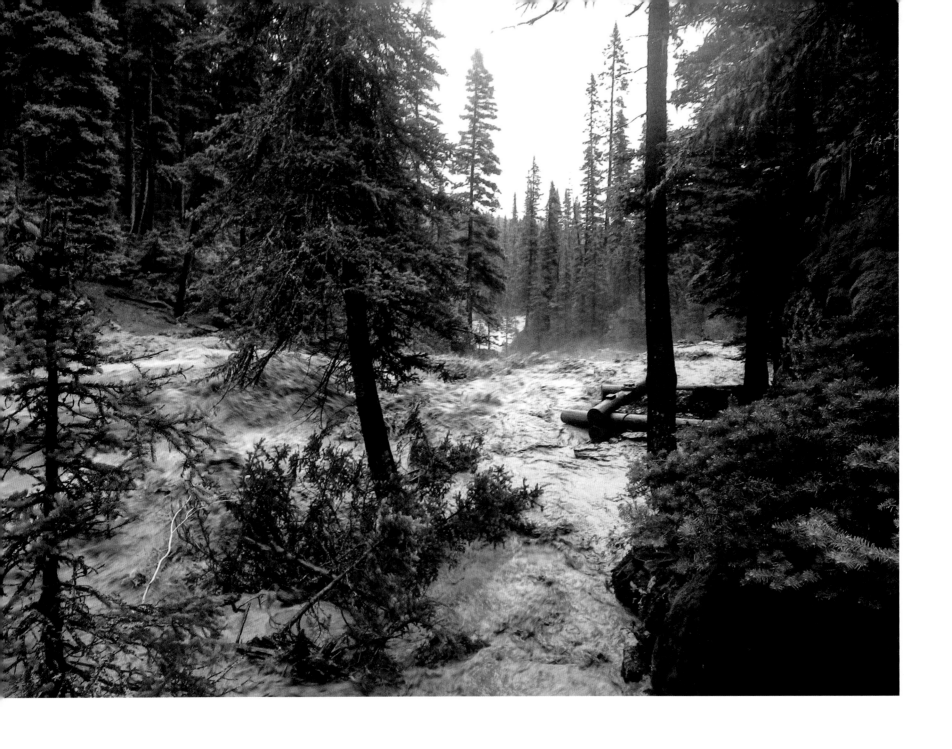

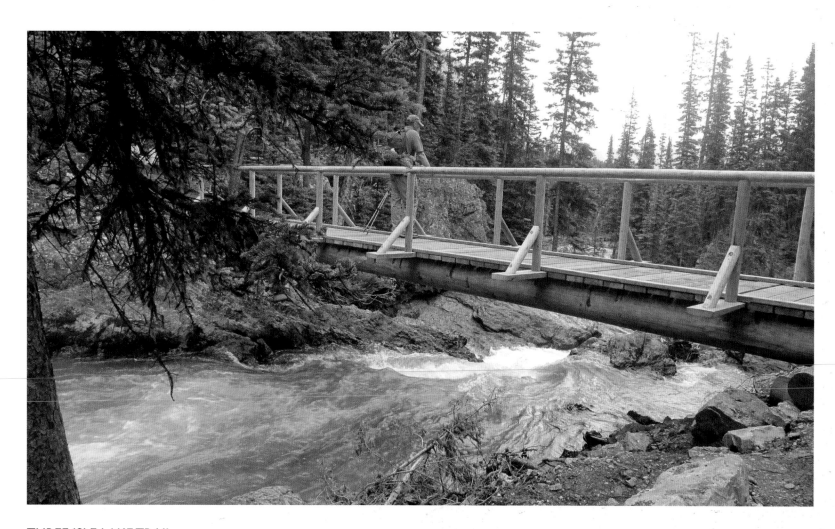

THREE ISLE LAKE TRAIL

Opposite: Caught out in the storm at Forks backcountry campground and worried about their safety, the photographer and his group hurried down the trail on the morning of the 20th, only to find their escape cut off at Upper Kananaskis Falls, which is where this photo was taken. The bridge had gone and the Kananaskis River was an unrecognizable monster. They set up camp on the hill above in hopes of being rescued and were eventually found by a helicopter crew sent out to look for them. Photo Bruce Steiner

Above: The new bridge erected in 2015. Photo Jack Tannett

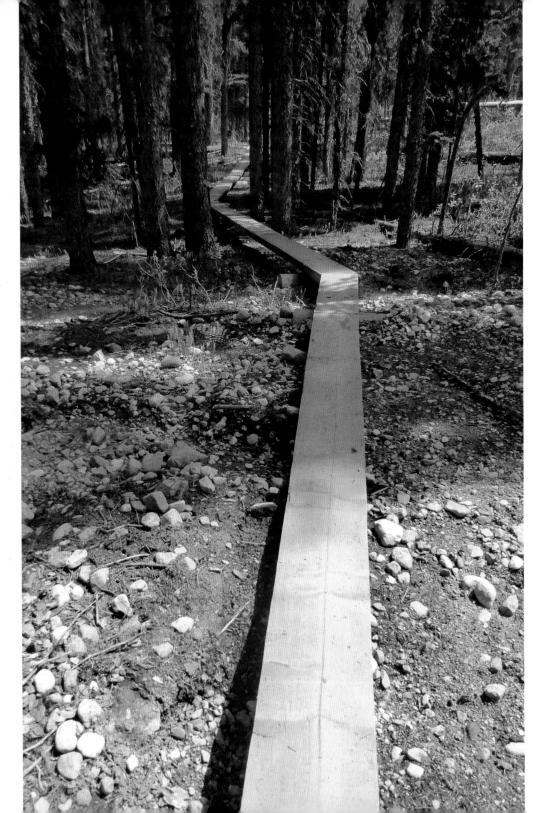

THREE ISLE LAKE TRAIL

Opposite: The trail as it approaches Forks backcountry campground was devastated by bridgeouts, washouts and erosion. Photo Jack Tannett

Left: In 2015 the trail was rerouted and many metres of boardwalk laid down. Thankfully, the headwall above the forks is in good shape, but more repairs are needed to Three Isle Lake backcountry campground at the end of the trail. Photo Gillean Daffern

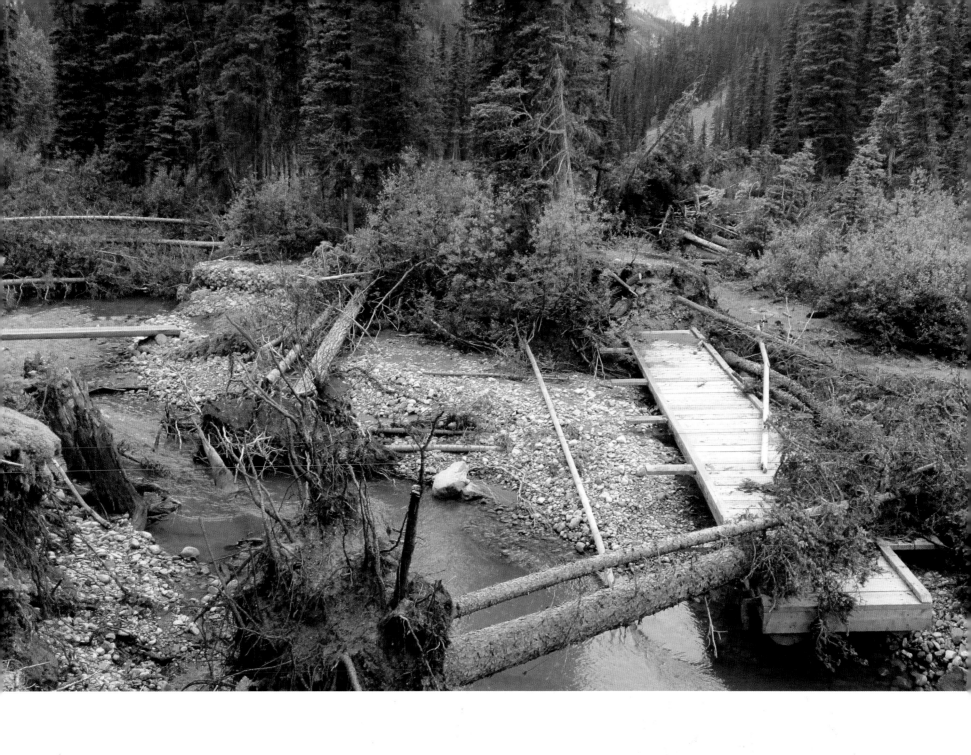

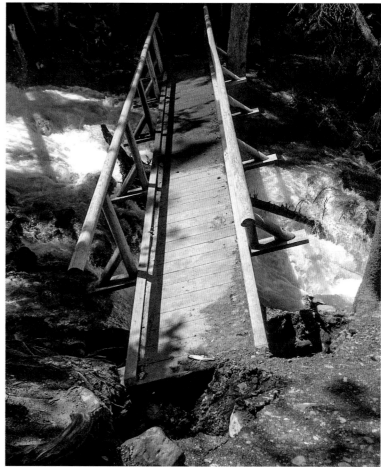

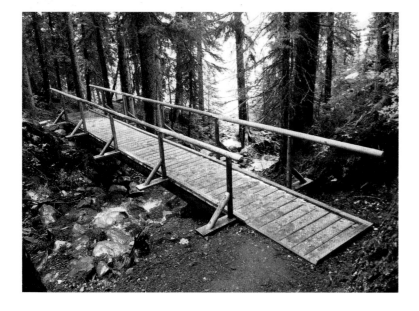

UPPER KANANASKIS LAKE TRAIL
Above: After the flood, the Sarrail Creek bridge was too short.

Top left: Rawson Creek bridge is a goner.

Bottom left: Sarrail Creek bridge transferred to Rawson Creek. Sarrail Creek will get a longer, fibreglass bridge in 2016.
All photos courtesy of AEP

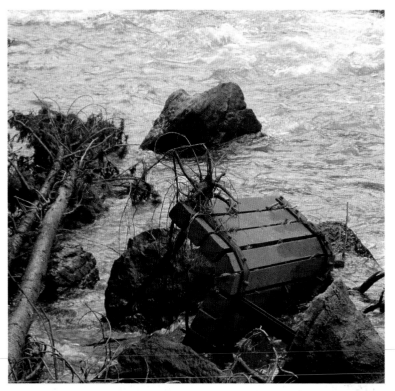

UPPER KANANASKIS LAKE TRAIL

Left: The Bernie Kathol memorial bench at Lower Kananaskis Falls viewpoint shortly after the flood. Photo courtesy of AEP

Above: More of the bench appears some months later.
Photo Jack Tannett

In 2015 the flooded-out section of trail below the falls was re-aligned across the hillside. Eventually a side trail will lead to a new viewpoint and a new memorial bench.

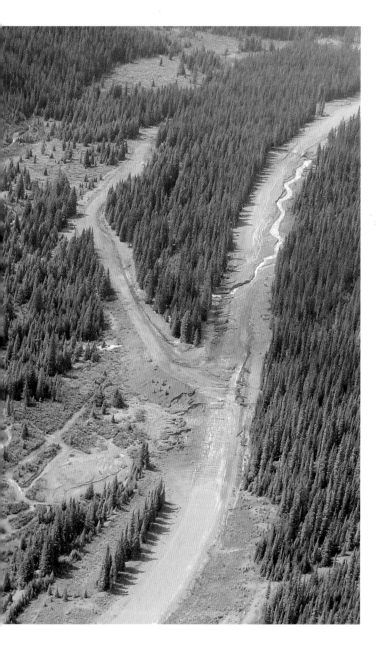

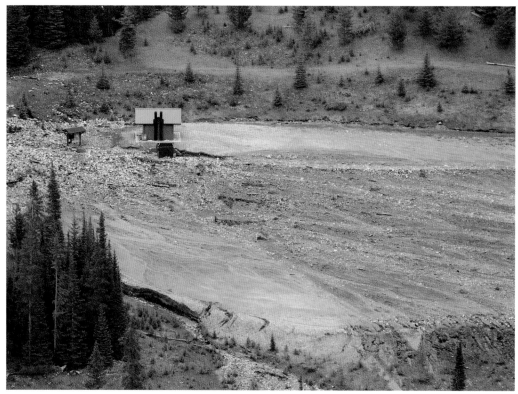

HIGHWAY 742

Left: Aerial view of the highway at the intersection with the decommissioned Ranger Creek day-use area.
Photo courtesy of AEP

Above: The Chester Lake parking lot covered in mud and stones brought down by Chester Creek. The slide forced a reroute of the first section of trail.
Photo Gavin Young, courtesy of the Calgary Herald

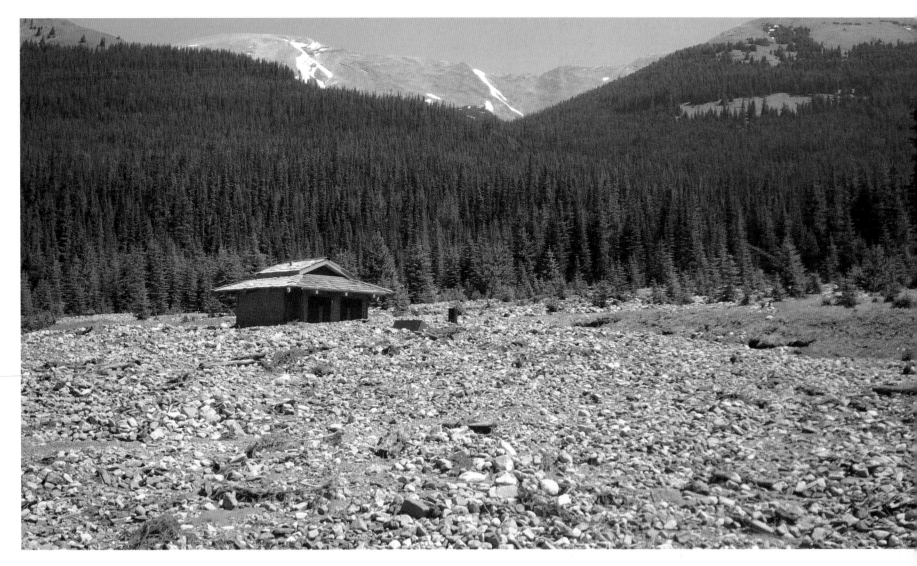

Sawmill parking lot has disappeared under an avalanche of rocks and you certainly can't open the doors to the toilet. Before the year was over the parking lot had been repaired and was ready for the onslaught of winter users. Repairs to nearby trails will be tackled in 2016/17. Photo courtesy of AEP

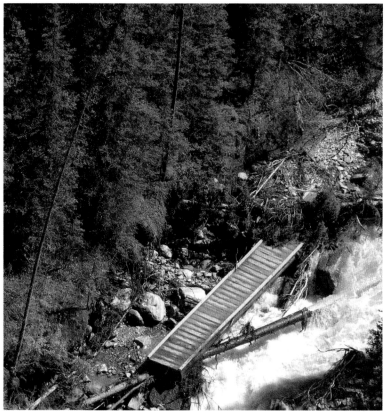

BULLER PASS TRAIL
The first bridge across Buller Creek has been pushed aside.
It was rebuilt in 2015 as part of the High Rockies Trail.
Photo courtesy of AEP

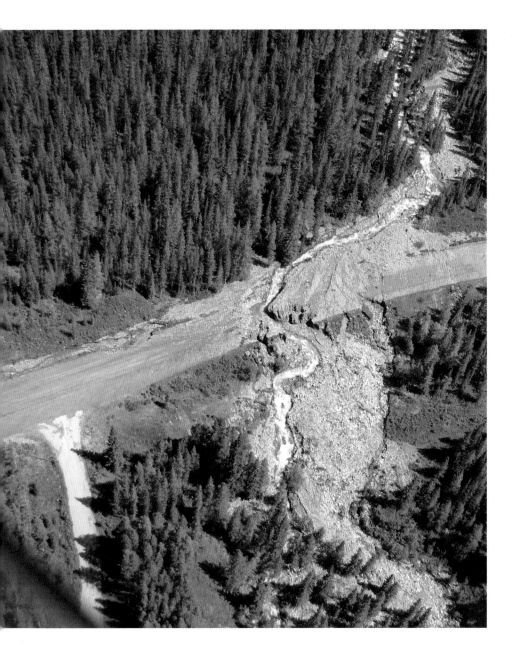

HIGHWAY 742
Left: Red Basin Creek cuts through the highway just south of
Spray Lake day-use area. Photo courtesy of AEP

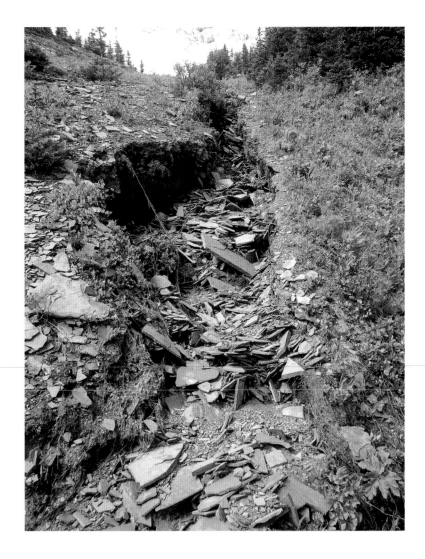

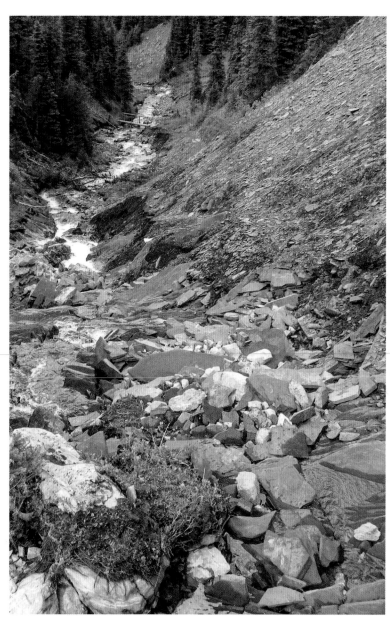

BULLER PASS TRAIL

The trail near Guinns Pass junction has suffered from erosion and slumps, a typical scenario for many other backcountry trails.

Photos courtesy of AEP

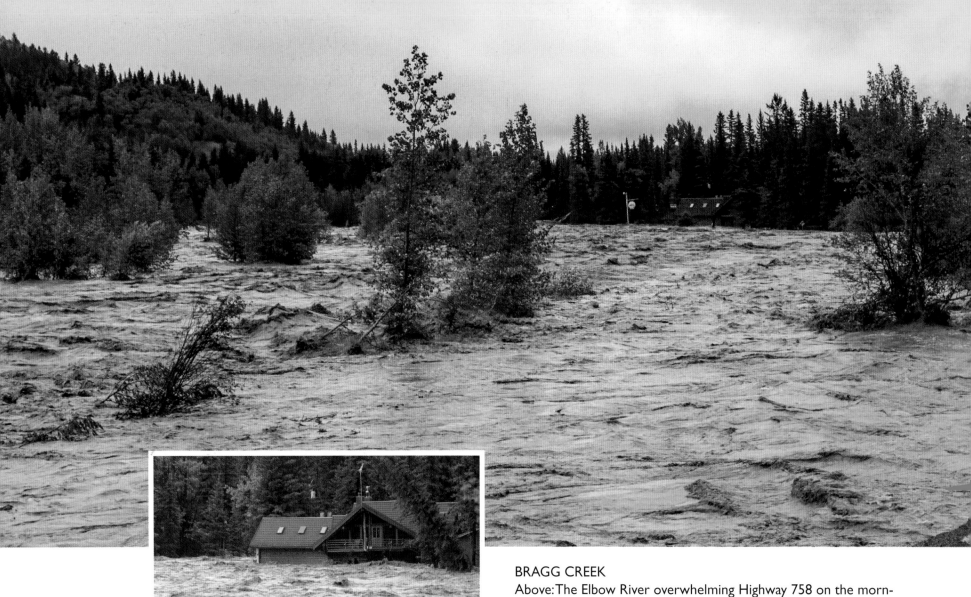

BRAGG CREEK
Above: The Elbow River overwhelming Highway 758 on the morning of the 20th. In the distance is the Bragg Creek Trading Post.
Photo Lynn Myette

Inset: A closeup of Bragg Creek Trading Post with water up to the second floor. Photo Lynn Myette

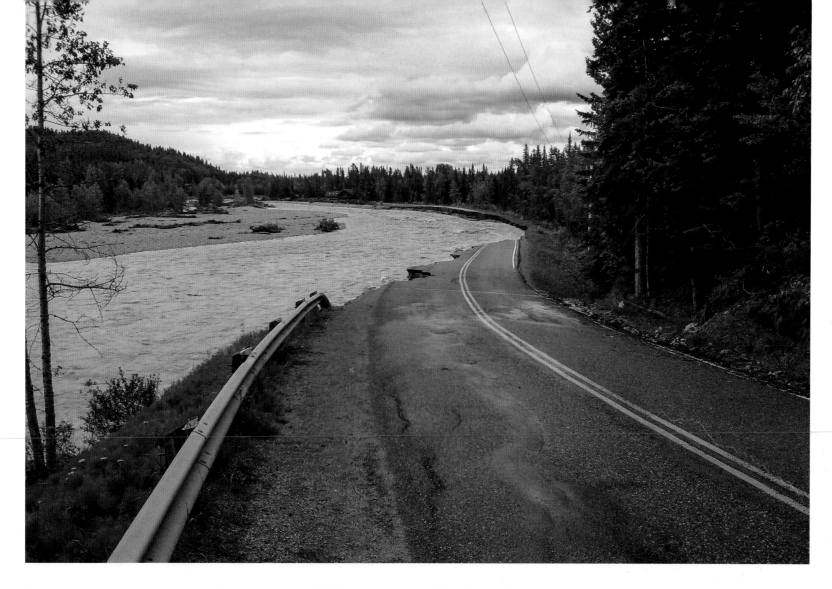

The same scene a few days later. Photo courtesy of AEP

The Elbow River breached its banks at the Bragg Creek Trading Post, the water running along White Avenue and cutting across at several places into downtown Bragg Creek and flooding the shopping centre and businesses lining Balsam Avenue. In all, 1150 people had to be evacuated and 321 homes and businesses were damaged. Some were still not open for business in 2016.

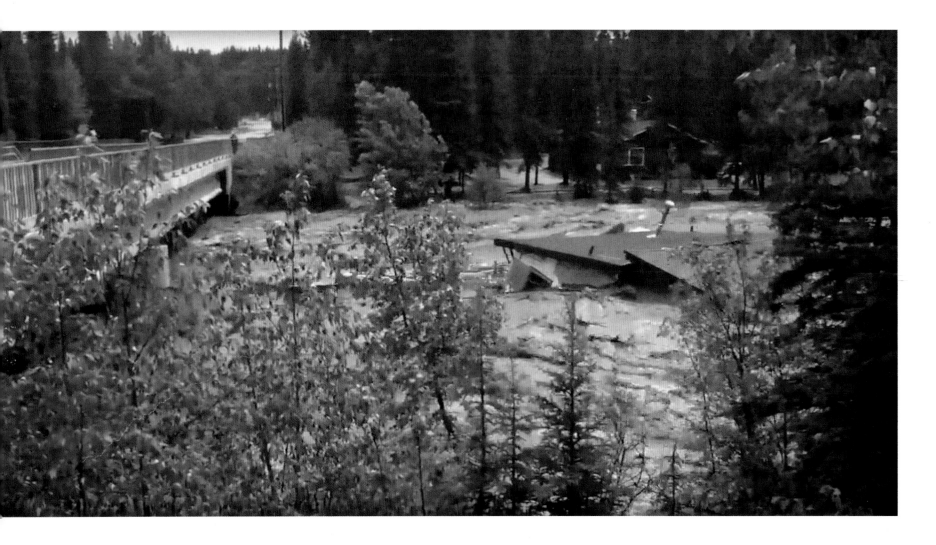

BRAGG CREEK

The famous screen shot of a house floating down the Elbow River towards certain destruction against the Balsam Avenue bridge. Amazingly, the bridge held. Screen shot by Tristan Zaba

Opposite: After the waters receded, this is what the patio looked like at the popular Infusion Restaurant. The restaurant was torn down and the owners moved to Calgary, where they opened up Infusion number two. Photo Allan & Angélique Mandel

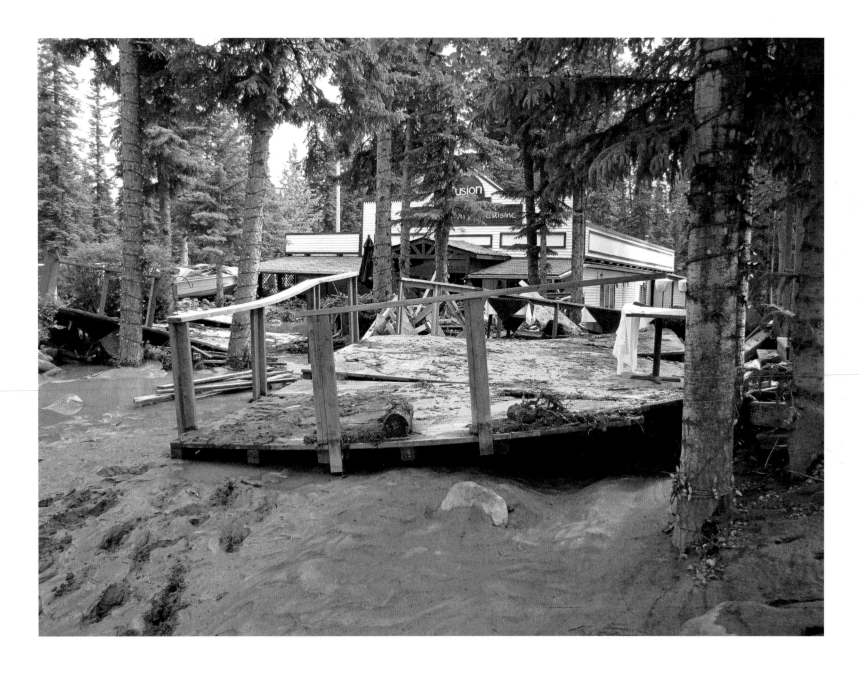

CANYON CREEK

Left top: An angry Canyon Creek washing away the Shell bridge on the morning of the 20th.
Photo Reg Mullet

Left bottom: The repaired Shell bridge in 2015. This is what Canyon "Creek" normally looks like.
Photo Gillean Daffern

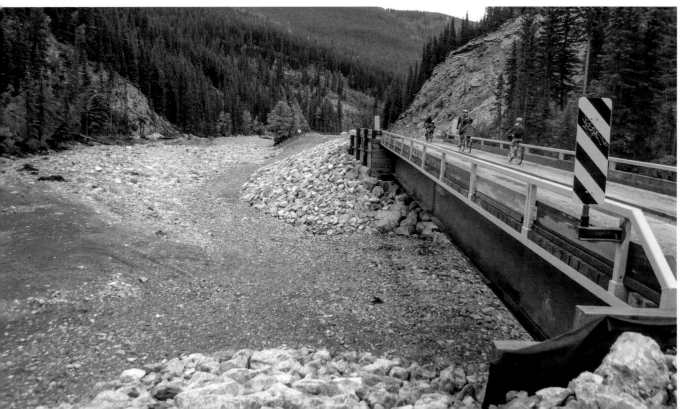

Opposite bottom: The MMBTS bridge over Canyon Creek which is (was) where all the DHS trails on the west side of Moose Mountain Road came together to cross the creek to Canyon Creek Road.
Photo Gillean Daffern

Opposite top: Photo taken from the same place on June 20th. The bridge is gone and water is pouring down T-Dub.
Photo Reg Mullet

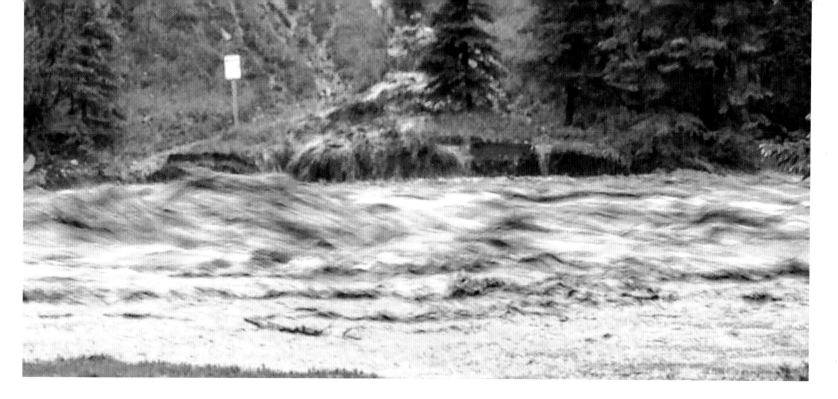

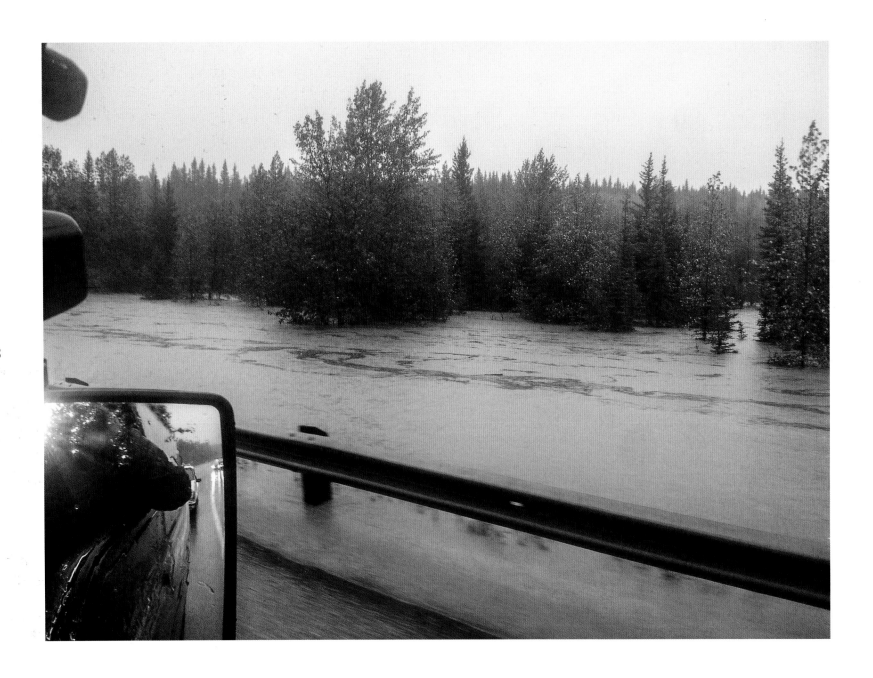

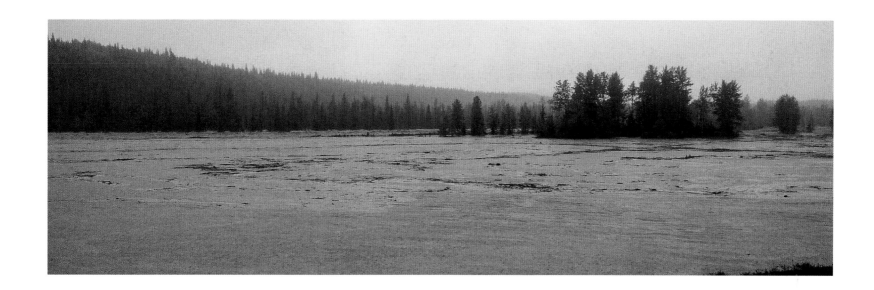

ALLEN BILL POND

Above and opposite: It's the early morning of the 20th and from Highway 66 there is no sign of Allen Bill Pond, or even of the Elbow River, just wall to wall water across the whole valley floor.
Photos Reg Mullet

Right: When the waters went down, the pond had vanished, together with the River Cove group camp access road in the distance. This was not the first time the pond had been wiped out. After the 2005 flood it was resurrected and a berm with riprap built to keep out the river. Unsuccessfully as it turned out. The highway sign now reads "Allen Bill ☐ day-use area."
Photo Gillean Daffern

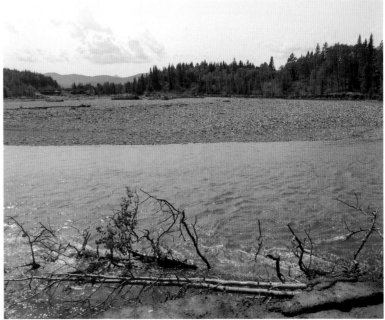

ELBOW/FULLERTON TRAIL

Left: Where has the trail gone? This popular trail from Allen Bill parking lot ends cold turkey in the Elbow River, which had pushed its way north. In 2014/15 the first section of trail was almost completely rebuilt along the banktop. A small section left alongside the river is not safe from future floods and at some point will likely have to be rerouted. Photo Gillean Daffern

Top: The lovely flowery meadow we once crossed has been replaced by a sterile cobble flat and the Elbow River.
Photo Gillean Daffern

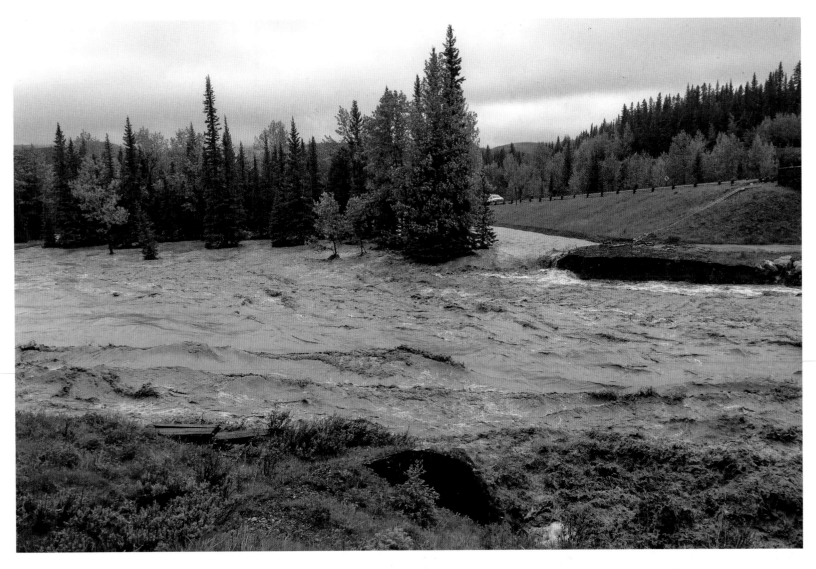

ELBOW RIVER
It's the morning of the 20th and the river is surging along toward the highway bridge on Highway 66. Photo Rob Mueller

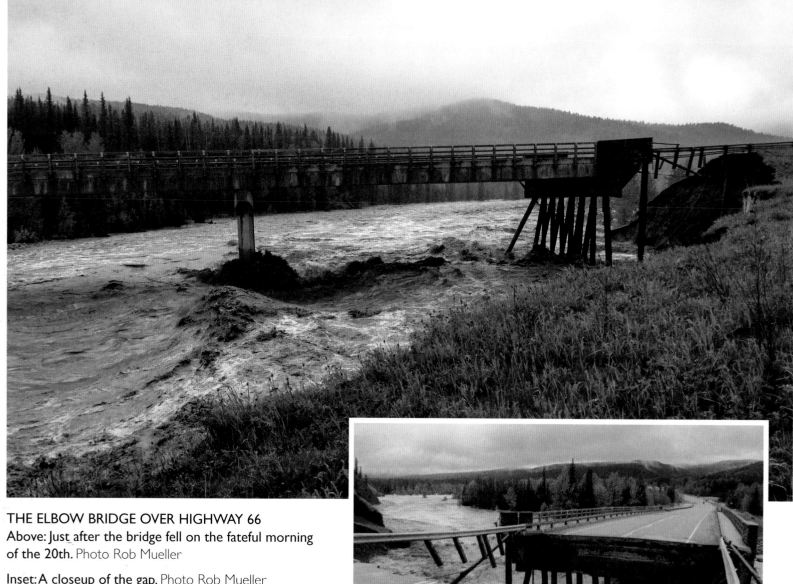

132

THE ELBOW BRIDGE OVER HIGHWAY 66
Above: Just after the bridge fell on the fateful morning
of the 20th. Photo Rob Mueller

Inset: A closeup of the gap. Photo Rob Mueller

Opposite page: After the waters went down, we were
left with a very forlorn-looking bridge. A Bailey bridge
was installed just downstream of it and served for
nearly a year until the bridge was repaired the next
spring. Photo Jack Tannett

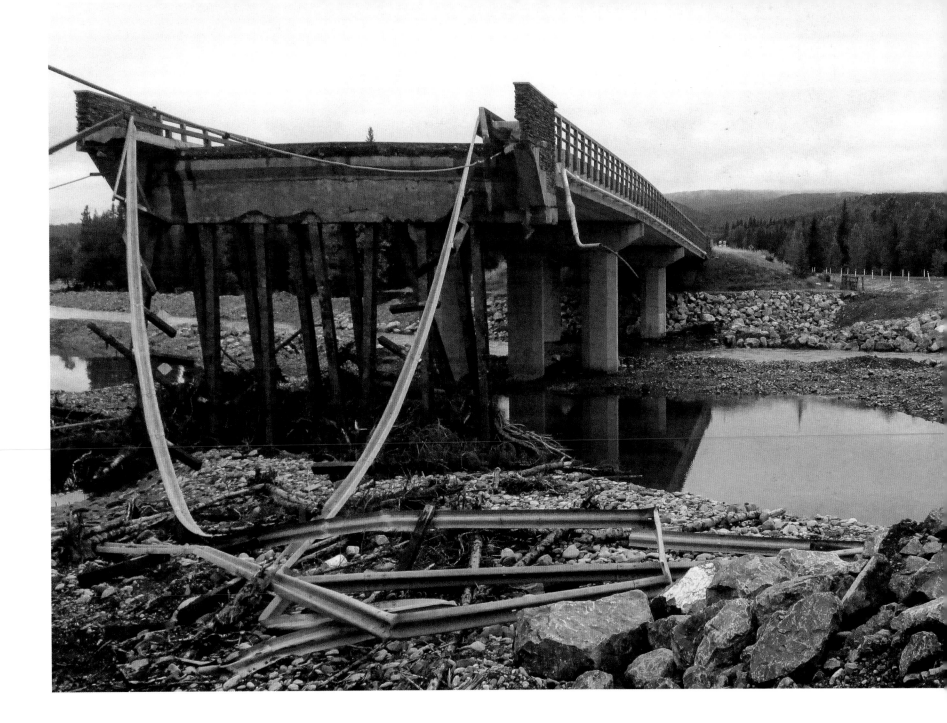

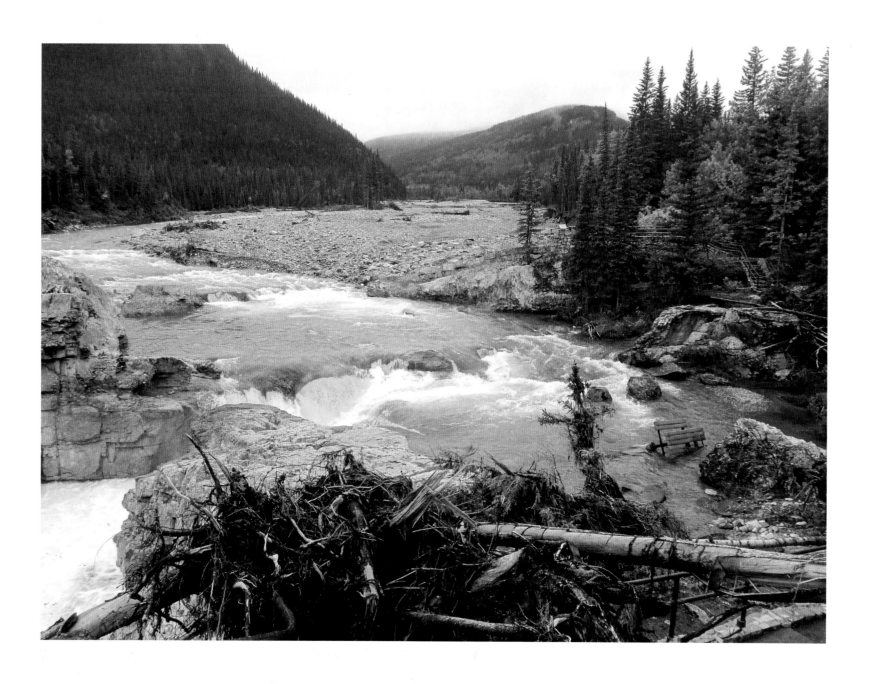

ELBOW FALLS

Right: Elbow Falls on the morning of June 20th was an awesome sight.
Photo courtesy of AEP

Opposite: In the aftermath, note the absence of trees, the height of the debris in the foreground, and the picnic table. Another picnic table was swept over the falls and ended up wedged in the next rapid down, called The Notch, where it remained a hazard for kayakers.
Photo Jack Tannett

It was reckoned that 17,000 sq. m of forested land with trails, picnic tables and fire pits had been washed away or buried under cobbles. The falls themselves were just one third of their original height, the pool at their base filled in with rocks. Kayakers now refer to the falls as a mere ledge.

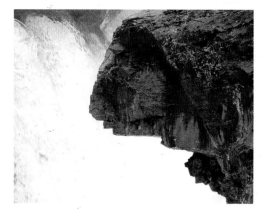

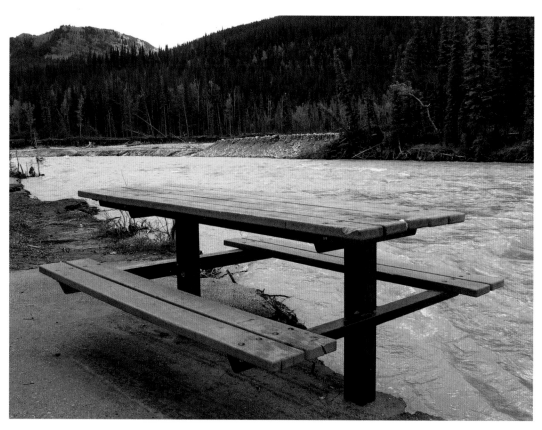

ELBOW FALLS

Above left: Two photos showing the same piece of rock at the side of the falls. Compare the before photo at top with the after photo at bottom. The profile of a face has lost its chin.
Photos Jack Tannett

Above right: A lone picnic table on the edge.
Photo courtesy of AEP

BEAVER FLATS TO COBBLE FLATS TRAIL

Opposite left: A tree wrapped with debris gives some idea of the height of the flood water as it poured out through the canyon.
Photo Gillean Daffern

Opposite right: The water racing round a bend in the canyon dashed high against this face, washing away the trail and leaving behind a vertical wall of unstable till booby-trapped with large boulders. It's hard to believe that this location has twice been touted for a dam. Photo Gillean Daffern

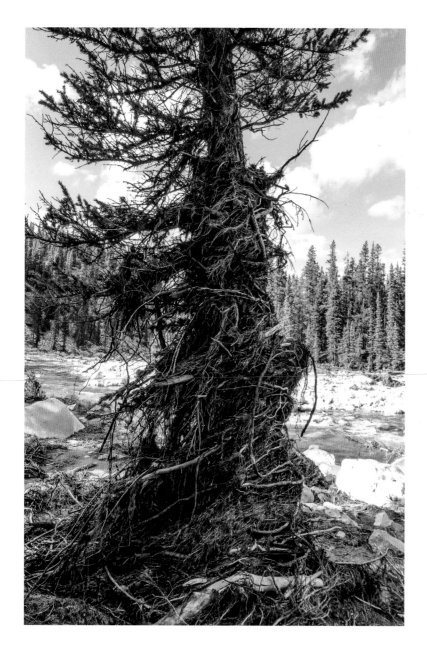

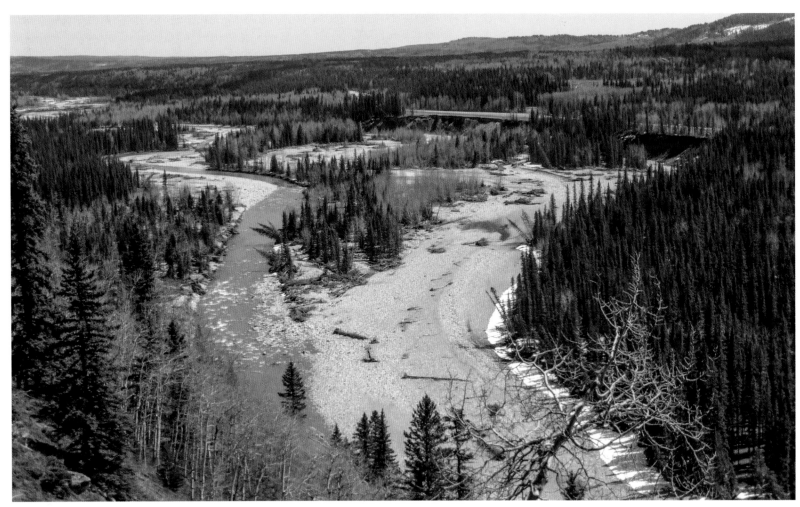

138

ELBOW RIVER
Above: Looking down on the Elbow River from the viewpoint on Snagmore trail. During the flood the river forged a new course — that's the blue water — leaving behind a winding swath of stones to mark the old channel. Photo Gillean Daffern

A QUARTET OF BRIDGES, BEFORE AND AFTER
Opposite left top and bottom: Lusk Pass trail at the crossing of the Jumpingpound's southwest fork. Photos courtesy of AEP

Opposite right top and bottom: Diamond T Loop at Chaarhziya Waptan. Photos courtesy of AEP

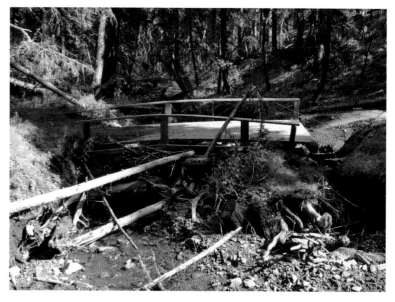

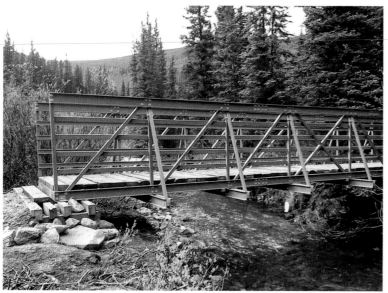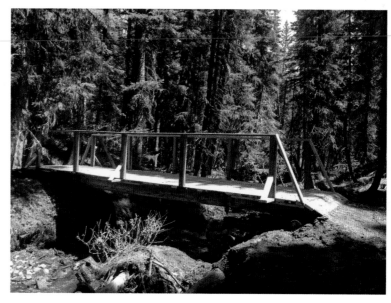

LITTLE ELBOW TRAIL
One of two large chunks taken out of the trail when the Little Elbow River moved left. In 2014, contractors AM MacKay Diversified built bypasses to fire road standard. Photo Gillean Daffern

Opposite: A brand new waterfall on the Little Elbow came about when the river cut through a bend. Conversely, just outside of K Country, Livingstone Creek left Livingstone Falls high and dry when it made a new channel around it. Photo Gillean Daffern

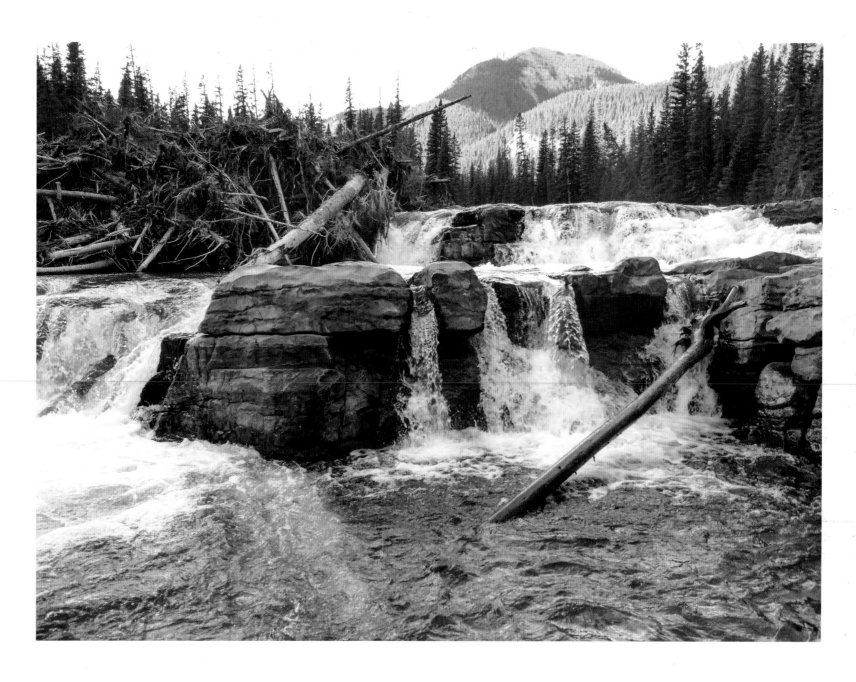

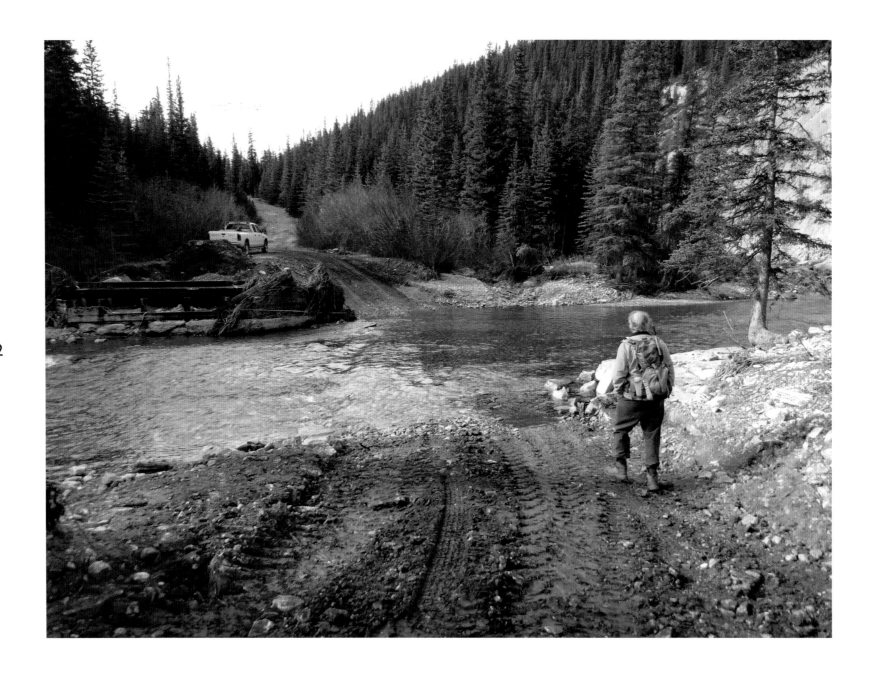

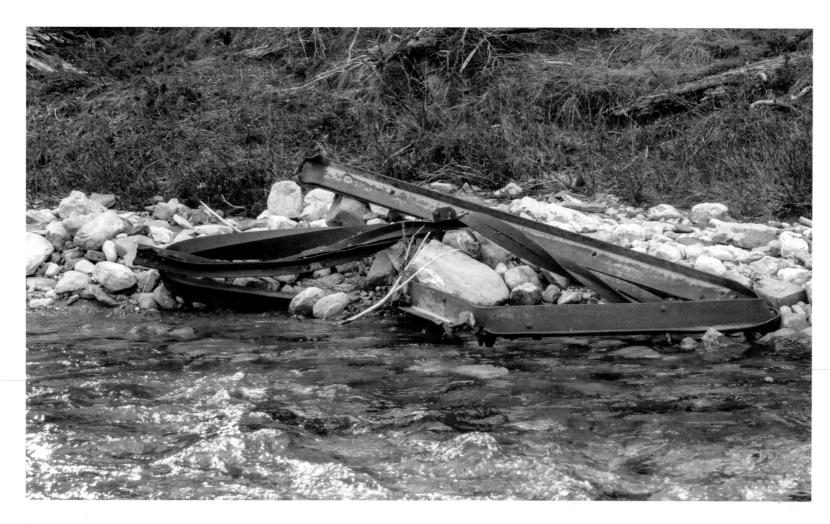

LITTLE ELBOW TRAIL

Opposite: The seemingly impregnable blue steel bridge was swept away by flood water laden with downed trees that acted like battering rams. To get at the trail west of the bridge, the contractors were forced to dump loads of gravel at the crossing place.
Photo Gillean Daffern

Above: Bits and pieces of the bridge can be spotted at various locations downstream between the crossing and the confluence with the Elbow River. Photo Gillean Daffern

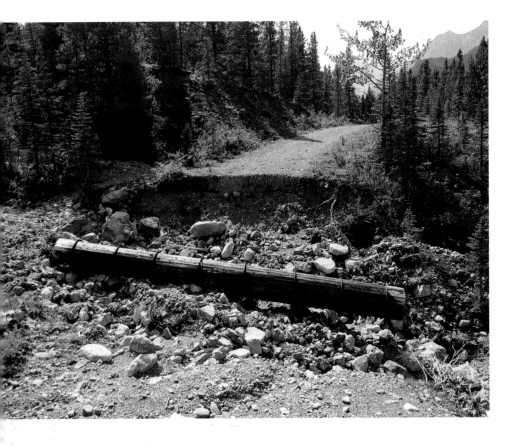

LITTLE ELBOW TRAIL

Above: A washout on the trail between the blue bridge and Mount Romulus backcountry campground. Photo Colin Sproule

Right: One section of the trail between Tombstone Pass and Tombstone backcountry campground was a ditch. Remarkably, this section was restored to fire road condition by the end of 2015. The fire roads along the Elbow and Sheep river valleys still look a little like this. Photo Colin Sproule

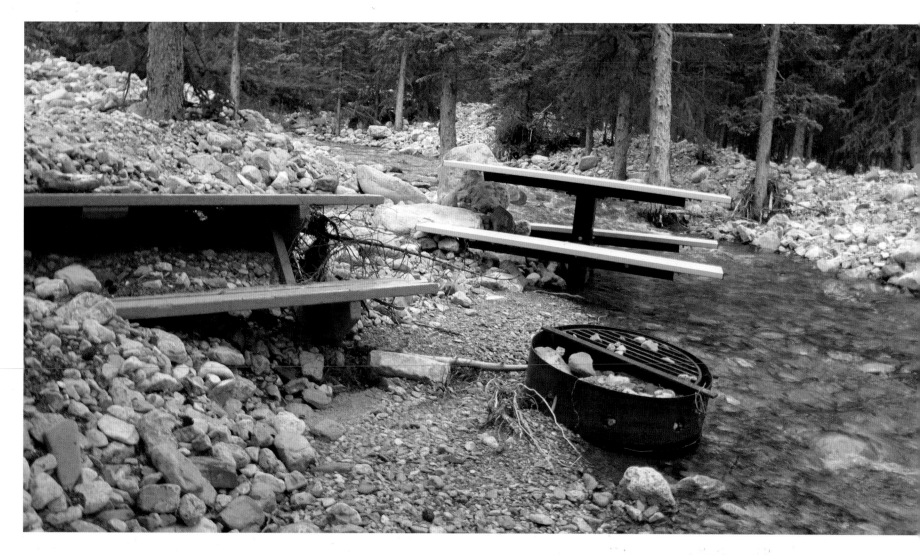

MOUNT ROMULUS BACKCOUNTRY CAMPGROUND
doesn't look quite ready to receive campers. Work started on
repairing it in 2015. Photo courtesy of AEP

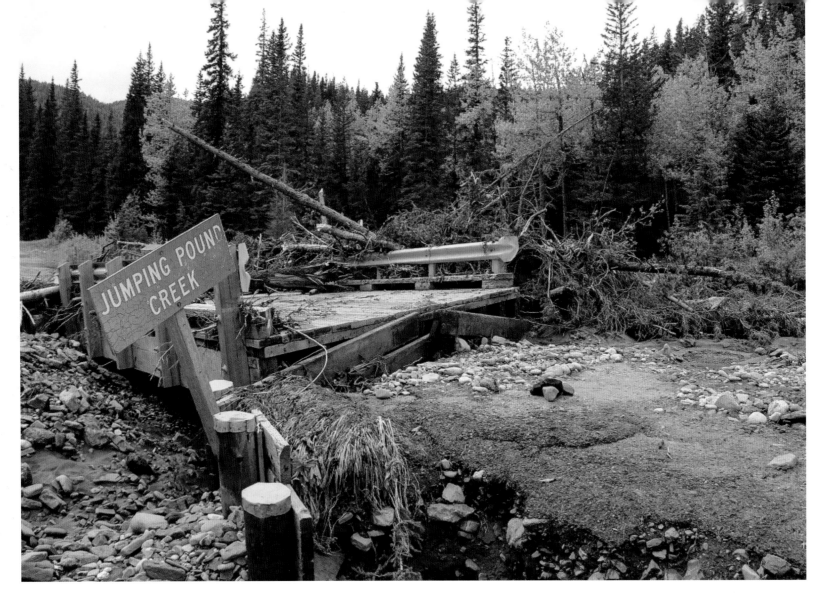

POWDERFACE ROAD
Broken bridge at Jumpingpound Creek crossing is just one of four bridges that had to be replaced. Photo courtesy of AEP

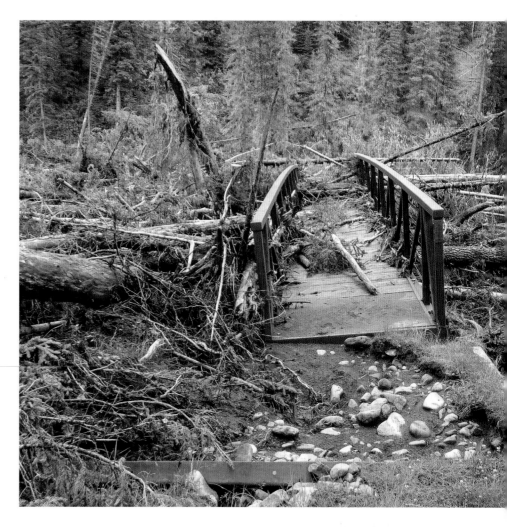

TOM SNOW TRAIL

Successive floods capped by the biggie of 2013 have utterly destroyed much of the Tom Snow trail (aka Trans Canada Trail) in Moose Creek. In 2016 it is due for a substantial reroute onto the ridgetops. Photo Gillean Daffern

The beleaguered footbridge over Jumpingpound Creek connecting Spruce Woods day-use area to the Tom Snow trail has since been removed and will not be replaced. This is the second time a bridge at this location has washed out. Photo Troy Johanson

SANDY McNABB DAY-USE AREA

Below: Silt up to the top of the picnic tables makes them easier to sit on. Photo Gillean Daffern

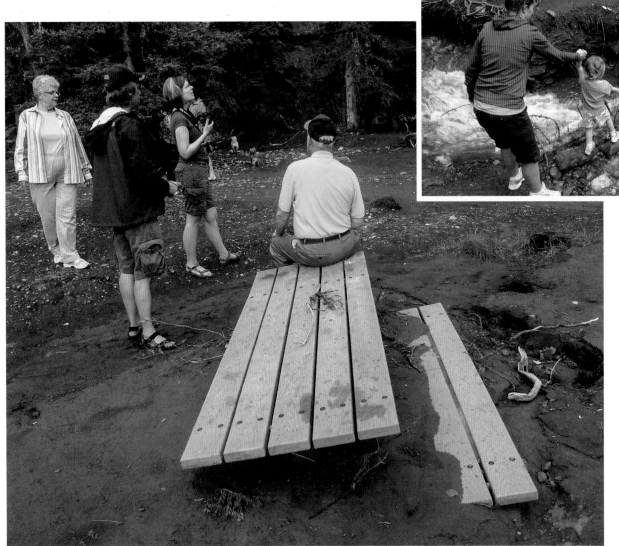

Inset: A determined family finds a way to get to nearby Sheep Falls.
Photo Gillean Daffern

Opposite: The bed of the Sheep River below the damaged access road to Sandy McNabb day-use area has completely changed. The cobble flat and the rapids are all new.
Photo Gillean Daffern

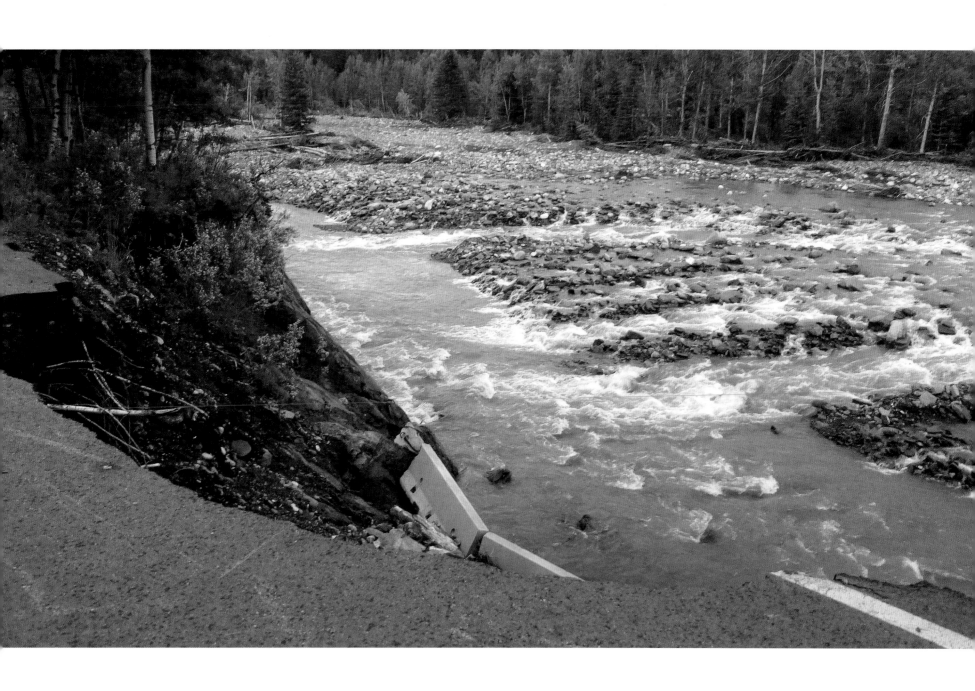

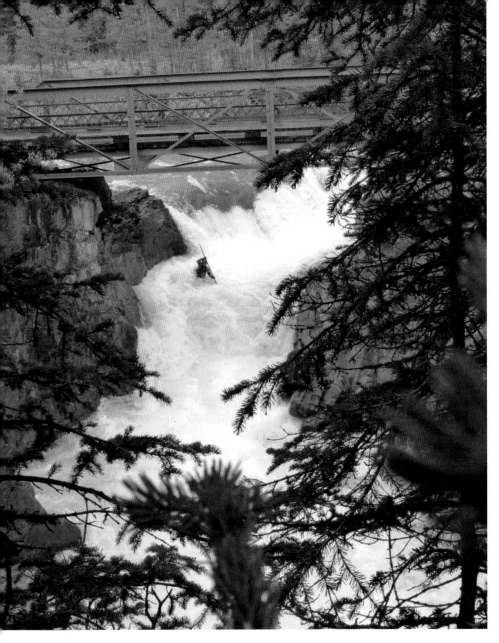

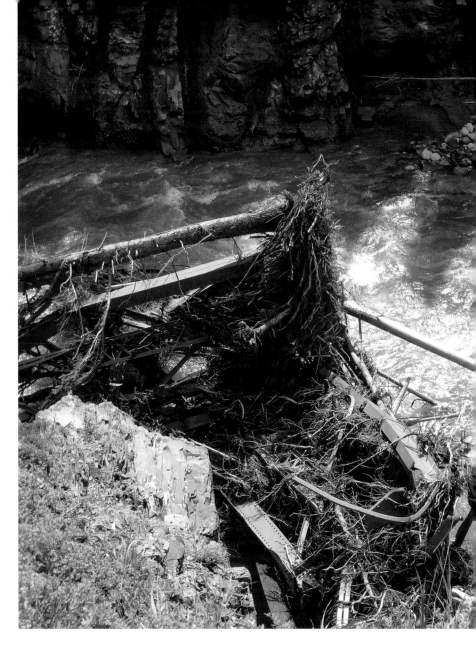

TIGER JAWS FALL, SHEEP RIVER
Pre-flood, the photographer's daughter plays under the steel bridge. Photo Jack Tannett

After the flood, the steel bridge lies wrapped up in trees many bends downriver. Photo Gillean Daffern

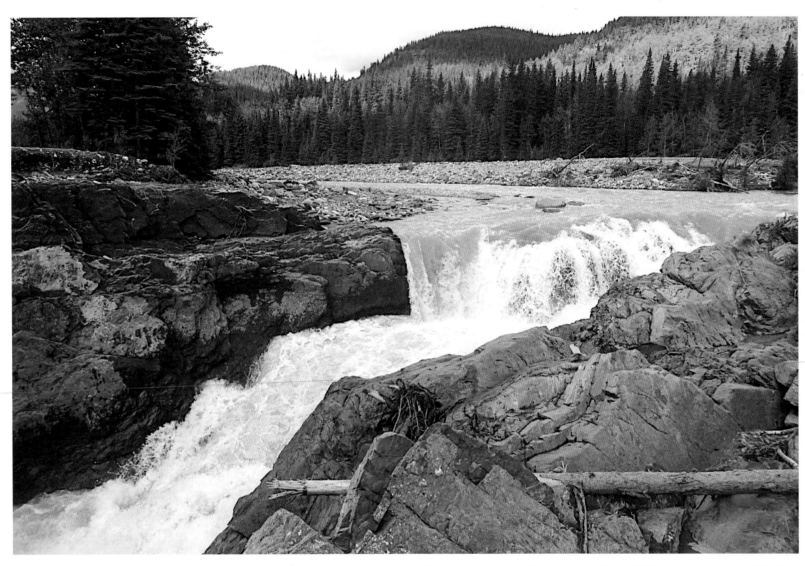

151

The falls without a bridge for the first time in over 60 years. The configuration of the river upstream has also changed with the appearance of a large cobble flat. Photo Alf Skrastins

Farther down the Sheep River, Triple Falls proved unrunnable after rockfall peppered the second drop.

SHEEP TRAIL

Opposite: The bridge over the Sheep River west of Junction Creek day-use area looks rather wobbly after the flood. Photo Calvin Damen

Top: Diverting the river during bridge rebuilding in 2015. This will be the fourth version of a bridge at this site. The first two, Browns Bridge and Burns Bridge, coexisted side by side for a time when the coal mine up the valley was reopened in the 1940s. Photo courtesy of AEP

Right: The new bridge was finished in late November of 2015 just days before Highway 546 closed for the winter. Unfortunately it could be many years before the rest of Sheep trail is restored to its former status.
Photo Joanne Godfrey

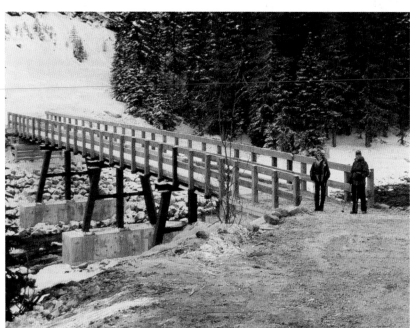

SHEEP TRAIL

Right: The difficulties start only 400 m west of the bridge with a huge washout at a gully crossing. But the hardest-hit part of the trail (aka fire road) is the midsection between Burns Mine and Burns Creek, where the trail is often missing. In this photo the biker is not even sure he is on the trail. Photo Colin Sproule

Below: Changing water courses pour over slight dips in the terrain, creating waterfalls and pools. Photo Colin Sproule

Opposite: Outfitters trail, an alternative route to Sheep trail in the upper valley, took a direct hit from a mud slide off the Rae Creek Hills. Photo Pat Michael

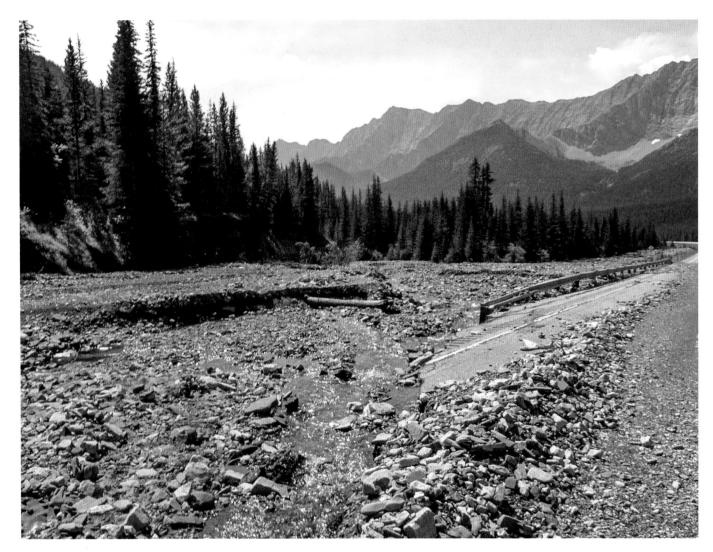

HIGHWAY 40

Above: Just south of Highwood Pass, Storm Creek is making a run for the other side of the highway. Photo Derek Ryder

Opposite: Farther down the highway is an even bigger mess. Photo Derek Ryder

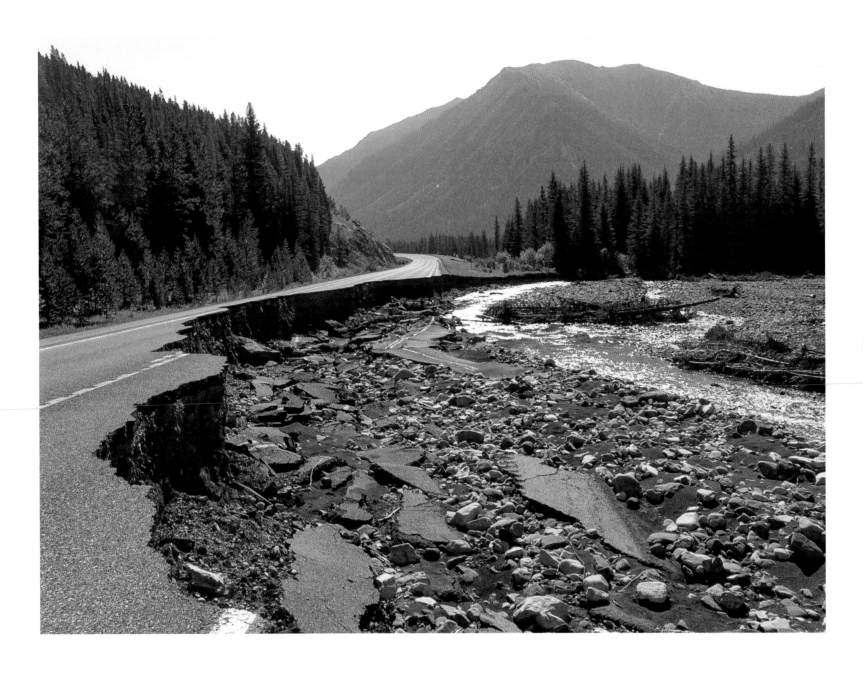

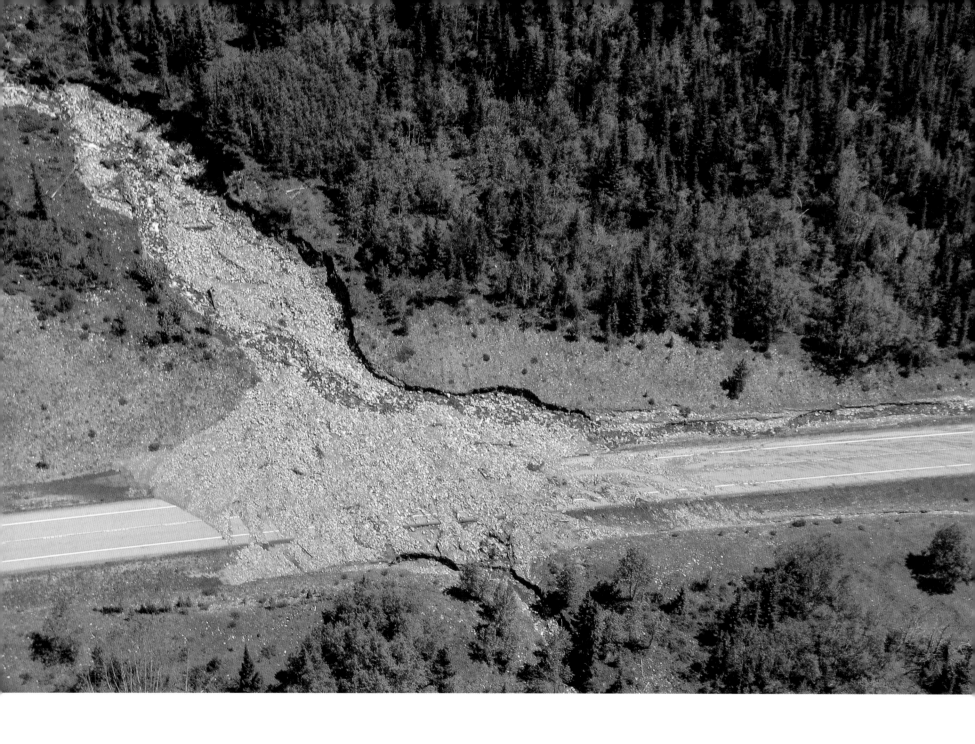

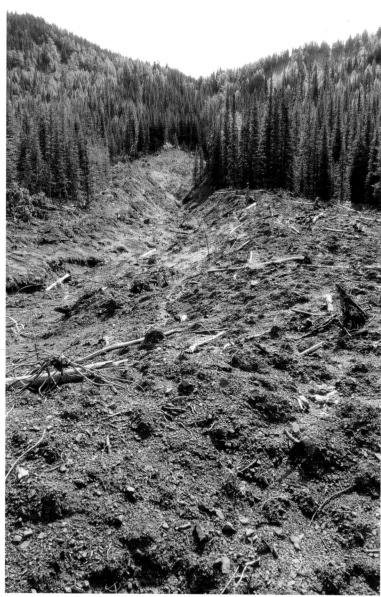

MIST CREEK TRAIL
Above: Just minutes from Mist Creek trailhead the trail comes to a sudden halt above a steep bank. No more trail ahead of you, just the wayward Storm Creek and a huge cobble flat.
Photo Gillean Daffern

RUNNING RAIN LAKE TRAIL
Right: A ridge to creek mud slide buried the trail to this popular fishing lake. Photo Gillean Daffern

HIGHWAY 40
Opposite: Debris flow just south of Lantern Creek day-use area.
Photo courtesy of AEP

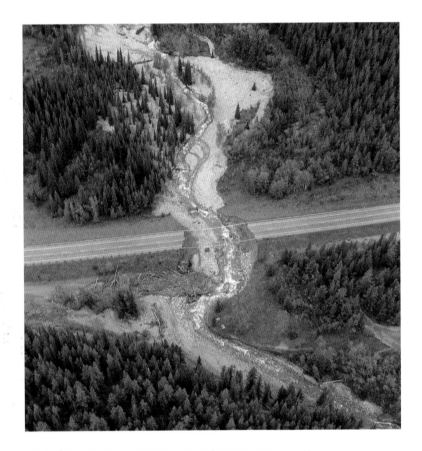

LINEHAM CREEK CROSSING ON HIGHWAY 40

Above: An aerial view of the washout before the Bailey bridge went in and a new connector road was built to the Lineham Creek day-use area access road, seen at bottom right.
Photo courtesy of AEP

Centre: A close-up view of drooping guard rails and failed culverts that were tossed aside willy-nilly by a raging LIneham Creek, which has its headwaters in the Highwood Range.
Photo courtesy of AEP

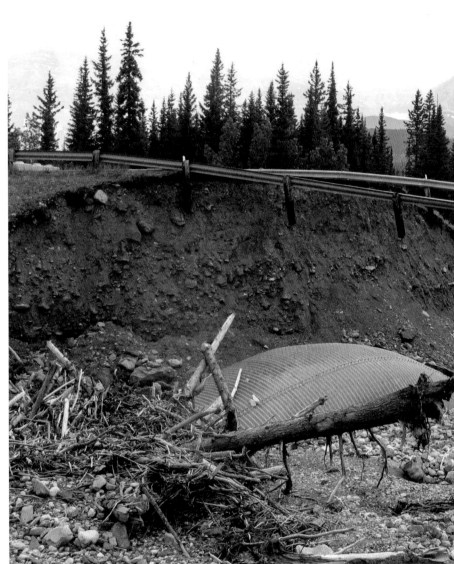

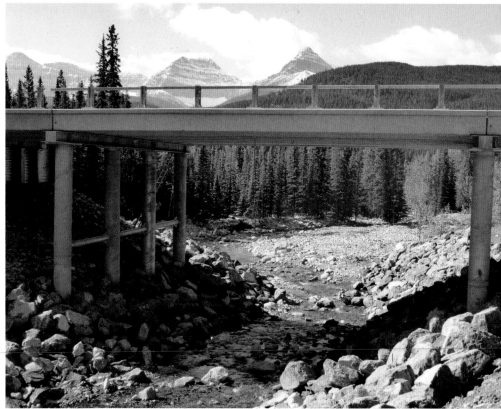

Above: Alberta Transportation decided that rather than use culverts again, a span bridge was the only way to get the highway across the huge gap. The bridge was eventually built in late 2015, with the creek corralled between banks of riprap. Photo Gillean Daffern

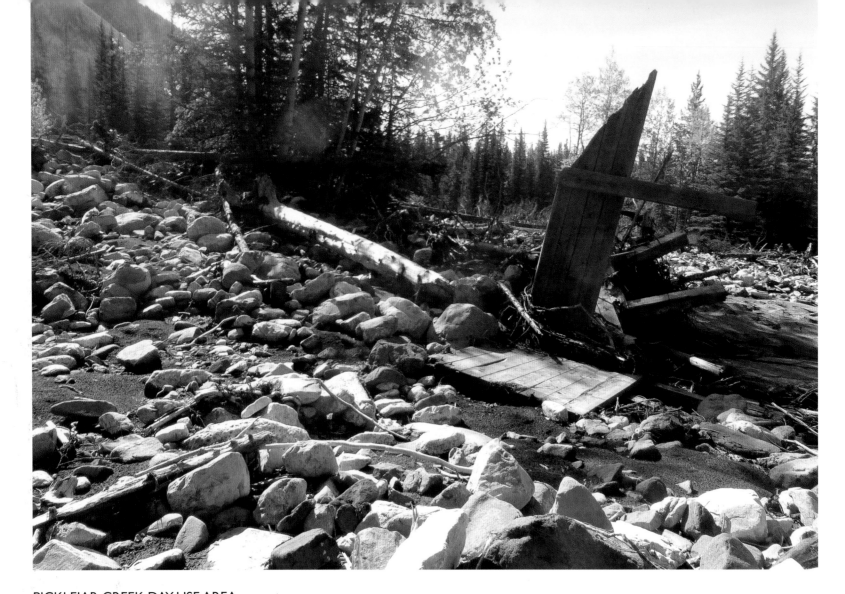

PICKLEJAR CREEK DAY-USE AREA

Above: The day-use area was a disaster zone and will never be rebuilt in the same place. Photo Gillean Daffern

Opposite: The access road was destroyed by water and downed trees driven up from underneath the asphalt.
Photo Gillean Daffern

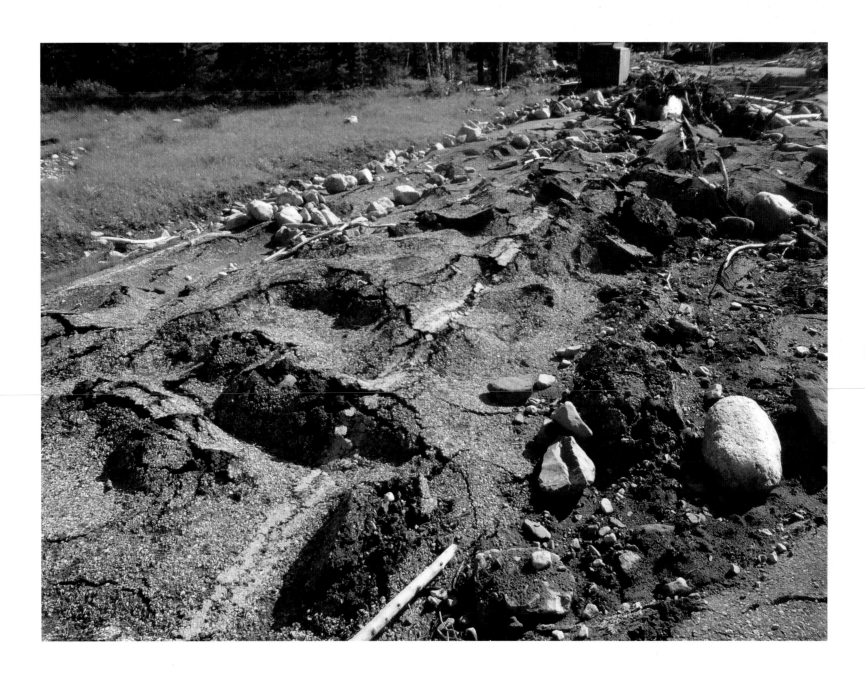

163

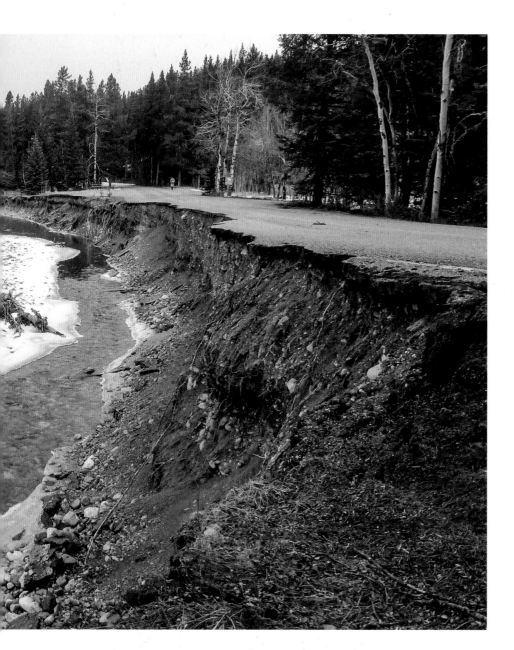

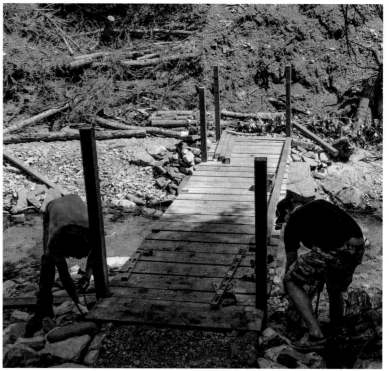

CAT CREEK

Left: The access road into Cat Creek day-use area, also a popular trailhead used by hikers and outfitters, is badly eroded by the Highwood River. A reroute will have to be made sometime in 2016 or 2017. Photo Gillean Daffern

Above: Putting in the first of two new bridges on Cat Creek interpretive trail. Photo Gillean Daffern

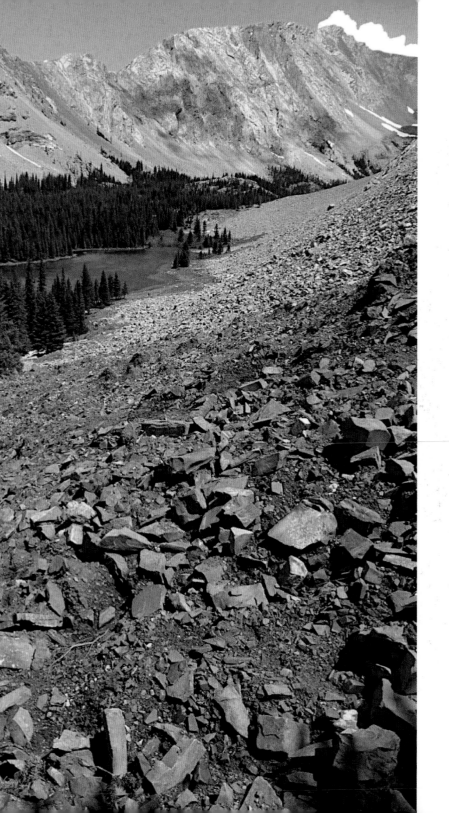

PICKLEJAR LAKES
A slide of rocks and mud ran across the trail down to First Lake. Hikers have since been able to forge a decent trail across it.
Photo Alf Skrastins

165

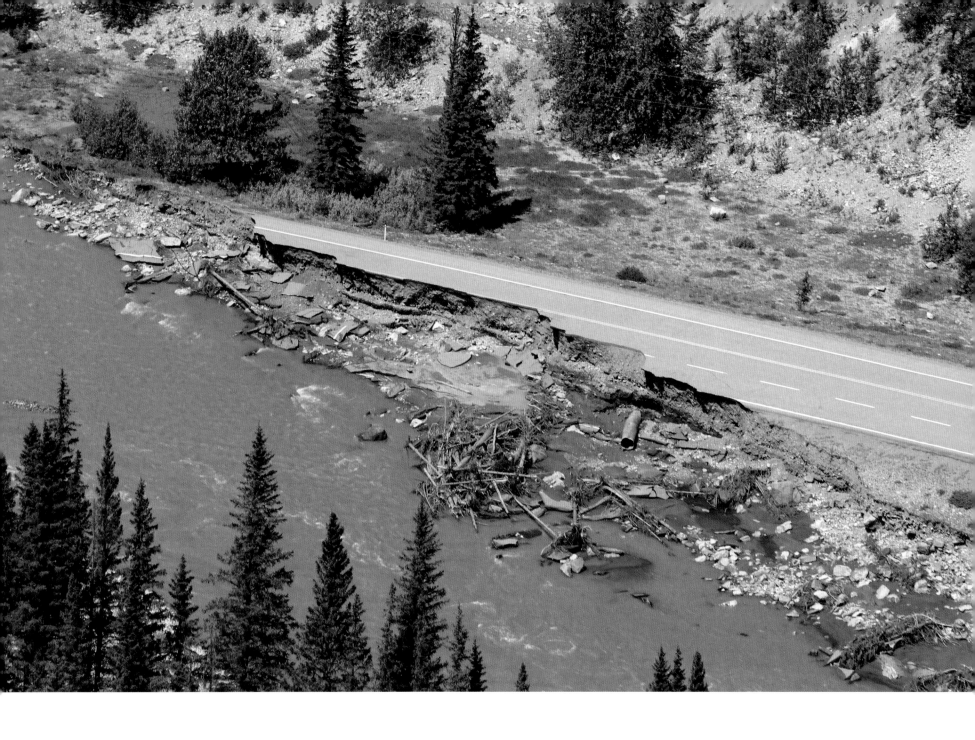

HIGHWAY 541 AT GUNNERY GRADE

Right: Aerial view of the missing highway at Gunnery Grade. There was a reason why the old-timers built the original road higher up the hillside. Photo courtesy of AEP

Opposite: A close-in view of the washout. The line of the old road can be seen at the top right.
Photo Gavin Young, courtesy of the Calgary Herald

Below: The newly repaired road ready to wash out in the next big flood. Photo Jack Tannett

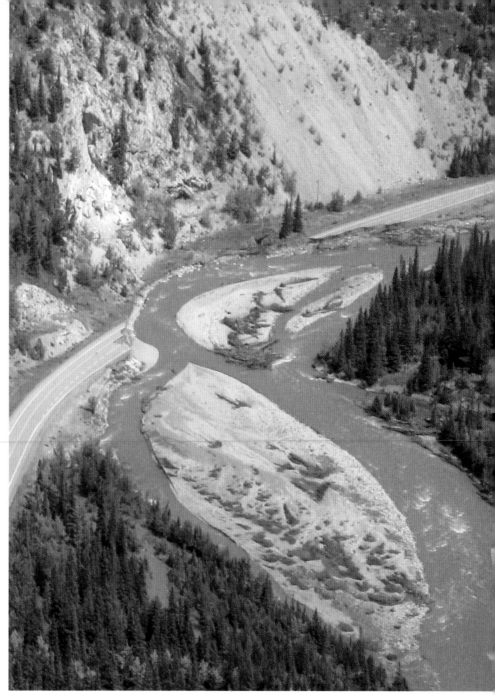

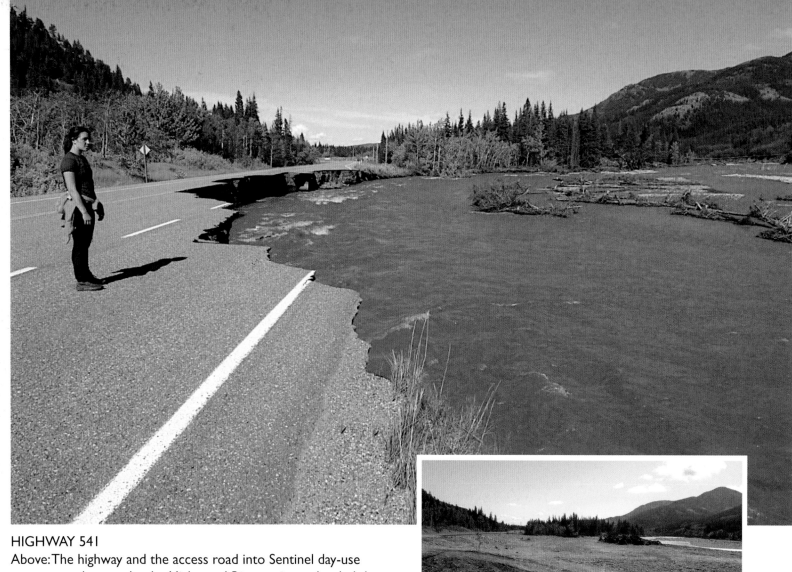

HIGHWAY 541

Above: The highway and the access road into Sentinel day-use area were taken out by the Highwood River as it quadrupled the width of its bed. Photo Alf Skrastins

Inset: Retreating waters revealed a mega cobble flat that's become a temporary parking area until a new trailhead is built sometime in the future. Photo Gillean Daffern

HIGHWOOD HOUSE

Below: Silt surrounds Highwood House at the junction of highways 40, 940 and 541. The building may look untouched, but water pouring into the basement delayed the opening to 2015.
Photo courtesy of AEP

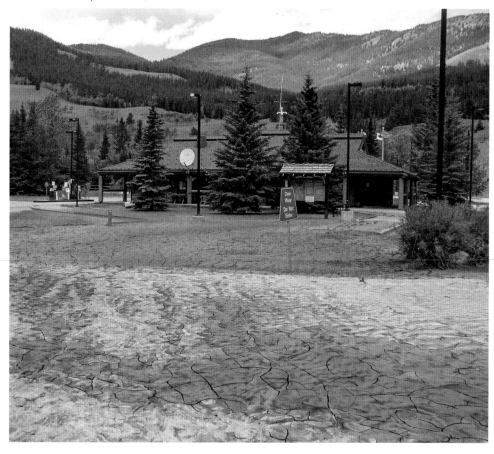

GREAT DIVIDE TRAIL

Right: Like many other creeks, Baril Creek changed course and made the original two-log bridge redundant. Photo Gillean Daffern

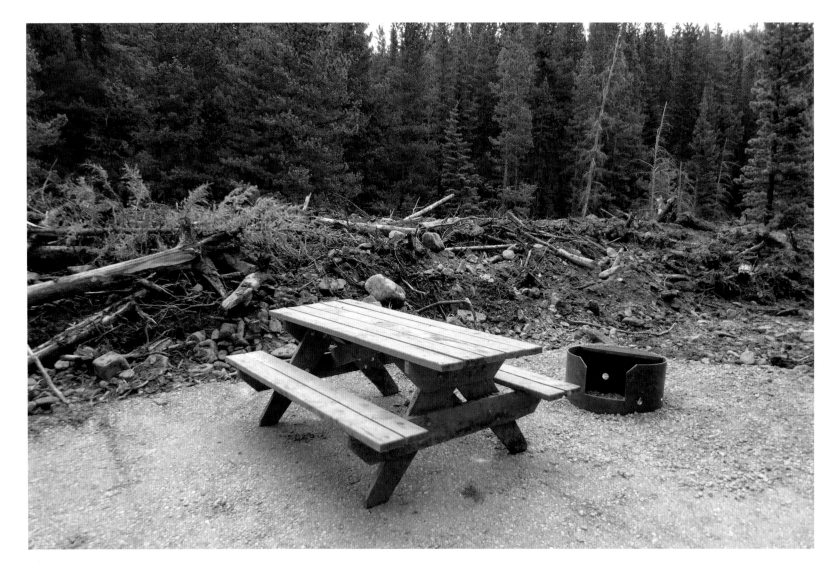

ETHERINGTON CREEK
Though open, Loop A of Etherington Creek Campground is not as pretty as it once was. Photo Gillean Daffern

Opposite: Much of Etherington Creek trail was taken over by the creek. In 2015 the Calgary Snowmobile Club helped AEP build a bypass around the worst of it. Photo Gillean Daffern

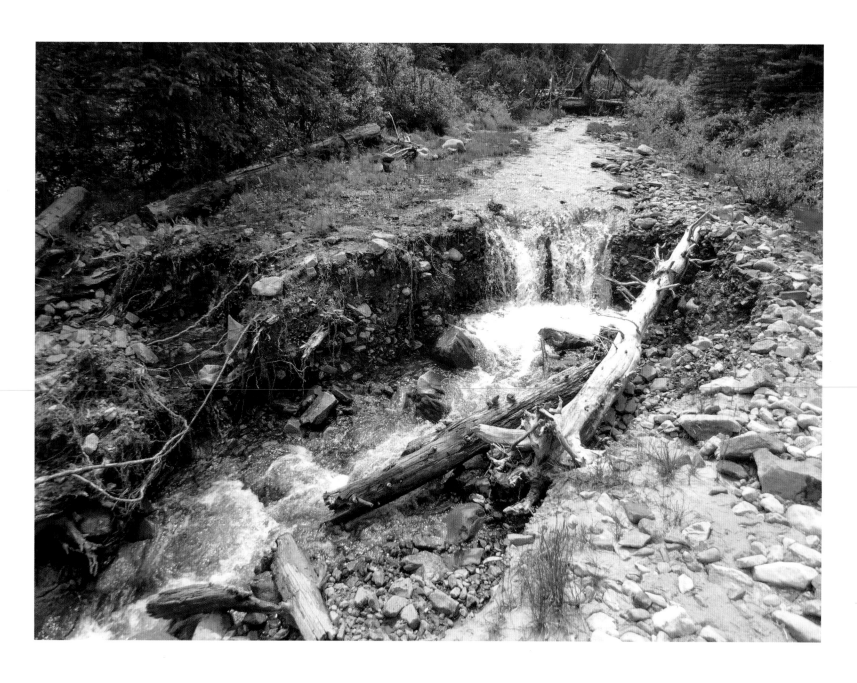

THE LOST CREEK LOGGING ROAD IN CATARACT CREEK

Below left: The road was badly damaged for a stretch of 4 km, with much of the surface ground down to bedrock and stones and awash in water. This photo shows a deep fissure that opened up on the way down from Highway 940. As you can see, the gap was bridged rather precariously by a piece of plywood. Photo Gillean Daffern

Below right: The heavy-duty 2 km bridge was pushed aside onto the far bank like it was a plastic plaything. Interestingly, the 1 km snowmobile bridge across Cataract Creek was untouched when the creek moved south. For two years it sat high and dry on top of stones until it saw new duty spanning a side creek on the new logging road. Photo Gillean Daffern

Opposite: The 3 km bridge, wrapped with tree debris, was not reusable. Photo Gillean Daffern

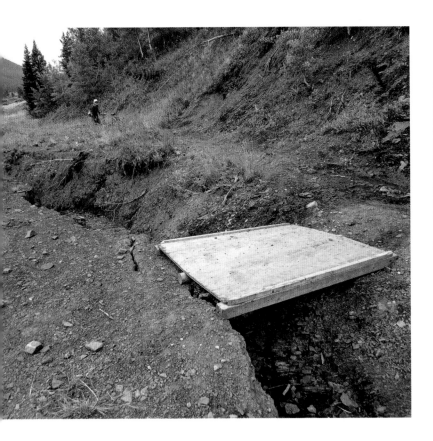

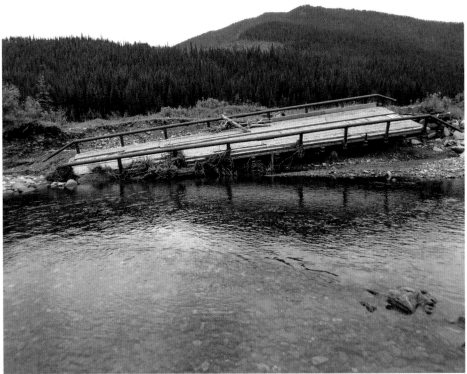

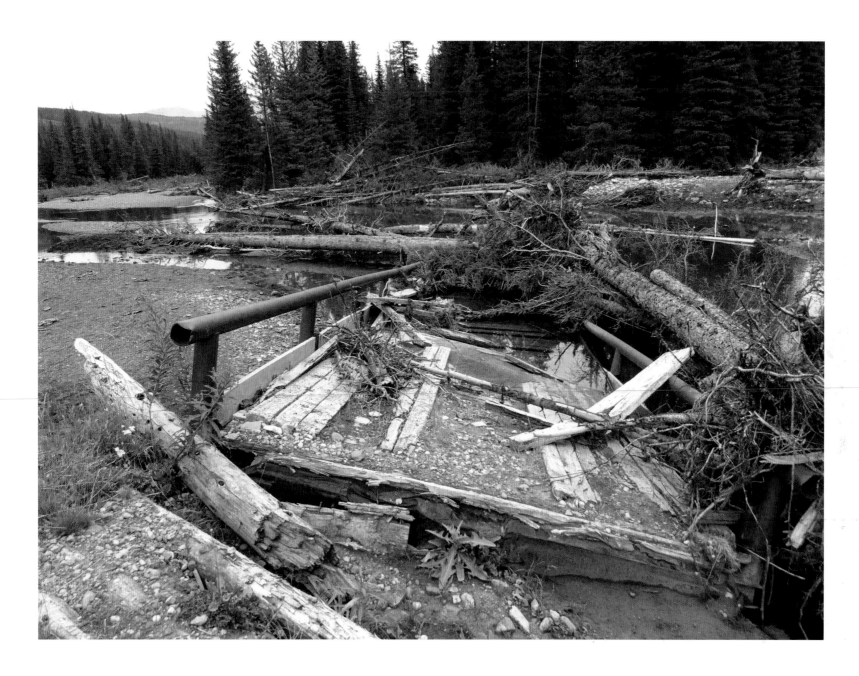

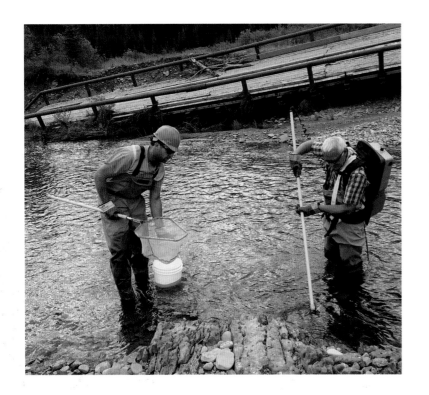

THE LOST CREEK LOGGING ROAD IN CATARACT CREEK

Opposite: Removing the 2 km bridge (seen here) and the 3 km bridge upstream was a lengthy affair even after gaining the necessary approvals. Working with an environmental consultant, SLS cordoned off the river upstream and downstream of the work area, then used an electric shocker to find fish and remove them downstream. Oil-rig mats were laid down to protect the riverbed before the rollers went in, and sandbags were installed to make a berm between the bridge and the creek, the idea being to stop sediment from flowing into the creek. A turbidity gauge was placed in the water to measure the sediment. If the level got too high, pumps were at the ready to pump it out, though that never happened. Photo Dan LaFleur

174

Above and left: Removing fish from the work area.
Photos Dan LaFleur

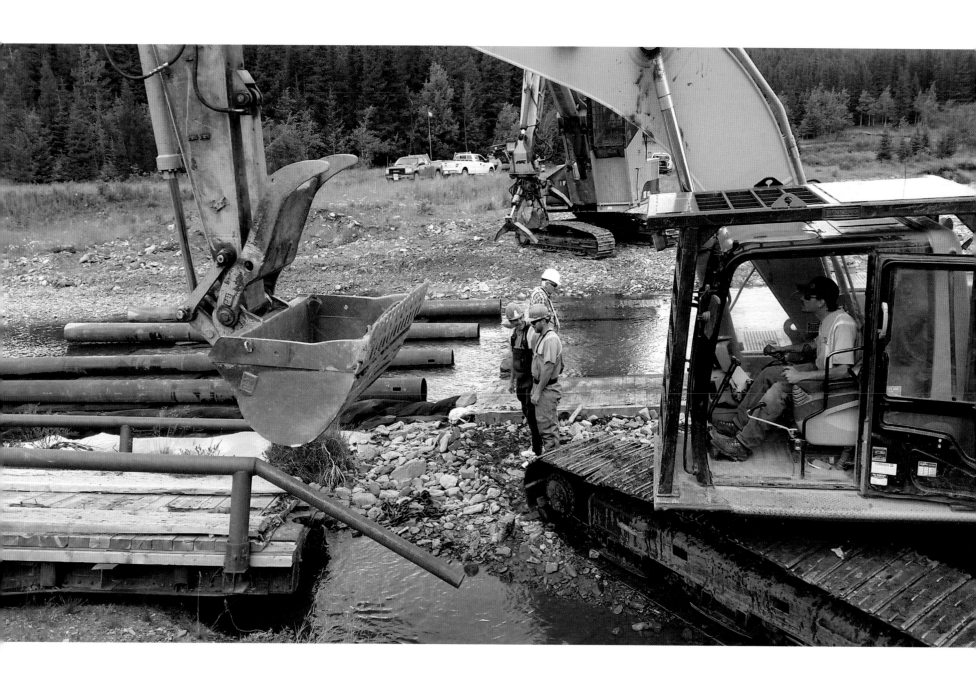

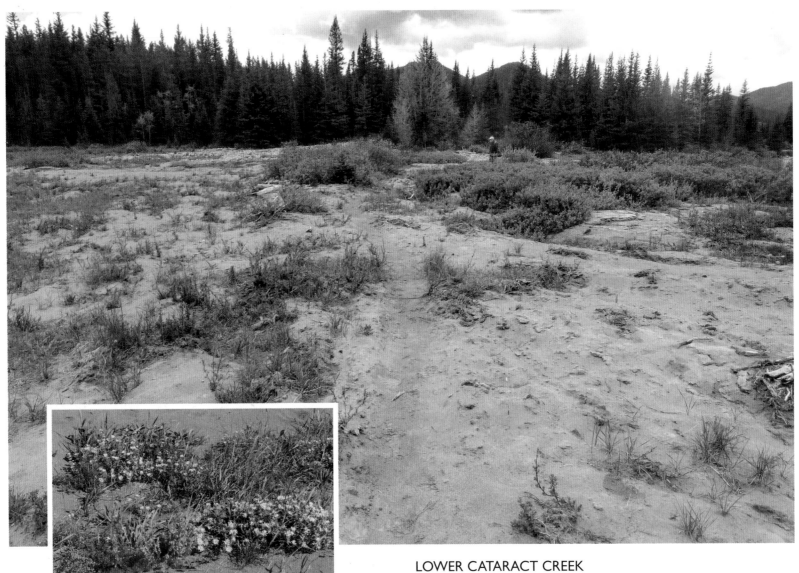

LOWER CATARACT CREEK
Sand, another by-product of the flood, created beaches up to half
a kilometre away from the creek. Photo Gillean Daffern

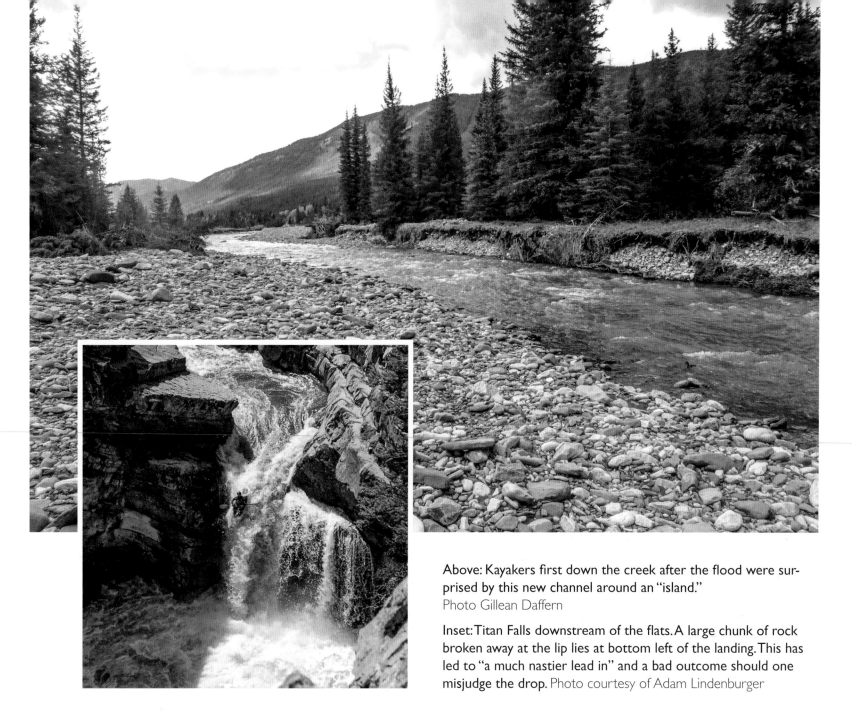

Above: Kayakers first down the creek after the flood were surprised by this new channel around an "island."
Photo Gillean Daffern

Inset: Titan Falls downstream of the flats. A large chunk of rock broken away at the lip lies at bottom left of the landing. This has led to "a much nastier lead in" and a bad outcome should one misjudge the drop. Photo courtesy of Adam Lindenburger

SALTER CREEK TRAIL
The old pack trail was covered by rock slides discharged from gullies off Mount Burke. Photo Gillean Daffern

Opposite: Who wants to clamber through this mess? Not us. Hikers bound for Mount Burke hastily made a reroute onto the ridge above. Photo Gillean Daffern

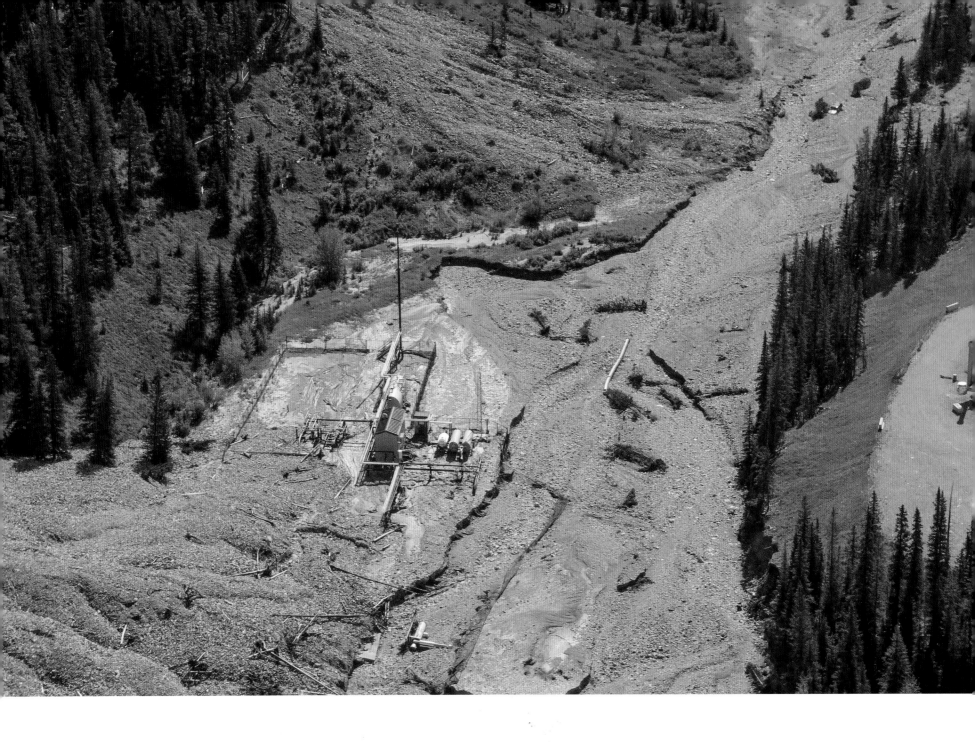

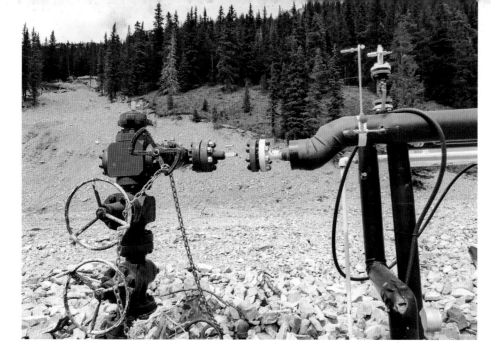

Left: One slide almost scored a direct hit on Direct Energy's installation. In this photo the red sour gas Christmas Tree has had its flowline disconnected. Out of sight at the bottom edge of the photo is a tree that nearly collided with the casing.
Photo Gillean Daffern

Below: Another view of the slide, showing the telemetry tower, the gas measurement skid and the SKADA communications building.
Photo Gillean Daffern

WILKINSON SUMMIT AT HIGHWAY 940
Opposite: Aerial view showing the complete decimation of the highway when rock slides came pounding down off Plateau Mountain. Remarkably, Direct Energy's measurement and SKADA communications building along the sour gas pipeline system suffered only minor damage.
Photo Dan LaFleur

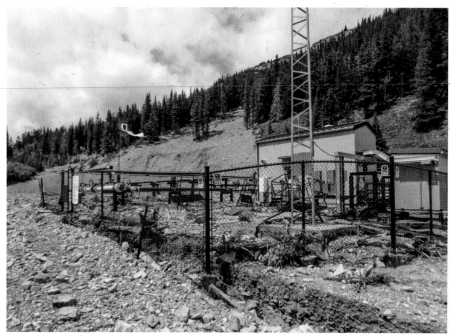

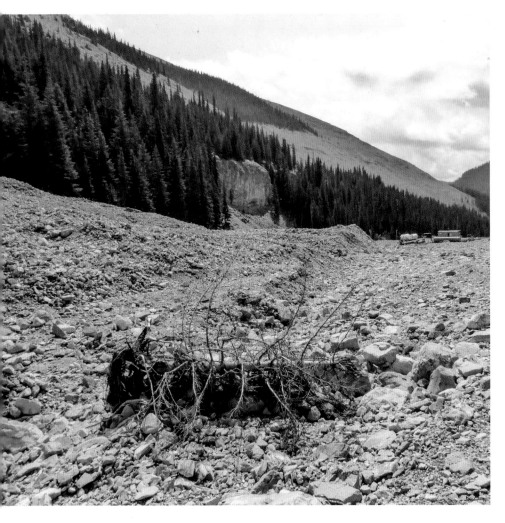

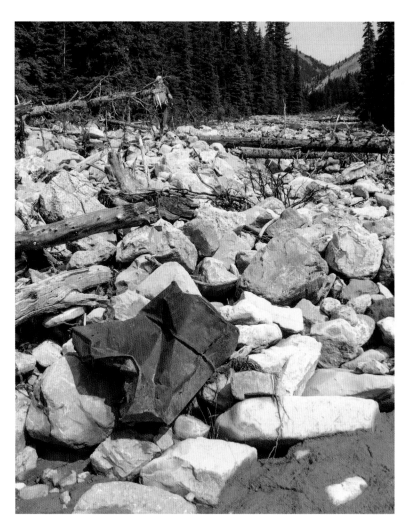

DRY CREEK

Above left: A rock slide off the top of Plateau Mountain hit a glancing blow to Direct Energy's gas metering station, situated like a sitting duck below the gully in the valley bottom.
Photo Gillean Daffern

Above right: The first well drilled in the valley was dry, hence the name of the creek which is also dry for most of the year. So it was startling to find the resource access road a churned-up jumble of rocks and trees. Photo Gillean Daffern

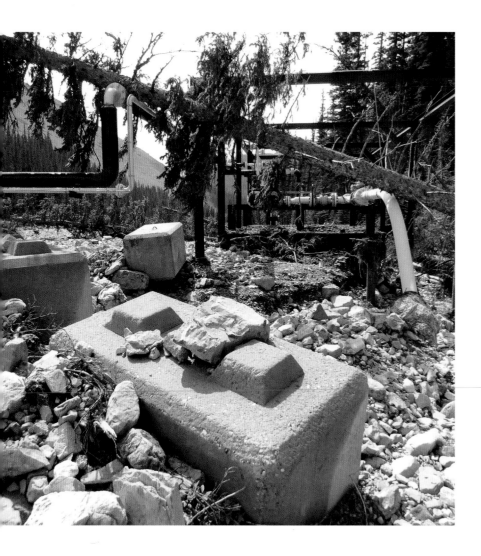

Above and right: The gas metering station, propane tank and communications building escaped damage, though elsewhere were broken pipelines and concrete blocks moved around like they were Lego. Photos Gillean Daffern

When the mixture of flood water and rocks broke this pipe, and before the automatic shut-off valve could be activated, hydrogen sulphide gas spewed out of the break and, losing pressure and temperature, congealed into what we know as sulphur.

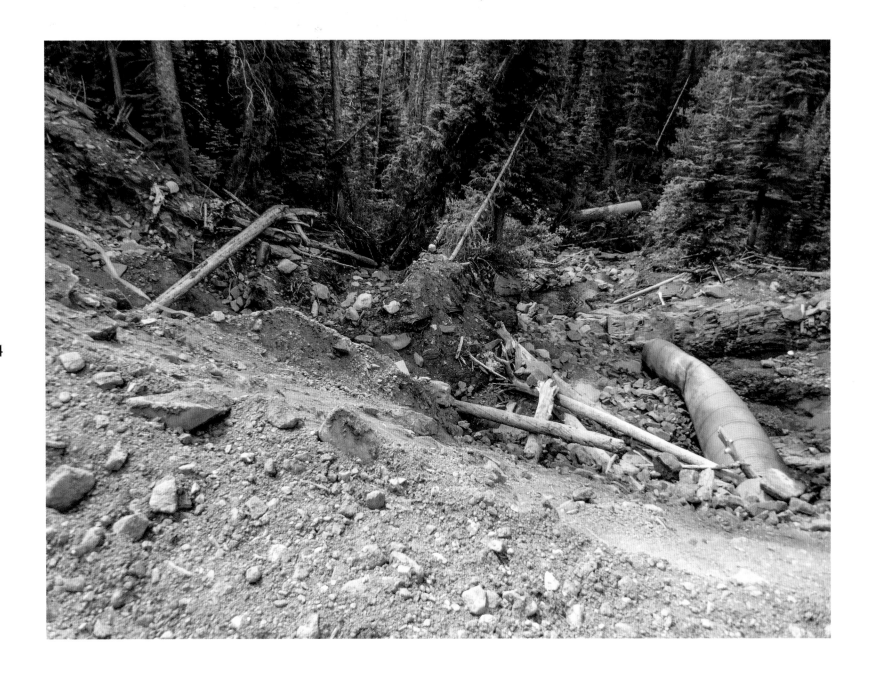

HIGHWAY 940
Opposite: Even the most innocuous of streams between Etherington Creek and Cataract Creek campgounds caused havoc to the highway at culvert crossings.
Photo Gillean Daffern

HAILSTONE BUTTE LOOKOUT
Right: En route to the lookout from Highway 940 you follow this well access road. Water overflowing Livingstone Creek (out of sight to the left) has eroded both sides of the road, leaving just a narrow arête in the middle for tightrope biking.
Photo Gillean Daffern

185

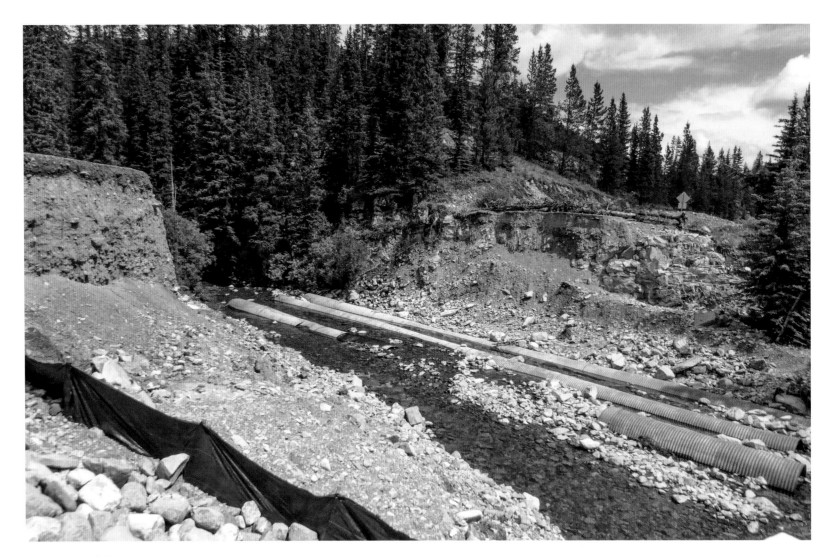

HIGHWAY 940
Tiny Livingstone Creek took out the road over three culverts near the junction with Highway 532. A Bailey bridge installed downstream kept traffic flowing. Photo Gillean Daffern

Opposite: Hard to believe this is the same spot: a brand new bridge with a span of 23 m, built in 2015.
Photo courtesy of Alberta Transportation

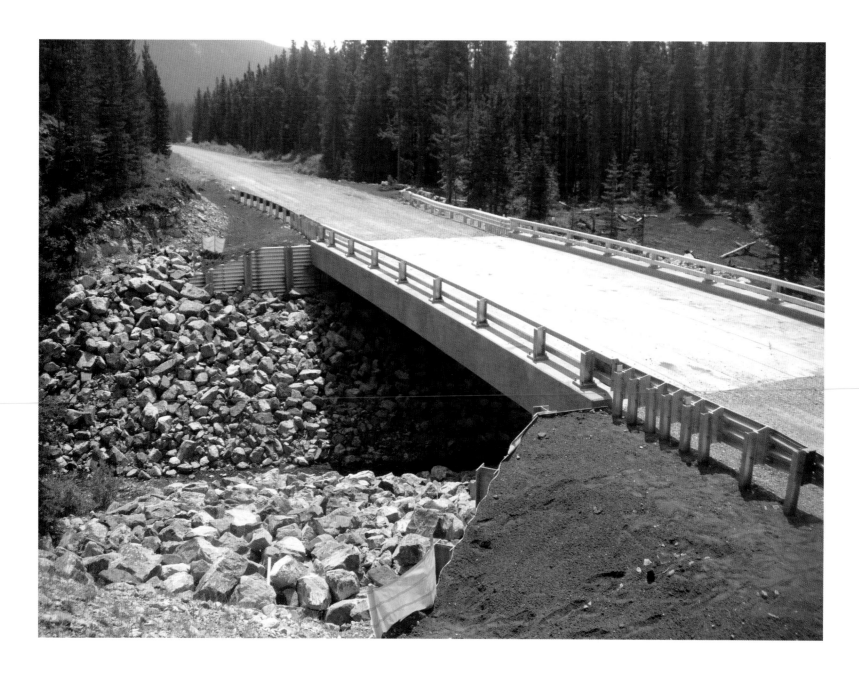

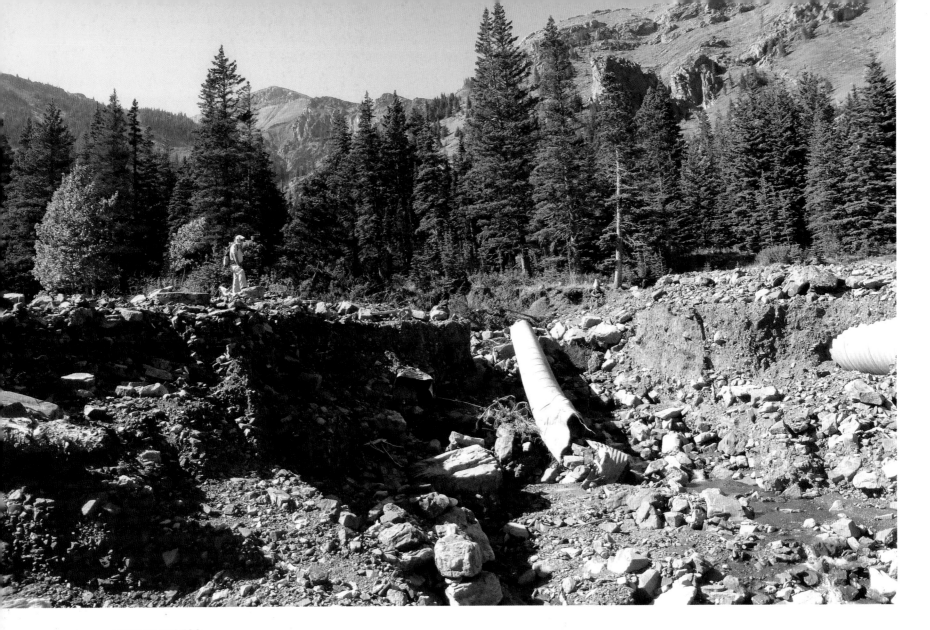

HIGHWAY 532
Above: Below Hailstone Butte, the tiny creek running out of Skeen Canyon created havoc at the big bend—only the first of six major washouts. Photo Gillean Daffern

Opposite: Johnson Creek's north fork has cut the road in two. Photo Gillean Daffern

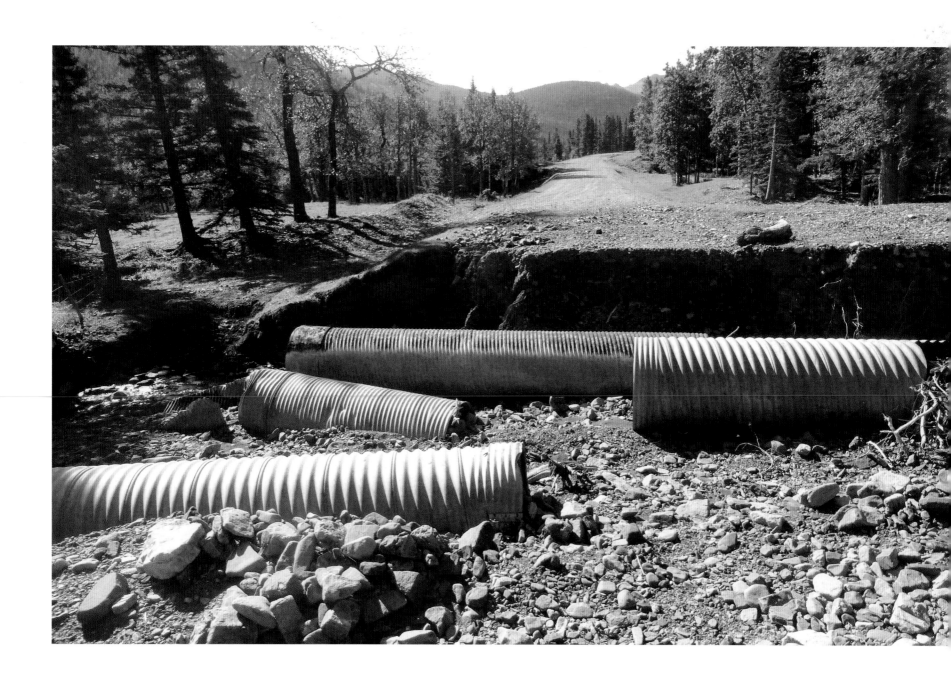

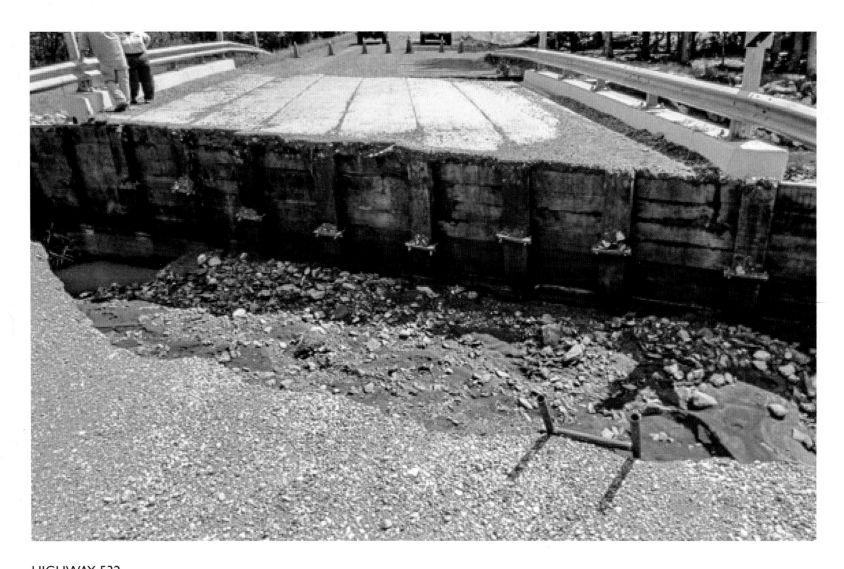

HIGHWAY 532

A ladder proved handy for getting from one side to the other over Willow Creek bridge. Photo Riny de Jonge

Opposite: Johnson Creek took a big bite out of Highway 532 near Indian Graves Campground. Photo Riny de Jonge

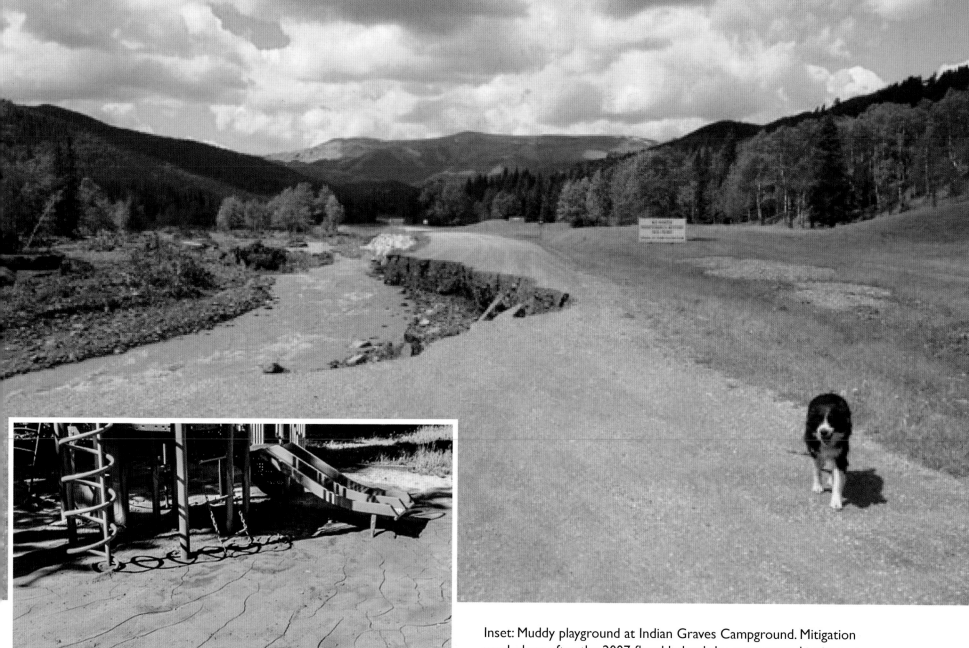

Inset: Muddy playground at Indian Graves Campground. Mitigation work done after the 2007 flood helped the campground escape more serious damage this time around. Photo Riny de Jonge

RMB | Rocky Mountain Books Ltd.
rmbooks.com
@rmbooks
facebook.com/rmbooks

Cataloguing data available from Library and Archives Canada
ISBN 978-1-77160-158-0 (paperback)

Printed and bound in China by 1010 Printing International Ltd.

Distributed in Canada by Heritage Group Distribution and in the U.S. by Publishers Group West

For information on purchasing bulk quantities of this book, or to obtain media excerpts or invite the author to speak at an event, please visit rmbooks.com and select the "Contact Us" tab.

We acknowledge the financial support of the Government of Canada through the Canada Book Fund and the Canada Council for the Arts, and of the province of British Columbia through the British Columbia Arts Council and the Book Publishing Tax Credit.

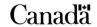

Canada Council
for the Arts
Conseil des arts
du Canada

BRITISH COLUMBIA
ARTS COUNCIL
An agency of the Province of British Columbia